2/2)/12

G

FOUR JEWS ON PARNASSUS—A CONVERSATION

FOUR JEWS
ON PARNASSUS

A CONVERSATION

BENJAMIN, ADORNO, SCHOLEM, SCHÖNBERG

CARL DJERASSI

ILLUSTRATIONS BY GABRIELE SEETHALER

COLUMBIA UNIVERSITY PRESS NEW YORK

COLUMBIA UNIVERSITY PRESS
PUBLISHERS SINCE 1893
NEW YORK CHICHESTER, WEST SUSSEX

Columbia University Press wishes to express its appreciation for assistance given by the
Pushkin Fund toward the cost of publishing this book.

Library of Congress Cataloging-in-Publication Data
Djerassi, Carl.
Four Jews on Parnassus—a conversation : Benjamin, Adorno, Scholem, Schönberg /
Carl Djerassi ; illustrations by Gabriele Seethaler.
p. cm.
Includes bibliographical references.
ISBN 978-0-231-14654-8 (cloth: acid-free paper)—ISBN 978-0-231-51830-7 (e-book)
1. Benjamin, Walter, 1892–1940—Drama. 2. Adorno, Theodor W., 1903–1969—Drama.
3. Scholem, Gershom Gerhard, 1897–1982—Drama. 4. Schoenberg, Arnold, 1874–1951—Drama.
5. Philosophy, Jewish—Germany—Drama. 6. Imaginary conversations. 7. Parnassus, Mount
(Greece)—Drama. I. Seethaler, Gabriele. II. Title.

PS3554.J47F68 2008
812´.54—dc22 2008021186

In memoriam
Diane Middlebrook
1939–2007

Between issue and return,
there is an absence in reality.
Things as they are.
Or so we say.
WALLACE STEVENS,
The Man with the Blue Guitar

CONTENTS

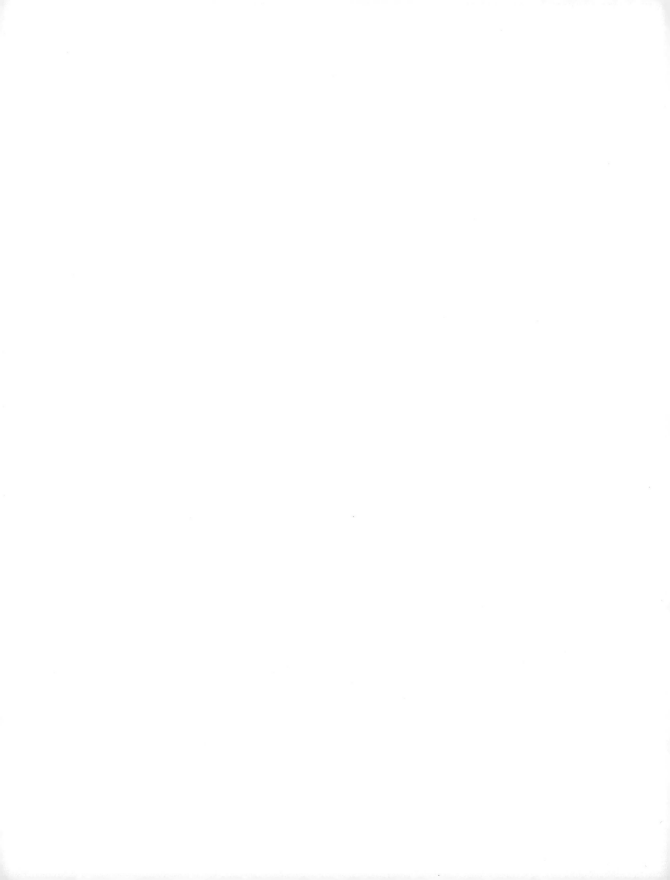

ILLUSTRATIONS

PREFACE

I HAVE chosen the format of direct speech to present an easily grasped and humanizing view of four extraordinary intellectuals of the twentieth century: Theodor W. Adorno, Walter Benjamin, Gershom Scholem, and Arnold Schönberg. From youth these men seemed convinced that they were destined for Parnassus; none of them ever discarded a scrap of writing, and, if he did, one of his friends picked it up and preserved it. As a consequence, the literature on these men—biographical, critical, interpretative, or revisionist—is enormous. And since they lived in the precomputer, faxless age of letter writers, a great deal of their professional and personal correspondence is extant, with much of it published in book form. Furthermore, each of them is the focus of an active archival site: Adorno's in Frankfurt, Benjamin's in Berlin, Scholem's in Jerusalem, and Schönberg's in Vienna. Especially voluminous is the writing about their personal and cerebral interaction as well as the manner in which Adorno and Scholem posthumously canonized Benjamin after his tragic suicide, thus precipitating the formation of an entire subdiscipline of Benjaminology.

Why did I pick this particular foursome? Because all four belonged to the peculiar subset of German and Austrian bourgeois Jews of the pre–World War II generation who often were more Berlinish or Viennese than their non-Jewish compatriots. None was deeply religious; some of them were essentially secular. This is also the generation and social subset to which I belong, and my personal experience with the indelible effects of growing up as a secular Jew in Vienna in the 1930s made me want to examine the range of the meaning of *Jew* through four individuals who responded so differently to that label. Sometimes even non-Jews such as Paul Klee—an important though silent character in my book—fell under suspicion in that era of vicious anti-Semitism and were branded: it was enough that their vocation or creative output resembled that of their secular Jewish counterparts.

Until recently, my own biographical writing was limited to autobiography, indeed an autobiographical explosion. In 1990 I wrote an autobiography, addressed to my fellow chemists,[1] that made heavy use of chemical pictography barely intelligible to a general audience. Having been bitten

by the bug of self-disclosure, two years later I published an autobiography meant for a general readership,[2] but presented in the somewhat unconventional style of twenty nonchronologically arranged, self-contained chapters. This autobiography marked my literary maturation beyond standard scientific information-laden prose and was followed a decade later by a slim memoir that described my full metamorphosis from scientist to late-blooming novelist and playwright.[3] In the process I learned an important lesson: autobiography contains a huge component of automythology, since the words set on paper have to pass through the personal psychic filter of an exhibitionist, which every autobiographer is. Only an utter masochist is capable of undressing completely before the voyeuristic reader to display every blemish, infirmity, or misdeed. Not so with biography, where the author deals with another person, frequently a deceased stranger, with most evidence based on written or photographic documentation.

The biographical sketches in my *Four Jews on Parnassus* arose from a blend of autobiographical and biographical impulses. I wished to write about four European intellectuals of the twentieth century—for me, *my* century, given that I was born in 1923. This was also a spectacularly important year for the four subjects I picked: Adorno and Benjamin first met in 1923, the year in which Adorno also first met his future wife Gretel as well as the year in which Scholem emigrated to Palestine and married; and also the year in which Schönberg became a widower and first released his *Komposition mit 12 Tönen*. But there is more to my choice of these four European Jews: I recognized themes in their lives that I also wanted to examine in my own as I approach its end. Just as in my own autobiography, I decided to deal with my four subjects through selected sketches, which are not necessarily chronologically connected. In this instance my choice was based on themes that in my opinion have hitherto been either largely underrepresented or even misrepresented in their otherwise overdocumented biographical records. Even more important, I have chosen to characterize my subjects by writing dialogue for them. The five episodes could, therefore, be categorized as docudramatic scenes, because (with two stipulated exceptions) every nugget of biographical information I disclose is based on historical documentation, at times even on direct quotation, derived from the bibliography or the personal interviews that are acknowledged at the end of my book.

I chose to present this biographical material exclusively in dialogue, with the exception of the prefatory sections to each sketch. One reason lies in my own biography. In my former incarnation as a scientist over half a century,

Gabriele Seethaler, *Mirror Images of Walter and Dora Sophie Benjamin, Theodor W. and Gretel Adorno, Gershom and Escha Scholem, and Arnold and Mathilde Schönberg.*

I was never permitted, nor did I allow myself, to use direct speech in my written discourse. With very rare exceptions, scientists have completely departed from written dialogue since the Renaissance, when, especially in Italy, some of the most important literary texts were written in dialogue— expository or even didactic to conversational or satirical—that attracted both readers and authors. Galileo is a splendid case in point. And not just in Italy. Take Erasmus of Rotterdam: his colloquies are a marvelous example how one of the Renaissance's greatest minds managed to cover in purely dialogic form topics ranging from "Military Affairs (*Militaria*)" or "Sport (*De lusu*)" to "Courtship (*Proci et puellae*)" or "The Young Man and the Harlot (*Adolescentis et scorti*)." This explosion of dialogic writing even stimulated literary-theoretical studies. From the sixteenth century on, critics have attempted to exalt, defend, regulate, or, alas, abolish this genre of writing, which on occasion has been defined as "closet drama": to be read rather than performed.

One of these critics was the Earl of Shaftesbury, who in 1710 commented in his "Advice to an Author" that "dialogue is at an end [because] all pretty Amour and Intercourse of Caresses between the Author and Reader" had disappeared. Since my purpose is to present a *humanizing* view of my four

subjects rather than theoretical insight into their work, I feel that dialog-
ic "Intercourse of Caresses" rather than the more dispassionate third-per-
son voice may be the most effective way of accomplishing this. I can only
hope that the intimacy of my caresses will convince the reader that, at least
in *Four Jews on Parnassus—a Conversation*, I was justified in disregarding the
Earl of Shaftesbury's counsel. London, October 2007

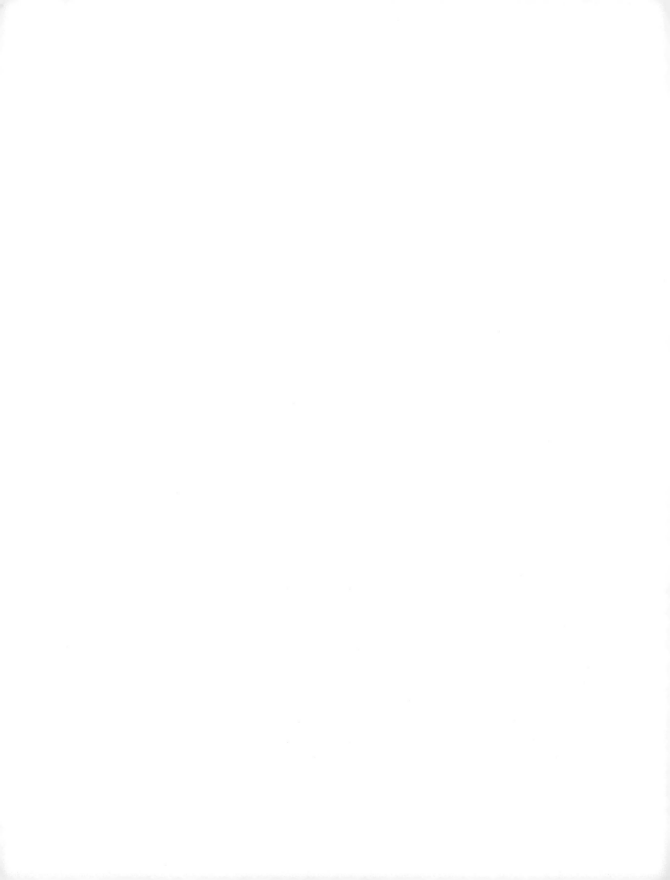

1. FOUR MEN

P ᴀʀ·ɴᴀs·sᴜs (pär-năsʻəs) also Par·nas·sós (-nä-sôsʻ): A mountain, about 2,458 m high, in central Greece north of the Gulf of Corinth. In ancient times it was sacred to Apollo, Dionysus, and the Muses. The Delphic Oracle was at the foot of the mountain. Metaphorically, the name "Parnassus" in literature typically refers to its distinction as the home of poetry, literature, and learning.

P ᴀʀɴᴀssᴜs ɪs a commonly accepted metaphor for the ultimate recognition of literary, musical, or intellectual achievement. Arrival on this exalted peak demonstrates that the process of canonization is complete. In the final analysis, the underlying theme in the following conversational quintet is an examination of the desire for canonization and the process whereby it is achieved. Among my four protagonists, solely Walter Benjamin—now considered to be one of the most important and influential philosophers and socioliterary critics of the twentieth century—ascended Parnassus posthumously. The other three had reached Parnassus while still alive. At the time of his suicide in 1940, only a limited circle of predominantly German intellectuals—among them Theodor Adorno, Hannah Arendt, Bertolt Brecht, and Gershom Scholem—considered Benjamin of Parnassian stature. The content and style of his writings was so complicated, even convoluted; the range of his interests so wide; and his publications so fragmented, that only a limited circle of contemporaries and especially recipients of his letters and reprints were able to absorb and appreciate the extraordinary depth and breadth of this powerful thinker. To paraphrase Hannah Arendt, "for fame the opinion of a few is not enough." Only in the 1950s as his writings started to be collected and published under the editorship of Adorno, his wife Gretel, and of Scholem did Benjamin receive recognition in Europe. In America the pivotal event was the publication of the English translation in 1968 of Hannah Arendt's collection of Benjamin's most famous essays under the title *Illuminations,* at which time Walter Benjamin was already ensconced on Parnassus. But as Arendt states in her introduction to *Illuminations*, "Posthumous fame is too odd a thing to be blamed upon the blindness of the world or the corruption of a literary milieu." Timing also has to be right and the post-Nazi, Marxist dialectics climate of the 1960s culminating in the student movements of 1968 was ideal.

There are certain rules and conditions that I have invented for the Parnassus where my four protagonists are finally meeting once more. Benjamin had asked his two friends, Adorno and Scholem, to meet him for an elucidation of some missing facts, because in my postmodern Parnassus everything that happened during a person's lifetime and since arrival on Parnassus is known; in fact, Internet access or Amazon-type ordering of current books is also possible, but no e-mail contact with the outside world nor any new creative work. So what is Benjamin's problem? Since he alone arrived posthumously on Parnassus, there is a gap in his autobiographical knowledge between his suicide in September 1940 and his arrival on Parnassus some two decades later. Could they help him fill that gap?

In the many hundreds of books and thousands of articles, the trio Benjamin, Adorno, and Scholem frequently occurs together. But what about the presence of the fourth, Arnold Schönberg? There is no evidence that either Benjamin or Scholem ever met the composer. In fact, not even Benjamin's writing shows any affinity to or interest in Schönberg, although I now describe a hitherto unknown, distant, factual familial relationship. Adorno, on the other hand, had a lifelong connection with Schönberg. Still in his early twenties, after a precocious doctoral thesis in philosophy, Adorno went in 1925 to Vienna to study composition with Schönberg, although his actual teacher was Alban Berg. For years, they had a respectful yet contentious relationship,[1] which underwent its severest test when Schönberg blamed Adorno for misrepresenting his persona when advising Thomas Mann for the development of the key figure, the twelve-tone composer Adrian Leverkühn, in his novel *Dr. Faustus*. Eventually, Schönberg forgave Mann, but not Adorno.

But that is not the reason why I have included Schönberg along with the trio. I needed him as an important foil as well as participant in chapters 2, 3, and 4, because the canonization process that reoccurs in all these chapters refers not only to persons but also to works of art, including music. Arnold Schönberg had invented a four-party chess game, coalition chess (*Bündnisschach*). The basic rules of the game are as follows. Two of the four players have twelve chess figures (yellow and black) at their disposal and are thus considered the two "big" powers, whereas the other two have only six figures (green and red), thus representing the "small" powers. After the first three moves, two "coalitions" ensue in that one of the small powers declares itself associated with one of the big ones. Thereafter the play continues until checkmate is reached.

Since the conversational confrontations of my protagonists can almost be considered an array of social chess gambits involving both attack-defense as well as collaborative moves, Gabriele Seethaler has introduced visual alterations of Schönberg's coalition chess as the leitmotiv for the five chapters—itself an attractive photorealistic gambit.

And now, meet my four characters, before we turn to their wives.

The sound of Max Bruch's "Kol Nidrei"[2] is heard for thirty to sixty seconds, starting with the full sound of the cello, as Arnold Schönberg and Theodor W. Adorno listen.

SCHÖNBERG: Stop! (*The music stops abruptly.*) Today is Yom Kippur ... the Day of Atonement when Kol Nidre is played. But why always Max Bruch's? At least up here, on Parnassus, let's hear my version for a change. Without the cello sentimentality of the Bruch. Kol Nidre needs words ... not just music!

1.1. Gabriele Seethaler, *Walter Benjamin, Theodor W. Adorno, Gershom Scholem, and Arnold Schönberg on Parnassus Inserted Into Arnold Schönberg's Coalition Chess.*

(*Schönberg's* Kol Nidre [Opus 39][3] *is heard through the musical introduction and the start of the male singer's voice:* "*The Kabbalah held some legend: In the beginning, God said 'Let there be light' until the words 'Bi-yeshivah shel ma'lah uve-yeshivah shel ma'tah.'*")

ADORNO: Enough! (*Music stops abruptly.*) You've made your point, but this isn't about music—twelve-tone or otherwise.

SCHÖNBERG: Then why did you ask me to come? I've never even met the other two.

ADORNO: But you have heard of them.

SCHÖNBERG: Everyone on Parnassus has been heard of . . . at least at some time. That doesn't mean one needs to meet them.

ADORNO: You agreed you would.

SCHÖNBERG: As a favor to you. Not that you deserve it . . . after what you did to me with Thomas Mann.

ADORNO: Maestro! Not now. I was not the one who put you into Mann's *Dr. Faustus.* It was his decision. Just imagine what you would have read in that book if I hadn't explained your music to him.

SCHÖNBERG (*grudgingly*): All right . . . not this time. But why did you want me here? What have I got to do with Benjamin and Scholem?

ADORNO: Square our triangle with your presence.

SCHÖNBERG (*ironic*): Very clever! But what if you should end up with a parallelogram?

ADORNO: I'll risk that . . . just so it does not remain a triangle. Besides, we need an outsider.

SCHÖNBERG: What's the topic?

ADORNO: Benjamin. Walter Benjamin. Or if you want his original full name that he has never used (*slow and deliberate*), Walter Bendix Schönflies Benjamin.

1.2. Walter Benjamin.

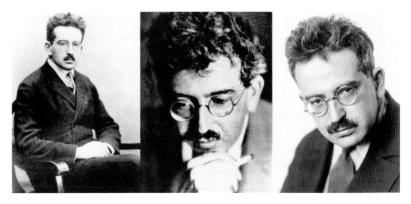

SCHÖNBERG: Ah, yes ... Schönflies, his mother's name. I checked that ... and came up with quite a surprise. Wait till I spring it on him.... Names and genealogy always intrigued me. Your name at birth, Theodor Ludwig Wiesengrund—

ADORNO (*interrupts*): Don't forget Adorno!

SCHÖNBERG (*laughs*): I was coming to it when you interrupted. How many people know you, Theodor Adorno, as (*slowly and deliberately*) Theodor Ludwig Wiesengrund Adorno? Up here, I would guess none.

ADORNO: Quite beside the point.

SCHÖNBERG: On the contrary. Your full name offered me enough letters for an anagrammatic revenge for what you did to me with Thomas Mann. Do you want to hear it?

ADORNO: Not really.

SCHÖNBERG: I'm too enamored by anagrams to resist it: "Oh, down did treason grow, under guile!"

ADORNO: Ouch ... that really hurt! But now for a change, just listen to us.

SCHÖNBERG: Anything about music?

ADORNO: Not if it's up to Benjamin. He doesn't even read notes. Art, of course, is another question. He's written one of the most influential articles on that subject in the last century.

SCHÖNBERG: But has he ever painted anything?

ADORNO: People who write about art don't usually do art. But you, the painter, should ask him. Now listen.

SCHÖNBERG: I never listen without interrupting. You should know that from your days in Vienna.

ADORNO: If you must ... interrupt. But first listen. Here he comes with Gershom Scholem.

BENJAMIN: "Vorbei—ein dummes Wort." Now why do I start with Goethe's tritest quote, "Gone—what a stupid word"? Because I have written so much about him? Because Goethe has Mephistopheles say these words and I'm about to start with my anno diaboli? I'm here to talk about truth ... the real truth ... the truth of deception. You may wish to call that fiction. But in that case, it's heavy fiction with the extra weight of mega calories ... not the puny calories contained in pastries or fois gras.

Paul Valéry once said that we all walk backward into the future. For once, I'll resist my unorthodoxy and do likewise. It was Sept. 26, in my anno diaboli 1940 when I killed myself in Port Bou. (*Chuckles to himself.*) It took my death to put that fishing village on the tourist map. If I'd waited one day ... or had come a day earlier, I could've crossed the border into Spain

1.3. Walter Benjamin.

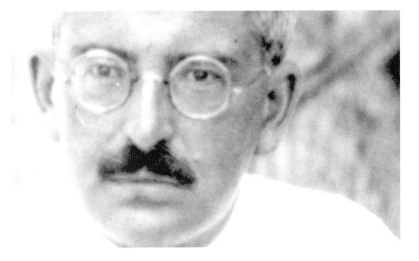

and on to Portugal . . . and then to freedom . . . or what I then thought to be freedom . . . in America . . . or Cuba . . . or China . . . or (*voice trails off*) But then how could I have known that the Spanish police would change their rules for twenty-four hours! If there was anything about Franco and his henchmen, it was consistency. But never mind. I was forty-eight, though wheezing like a sixty-year-old man, which I was in spirit and heart.

Lisa Fittko . . . that generous guide trying to lead us across the Pyrenees into Spain . . . called me "Der alte Benjamin" half jokingly, half pityingly as we stopped every ten minutes for one minute of rest. I had a weak heart, but with nitroglycerine tablets . . . I would've survived for years. Lisa, seventeen years younger than I, lived to be ninety-five. What about the people who got me up here to Parnassus? Hannah Arendt made it to age sixty-nine and Teddie Wiesengrund to sixty-six.

ADORNO: Adorno! Theodor Adorno, if you please! Not Wiesengrund!

1.4. Theodor W. Adorno.

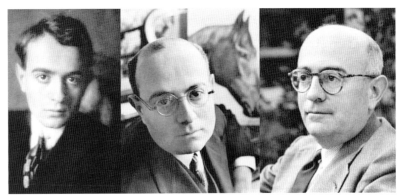

1.5. Gershom Scholem.

BENJAMIN (*wry smile*): Of course. Theodor Adorno. (*Aside.*) We Jews! There
are those, who want to hide their names . . . others who flaunt them. Take
you, Gerhard—

SCHOLEM: Gershom Scholem, if you please! Not Gerhard! At least not
now!

BENJAMIN: Even you, Gerhard, are becoming touchy up here. I used to ad-
dress you as "Mein lieber Gerhard" until my demise. But, since this is
postdemise, I'll defer to your wishes. You, Gershom Scholem, made it
to Jerusalem and lived until age eighty-five, while fools like me stayed in
Europe. Even Arthur Koestler made it to London . . . and didn't die till he
was almost seventy-eight. Also by suicide. . . . But suicide at forty-eight
can't be compared with one thirty years later. And to think that I gave
him half my supply of tablets! He could have died the same day as me. But
what if I had lived another thirty years? Just go to any library and you'll
find my collected writings in seventeen volumes . . . yet hardly a *real* book
among them. If I'd made it into Spain and onward and lived as long as
Koestler, would there then have been thirty-four volumes . . . including
some books? One thing I'm sure. If I'd made it to America, even I would
have called myself Walter Benjamin (*uses American pronunciation*) . . . not
Walter Benjamin (*uses German pronunciation for both names*). Or would I
have taken another name? I once wrote as "Detlef Holz." A strange name
for a Jew. . . . Detlef. And Holz? "There's nothing wooden about you," you
once said. But there's something wooden about everyone: Attitude . . .
movement . . . even heart. But let's skip Detlev Holz, because there was
another and much more important pseudonym, Agesilaus Santander!
You thought you'd solved what that stood for . . . contrary to most of the
others . . . especially my biographers. None of them had ever met me. I
was dead . . . dead for years, before they started paying attention to me.

SCHOLEM (*slow and precise*): Agesilaus Santander! How obscure can you get? But the last three letters … D E R … seemed to be the key to an ingenuous anagram. "Der Angelus Satanas."

BENJAMIN: Ingenuous? Yes. But anagrams must follow rules. Your satanic angel has seventeen letters, my pseudonym has eighteen!

SCHOLEM: I once thought of some other eighteen-letter anagrams for Agesilaus Santander: Saul Andreas Agstein or Stanislaus Adaneger. But they really meant nothing … other than providing anonymity. "Der Angelus Satanas" seemed so relevant, I was willing to forget about the missing letter.

BENJAMIN: If you want to read a meaning into that name let me offer a hint. Where did I first write about it?

SCHOLEM: Spain?

BENJAMIN: Indeed. And isn't Santander located in Spain near Bilbao?

SCHOLEM: What about Agesilaus?

BENJAMIN: An obscure Spartan king, who had injured his leg.

SCHOLEM: So obscure that even I have never heard of his injury.

BENJAMIN: Exactly the reason why I chose him … and because I had a similar problem with my leg!

SCHOLEM: This started out as some sort of monologue—a Parnassian one going forward and back. Fantastic, I thought. Back in Berlin I always loved to listen to you. I wasn't even twenty.

BENJAMIN: But so precocious!

SCHOLEM: A piker by comparison to you.

BENJAMIN: Yet it seems you were about to complain.

SCHOLEM: A Parnassian monologue needs more drama … more emotion.

BENJAMIN: I'm reflecting, not emoting. And if you want dramatic monologues, read Shakespeare. He uses Hamlet's monologs to penetrate the subjectivity of his dramatic character … something that had not been done before in English theater.

SCHOLEM: This monologue is about to degenerate into a lecture … and now on theater? Why? Because your first book dealt with the origin of German tragic drama? Parnassus is no place for lectures … even though some of its occupants got here because of them!

BENJAMIN: No one knows better than you how hard I fought for an academic position … and never got one. But why not consider it a lecture from the grave? This way I'll be sure we all start on the same page.

SCHOLEM: But to whom is this addressed? There are only three of us here …

and two of us know you almost better than you know yourself. So what's the gist of your self-reflective lecture?

BENJAMIN: Facts! Facts . . . missing facts.

SCHOLEM: Self-reflection is based on personal knowledge. The facts known to you.

BENJAMIN: But I'm different.

SCHOLEM: As you always claimed.

BENJAMIN: This is a different difference. The facts known to me stopped in September 1940. Now I'm speaking from Parnassus, which offers unexpected views of the recent past and, of course, the future. But before I got to Parnassus? There's a huge hole in my personal knowledge . . . almost twenty missing years following my demise.

ADORNO: Why such a gentle word for such a tragic event?

BENJAMIN: All right . . . suicide. I don't know where I was buried beyond what I have heard from you two . . . that my so-called grave in Port Bou is not my grave. So what did they do with my body . . . and that briefcase . . . and of course its contents?

SCHOLEM: Now you're making sense. It's the contents . . . not your bones or ashes . . . that are the key. The contents deal with Walter Benjamin on Parnassus—the rest is only of touristic consequence.

SCHÖNBERG (*interrupts*): Wait a moment! Wait!

BENJAMIN (*who had not noticed Schönberg*): Who are you?

SCHÖNBERG: Schönberg. Arnold Schönberg.

BENJAMIN: I didn't know you were here.

SCHÖNBERG: I was here before any of you.

BENJAMIN: But how did you get here?

1.6. Arnold Schönberg.

SCHÖNBERG: To Parnassus? Surely you are joking!

BENJAMIN (*apologetic*): No . . . no. Not Parnassus. I meant to this . . . what shall I call it . . . personal review of missing facts? With two friends who might recall them?

SCHÖNBERG: My friend Wiesengrund—

BENJAMIN: Teddie?

ADORNO: Adorno!

SCHÖNBERG: Wiesengrund Adorno. He invited me.

ADORNO: I thought a neutral presence might be useful.

BENJAMIN: As judge or referee?

ADORNO: None of us needs a judge—

SCHOLEM: I've never had use for a referee. What student of the Kabbalah would ever welcome a referee?

ADORNO: He will just be an observer.

BENJAMIN (*to Schönberg*): Too bad we never met before. It could have been in Berlin . . . we lived there at the same time.

SCHÖNBERG: We're cousins, you know.

BENJAMIN (*astonished*): You and me?

SCHÖNBERG: Well . . . by marriage. The cousin connection is on your mother's side and my second wife, Gertrud.

BENJAMIN: What was her maiden name?

SCHÖNBERG: Kolisch.

BENJAMIN: You mean Rudolf Kolisch's sister? I went to some of his concerts in Paris. But I know of no Kolisch in my family.

SCHÖNBERG: It was all on the maternal side. My wife's family went through two generations each of Hoffmanns, then of Biedermanns, and finally of Freistadts to end up in the seventeenth century with a Pressburg . . . Michl Simon.

BENJAMIN: A relative of Sara Lea Pressburg . . . the great grandmother of Heinrich Heine?

SCHÖNBERG: So you have heard of her.

BENJAMIN: She was my great-great-great-great-great-grandmother. My mother always boasted about our Heine connection.

SCHÖNBERG: Your Sara and my wife's Michl Pressburg were siblings. So welcome, cousin!

ADORNO (*surprised*): I can't believe it! I've known Rudolf Kolisch for years, I've known you since the middle twenties, but no one ever mentioned that connection.

SCHÖNBERG: Well, it wasn't exactly common gossip. I only picked it up recently when I learned that I was about to meet the three of you.

BENJAMIN: But how did you find this out? You're a composer—

SCHÖNBERG: And a painter—

BENJAMIN: Granted. But also a genealogist?

SCHÖNBERG: Not really. But what if I were? You are a social critic ... a critical philosopher ... a philosophical historian—

SCHOLEM: Don't forget literary critic. Many of us ... including Bertolt Brecht ... considered Walter the greatest German literary critic of his time!

BENJAMIN: Enough!

SCHÖNBERG: But also a graphologist—

BENJAMIN: Anything wrong with graphology? You gain a lot of insight—

SCHÖNBERG: What kind of insight? At best ... vague guesses, if not pure conjecture. With genealogy, you get history ... indisputable facts!

SCHOLEM: I wonder whether Walter and I are related?

SCHÖNBERG: I checked on all of you. Benjamin and Schönberg via Kolisch are the only two.

BENJAMIN: Enough of that. But why the interruption?

SCHÖNBERG: The rules! What are the rules of this "out of the grave" engagement? I believe in rules.

ADORNO: You would ... or you could never have come up with a twelve-tone method.

SCHÖNBERG: But rules are important.... And not just in music. Take my coalition chess.

BENJAMIN: Did you say "chess"? Scholem and I ... or Brecht and I ... used to play rather good chess at one time. But *your* chess? I have never heard of a Schönberg move, let alone Schönberg's coalition chess.

SCHÖNBERG: A game for four ... not two. I even created the pieces.

BENJAMIN: Four-handed coalition chess? I thought chess was always about competition and checkmating. Live and learn! Even in the grave.

SCHÖNBERG: Graves in general ... or your own?

BENJAMIN: A good point. Let's talk about *my* grave.

SCHÖNBERG: Wait a moment! There are rules up here in Parnassus ... behavior that is inadmissible ... misbehavior that is tolerated ... and especially the meaning of time. Remember, I've been up here longer than any of you. In fact, the only one, who was still alive down there after having reached Parnassus. A type of commuting that none of you experienced.

BENJAMIN: Rules about time? Now that interests me.

SCHÖNBERG: I'd expect you to be. I'm thinking of travel through space and time . . . forward to self-perpetuation . . . and simultaneously backward to self-immolation.

SCHOLEM: Self-immolation is one of Walter's specialties.

SCHÖNBERG (*to Benjamin*): Let's take that sudden interest in your grave. You allow yourself to talk *from* the grave *about* your grave? What about us three? Aren't we just as dead?

BENJAMIN: But you know where you are buried.

SCHÖNBERG: And you don't?

BENJAMIN: I know where I died . . . but my grave?

ADORNO (*sighs wearily*): So what about your grave?

BENJAMIN: Where is it? Where is the tombstone? What does it say?

SCHOLEM: You think tombstones are important? Take us two. We were both born in Berlin. You died in Spain, and I in Jerusalem. Now that we both reside on Parnassus, there is a Walter Benjamin Platz in Berlin— even a plaque where your last home stood—but no Scholem Platz or Scholem Strasse or even Scholem Gasse—

SCHÖNBERG (*quickly interrupts*): If I had a choice, I'd prefer a bridge named after me. There's a square and a park in Vienna bearing my name . . . even an Austrian postal stamp . . . but no bridges. But if my music did any- thing . . . it was bridging the old and new.

SCHOLEM: A bridge wouldn't be bad . . . even though a bridge connects as well as separates. But there isn't even a bust or plaque to mark the place in Berlin where I was born. Just my name on a grave in the Jewish Weis- sensee cemetery, where the other Berlin Scholems are buried.

1.7. Gabriele Seethaler, *Walter Benjamin's Face Superimposed Upon Walter Benjamin Platz, Walter Benjamin's Plaque in Berlin.*

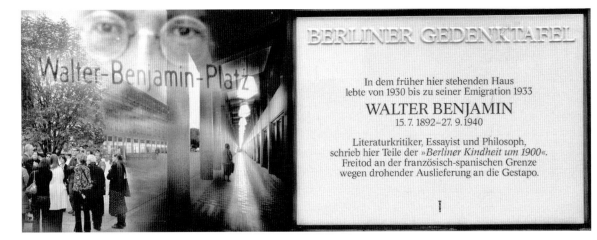

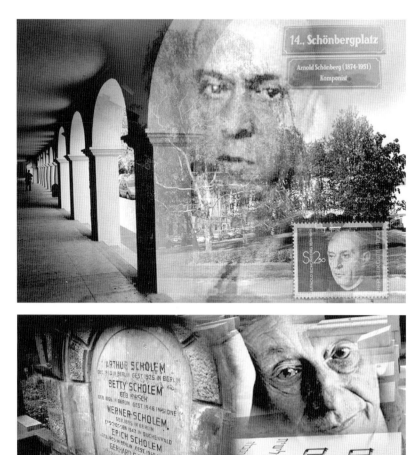

1.8. Gabriele Seethaler, *Arnold Schönberg's Face and Stamp Superimposed Upon Arnold Schönberg Platz, Vienna.*

1.9. Gabriele Seethaler, *Gershom Scholem's Face Superimposed Upon Scholem's Family Grave in the Jewish Weissensee Cemetery (Berlin), Where the Other Berlin Scholems Are Buried, and Gershom Scholem's Grave in Jerusalem.*

Below

1.10. Gabriele Seethaler, *Gershom Scholem's Face Superimposed Upon Israeli Stamps.*

BENJAMIN: At least you have that.

SCHOLEM: But I was never buried in it! I died in Jerusalem and that's where my bones lie. Yet there isn't even an Israeli stamp of me. (*Quick and irritated*): Former presidents of Israel . . . dozens of rabbis . . . even ducks or flowers of the Holy Land . . . these I can understand. But what are Alexander Graham Bell . . . Antoine de Saint-Exupéry . . . King Hussein of Jordan . . . Johann Sebastian Bach . . . and other goyim doing on those stamps but no Gershom Scholem, who made the Kabbalah respectable? Instead they buried me in Sanhedria—an ultra-Orthodox cemetery in Jerusalem—when I don't even follow kosher rules and am barely seen in a synagogue. I'd rather have had a stamp.

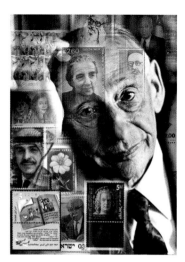

BENJAMIN: Your books carry more weight than any such stamps.

SCHOLEM (*sarcastically*): Of course, when it comes to weight, I win. My book on Sabbatai Sevi, the false messiah, is nearly one thousand pages long.

ADORNO (*quickly interrupts*): I was buried in the family tomb in Frankfurt ... not too far from Alzheimer ... whose disease fortunately never reached Parnassus.

There is now even a monument on the Theodor W. Adorno Platz in Frankfurt. But all it shows is a desk and chair ... and a metronome! No face ... no body!

SCHOLEM: But there is a stamp of you!

1.11. Gabriele Seethaler, *Theodor W. Adorno's Face Superimposed Upon Theodor W. and Gretel Adorno's Grave and Alois Alzheimer's Grave in Frankfurt.*

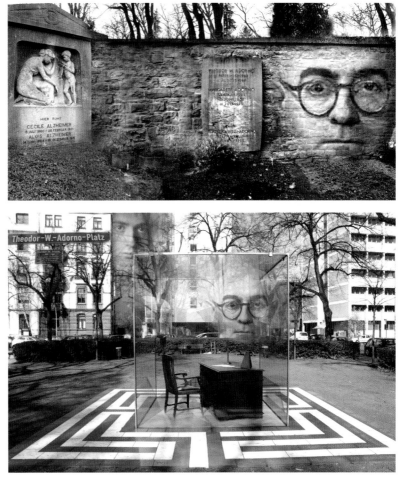

1.12. Gabriele Seethaler, *Theodor W. Adorno's Face Superimposed Upon the Theodor W. Adorno Monument on Theodor W. Adorno Platz in Frankfurt.*

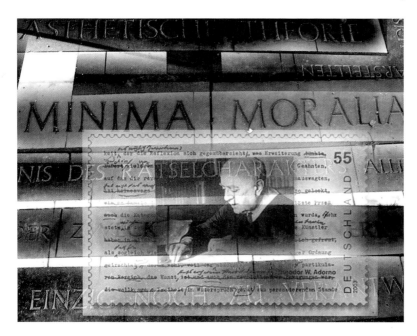

1.13. Gabriele Seethaler, *Inscriptions on the Floor of the Theodor W. Adorno Monument in Frankfurt Superimposed Upon Theodor W. Adorno's Stamp.*

ADORNO: True. And while they waited until the centenary of my birthday before coming out with one, I have to admit that I liked what it showed. Not just my face, but also how I always corrected my manuscripts.

SCHOLEM: You were notorious for rewriting your manuscripts until the very last moment.

BENJAMIN (*stubborn*): You two argue about recognitions. I would like to know what they did with my body.

SCHÖNBERG: I was cremated in Los Angeles and twenty-three years later they moved my ashes to Vienna with a tombstone by none other than Fritz Wotruba.

I s that important? What is important is that I am up here. (*Ironic.*) Walter Benjamin's voice from the grave wondering about his grave? Isn't that a contradiction in terms?

BENJAMIN: How would I know? It's my first posthumous discourse.

SCHOLEM: Just a few months after your death, Hannah Arendt passed through Port Bou on her flight from France.

BENJAMIN: And?

SCHOLEM: She found nothing ... not even a grave marker. At least that's what she wrote me.

SCHÖNBERG (*to Benjamin*): What's really behind this preoccupation with your grave? This mélange of nostalgia and curiosity.

1.14. Gabriele Seethaler, *Arnold Schönberg's Face Superimposed Upon Arnold Schönberg's Grave, Zentralfriedhof, Vienna.*

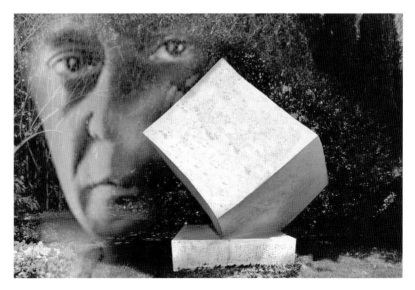

1.14. Gabriele Seethaler, *Arnold Schönberg's Face Superimposed Upon Arnold Schönberg's Grave, Zentralfriedhof, Vienna.*

BENJAMIN: I always thought that the words "It is more arduous to honor the memory of the nameless than that of the renowned" would be an ideal grave marker during those horrible days of 1940.

SCHÖNBERG: Is that a quote?

SCHOLEM (*whispering to Schönberg*): You shouldn't have asked. Walter wrote this years ago... It was in his notes on his "Theses on the Philosophy of History." (*Louder, addressing Benjamin.*) I understand your preoccupation.

BENJAMIN: How could you?

SCHOLEM: There's no reason to hide it now... posthumously. I've also thought about my grave. When I was nineteen, I wrote in my diary: "Everything I wish for myself, that I would want to write on my gravestone, I could summarize epigrammatically without lying... He was Scholem... he was as his name demanded, he lived his name, wholly and undivided."

ADORNO: You say, "he was Scholem?" What does that mean?

SCHOLEM: In Hebrew *shalem* means "whole"... or undivided.

BENJAMIN (*taken aback*): In all our hundreds of letters, you never volunteered that.

SCHOLEM: You never asked.

BENJAMIN: Let me ask now. I do know that Gershom was the son of Moses and Zipporah. But what does it mean?

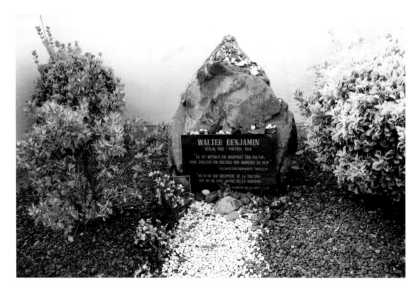

1.15. Gabriele Seethaler, *Walter Benjamin's Grave Marker, Port Bou, Spain.*

SCHOLEM: In Exodus 2:22 the word means expulsion. Its derivation comes from the word *ger,* meaning a sojourner, or someone who is in a certain place but does not really come from there . . . a stranger.

BENJAMIN: How apt! Now I understand why you changed Gerhard to Gershom. And is that now inscribed on your grave . . . what you wished at age nineteen?

SCHOLEM: No. Those were gravestone juvenilia.

BENJAMIN (*taken aback*): Still, I would like to know what mine said. (*Pause.*) Apparently nothing.

SCHOLEM: Not quite true. Years later, when people realized that you were not just some refugee who had committed suicide but one of our great thinkers, the local authorities did put up a grave marker.

BENJAMIN: So there is a grave!

SCHOLEM: I said grave marker, not grave. You weren't buried there. But I have some news for you.

BENJAMIN: Finally!

SCHOLEM: There is a Walter Benjamin memorial in Port Bou by none other than the Israeli sculptor Dani Karavan. This should please you . . . even though the glass is now cracked.

BENJAMIN: As so much else in my life.

ADORNO: Since you are now one of the famous, monuments are more useful than graves. One of the clear benefits of fame.

1.16. Gabriele Seethaler, *Walter Benjamin's Face Superimposed Upon Walter Benjamin's Monument by the Israeli Sculptor Dani Karavan in Port Bou, Spain.*

SCHOLEM: I can think of some more nebulous aspects.

SCHÖNBERG: Name one.

SCHOLEM: People feel free to violate your privacy.

BENJAMIN: That also goes with notoriety . . . not just fame.

SCHOLEM: Ah, yes, but fame makes us subject to *posthumous* violation of our privacy. That never ends.

BENJAMIN: What sort of privacy are you talking about?

ADORNO: All kinds—especially sexual.

BENJAMIN: Extending to our wives?

ADORNO: What a naive question.

END OF SCENE 1

2. FOUR WIVES

A
s ADORNO implied in his concluding sentence, readers interested in famous men are invariably interested in their private lives. The correspondence of Adorno, Benjamin, and Scholem with each other or with friends, at times also with parents or lovers, has been published in many volumes. In the case of Schönberg, over twenty thousand letters are extant in several repositories. But where is the correspondence with their wives? It isn't that the spouses did not correspond with each other; most of them were addicted letter writers. Does this mean that the letters were not preserved through mere sloppiness? Destroyed out of embarrassment? Or are they hidden away in archives? Especially puzzling in that regard is the correspondence of Benjamin and Scholem. They wrote to each other for

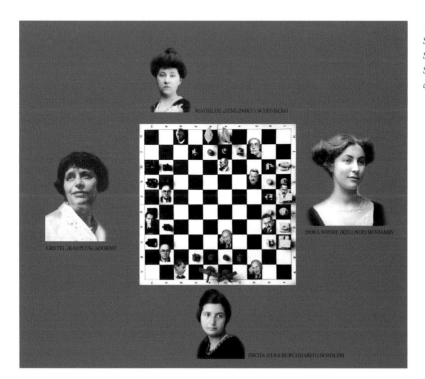

2.1. Gabriele Seethaler, *Mathilde Schönberg, Dora Sophie Benjamin, Escha Scholem, and Gretel Adorno Around Arnold Schönberg's Coalition Chess, Their Husbands as Chess Pieces.*

over twenty years, in an intimate and intellectually challenging exchange of letters that was carefully preserved and then published virtually in its entirety; yet they say practically nothing about their wives. Was this topic too intimate? Or did they simply consider it tangential to the weighty issues that concerned them in their letters? Their sheer length is virtually unimaginable in today's world of pithy e-mail messages or nonrecorded mobile phone conversations, compounded by the fact that at times Benjamin did not even have access to a telephone. An equally astonishing epistolary intercourse is that between Adorno and Benjamin, which covers eight years. In one instance, two monumental letters from Adorno to Benjamin alone amount to circa fifty single-spaced pages—sufficient for a modest masters degree dissertation, but in depth of content exceeding that of many a Ph.D. thesis.

Yet each of these four wives was an accomplished and energetic woman, well educated and deeply familiar with her husbands' intellectual spheres. All but one (Mathilde Schönberg) contributed to her husband's creative output. In spite of their substantial intellectual and emotional contributions, the wives have received minimal exposure in the voluminous biographical or autobiographical literature of these four intellectual giants. For instance, given the almost unbelievable minutiae that have been documented in Benjamin's life, relatively little is known from his own pen about his wife, Dora Sophie. In fact, after Benjamin's suicide at age forty-eight, her subsequent twenty-four years in London are shrouded in obscurity.

Who was Dora Sophie Benjamin?

Dora Sophie (to differentiate her from Benjamin's sister, Dora Benjamin) was born in 1890 in Vienna as the daughter of the Jewish Viennese professor of English Leon Kellner. Family life endowed her with a knowledge of English, which subsequently served her well; and she developed a passion for music while growing up. (Benjamin, in contrast, had only a rudimentary knowledge of the English language and almost none at all of music). At age twenty-one she married an affluent journalist and philosophical pedagogue, Max Pollack, who was a member of Benjamin's circle in Berlin at the outbreak of World War I. Dora Sophie Pollack was so smitten by twenty-two-year-old Walter Benjamin's inaugural speech as chairman of the Free Students Union that she presented him with roses. A year later they were traveling together and, after her divorce from Max Pollack, they married in 1917. During their marriage, Dora Sophie provided the bulk of their income, first as bilingual secretary, subsequently through journalistic work, later through editorship of the magazine *Die praktische Berlinerin*, and finally through fiction writing; her novel *Gas gegen Gas* appeared in 1930. Their only

son, Stefan, was born in 1918, while Benjamin studied for his doctorate in Bern, a period during which Dora Sophie also met Scholem and his future wife Escha and the latter's second husband, Hugo Bergman—people that readers will encounter shortly. As Dora Sophie wrote in a letter to Scholem, she wanted a partner who could give meaning to her life, while Walter needed protection from suicide. Neither motivation preserved their rocky marital relationship, which ended in 1930. The judicial record of their divorce proceeding presents a sordid melodrama full of sexual infidelities and quarrels over money. After Hitler's rise to power, Dora Sophie Benjamin moved to Italy, where she first served as cook and later owner of the Hotel Miramare in San Remo. On several occasions she provided refuge to her penniless former husband at the hotel. In 1938 she undertook a marriage of convenience with a South African businessman, which enabled her to move in 1938 to London with her son Stefan. She died there in 1964.

Two other points merit mention. Rumors, allusions, and even some documentary evidence suggest that Dora Sophie disliked—perhaps even despised—both Scholem and Adorno. (Interestingly, Scholem's second wife, Fania, had equally negative feelings about Benjamin: according to an interview in *Haaretz* in 1987, she thought Benjamin dishonest and selfish in that he would never have done anything to help Scholem if Scholem had been in need. Yet she admitted that Scholem truly loved Benjamin, probably more than any other person in the world). More pertinent to later sections in my book is the total absence of Judaism in the upbringing of Stefan Benjamin, who died in London at age fifty-four. His third wife was a Chinese Buddhist, and neither one of the daughters from that marriage ever set foot in a synagogue.

But these are not the sort of biographical details that Dora Sophie Benjamin would have recapitulated during a final, posthumous visit to Parnassus. More likely topics would have been her grudges about their early adulteries and her questions about the fate of the gift she had made to Benjamin on his birthday in 1920: a watercolor by Paul Klee titled *Presentation of the Miracle*. A second work by Paul Klee, *Angelus Novus*, acquired by Benjamin the following year, played such an important emotional and intellectual role in his life—and later in the lives of Adorno and Scholem—that for many it has turned into Benjamin's logo. Why has nothing been written by Benjamin or his friends about that *Presentation of the Miracle*? It is now in the permanent collection of the Museum of Modern Art in New York. But how did it get there? The answer to this hitherto puzzling question regarding provenance is offered below.

Walter Benjamin sits on a stool, head in his hands, while Dora Sophie Benjamin, his former wife, approaches him. She is talking to herself in a strong, almost combative tone.

DORA: Of course, I didn't get Walter up here. Hannah Arendt helped mightily... although these two men think they did it all. But in the end, he's here because of his work... and that's where I come in. Who kept him sane when he beat military service and studied in Bern? Who fed and housed him during those early years of restless wandering... in mind and in body. But there has to be closure.

WALTER (*looks up startled*): Dora!

DORA (*aggressive*): I should never have married you!

WALTER (*tired*): It was destined. But how did you get up here... and why now, after so many years?

DORA: Call it a tourist visa to Parnassus... to complete some unfinished business.

WALTER: Tourist visas to Parnassus? Impossible.

DORA: Business visa then.

WALTER: Don't spout nonsense. No wonder some friends called you a windbag.

DORA: Those were your friends... and my enemies. Still, here I am. Even on Parnassus, all you need is connections.

WALTER: And you have them?

DORA: One of your friends helped.

WALTER: Which one?

DORA: There he comes. (*Scholem enters.*)

SCHOLEM (*to Dora*): So you did make it? I thought you'd change your mind.

WALTER (*to Scholem*): And why are *you* here?

DORA: I wanted a witness.

WALTER: For what? Past events? I suspect the two of us will remember facts without Gerhard's help.

DORA: The facts? Perhaps. But it's motivation... and interpretation I want to address.

WALTER: Where do you want to start?

DORA: With adultery.

WALTER (*taken aback*): Mine... or yours?

DORA: Let's start with yours.

SCHOLEM: I think I should leave.

DORA: Stay! You know most of it... so why not all?

SCHOLEM: It's not the sort of behavior I condone.

DORA: Condoning is not the issue. I am talking about committing adultery...a subject that can't be unfamiliar to you.

SCHOLEM: Now wait a moment!

DORA (*waves away his interruption*): Never mind. In Walter's case, there was usually more condoning than committing. More intent...than consummation. Now that I reflect upon it...consummation of any kind, Walter, was never your real forte.

WALTER: You think this will be a productive discussion?

DORA: You...who discoursed all your life...never used to ask whether it was "productive." Consequential? Invariably. Dialectic? Much of the time. Contentious? With Gerhard...always. Even analytical. But productive? Not during your life time. Of course, when I think of all the doctoral dissertations and academic careers that were spawned from it posthumously...this Benjaminology industry...I concede that it proved productive. It may be sacrilegious to say that up here, but maybe it's turned out to be a bit *too* productive...too much Benjaminiana...collecting every bit of esoteric detritus you left behind irrespective of its value.

WALTER (*conciliatory*): Dora...why have you come?

SCHOLEM: You always had a sharp tongue. But why are so angry now?

DORA: An accumulation of grievances, I suppose. (*Addresses Walter.*) When I knew that we'd have one last conversation, I felt I'd have to ask you one question I was never able to ask before.

WALTER: Let's get it over with—but quickly. Ask.

DORA: Before I do, we must start with adultery...because that was the reason for our divorce.

WALTER (*mildly ironic*): The *real* reason?

DORA: The legal reason. The emotional one was that you had fallen out of love with me...if you ever were in love. But the real one was money...money that belonged to me and that you demanded because you couldn't support yourself. So you blackmailed me.

SCHOLEM: Dora, that is unfair.

DORA: I'm talking about facts...not fairness. Walter threatened to take Stefan away from me if I didn't pay up. My only child! Of course, before the judge, he accused me of adultery—

WALTER: Which you admitted.

DORA: Which I admitted...while you denied yours. Including the absurdity that you spent a December holiday in 1929 with Asja Lacis in Bad Königstein and stayed in separate rooms.

WALTER: How did you know we didn't?

SCHOLEM: Don't Walter.

WALTER: Don't what?

SCHOLEM: Even the judge didn't believe that. It wasn't a question of hotel registration. It was a question of what happened in the hotel. We all knew you were madly in love with Asja.

WALTER: So I was.

DORA: And sexually besotted. Or is that inaccurate?

WALTER (*quietly*): No.

DORA: But that is not what I hold against you. Sex was important to you as it was to me . . . but you never came to terms with it . . . you the ultimate seminal man.

SCHOLEM: Was that a compliment?

DORA: In the figurative sense that Walter was one of the truly seminal literary thinkers of our generation? Yes, a compliment, because he was ahead of most of his cohorts. And you, Gerhard, helped people recognize Walter's uniqueness . . . something I always credited you for even though you also used him for your own purposes. As did Teddie Adorno.

SCHOLEM: That isn't fair.

DORA: You both keep harping about fairness, while I am trying to focus on events and behavior. Right now we are talking about Walter's other side . . . the seminally sexual one as the literal spiller of semen . . . intoxicated with desire and yet distanced. But adultery is not just carnal congress. Emotional adultery is worse and in that department Walter was an addict. Every woman he desired—

WALTER: Every?

DORA: Every one of your women that I knew of was married or in a relation with another man. Grete Radt, Jula Cohn, Olga Parem . . . who turned down your marriage proposal in Ibiza . . . Asja Lacis in Capri . . . Inge Buchholz . . . and then Toet Blaupott ten Cate back in Ibiza. . . . And don't think that I don't know how to spell that absurd name (*quickly spells it* T O E T B L A U P O T T T E N C A T E *with heavy emphasis on each letter* T) . . . no less than five Ts . . . (*spits it out*) tee, tee, tee, tee, tee. . . . And even though you wanted to live with Toet, she always addressed you as *Sie, Sie, Sie* . . . never as *Du. (To Scholem.)* Listen to what she once wrote to Walter: "Why do you wish something that doesn't exist and won't exist, instead of recognizing how spectacularly good what exists is?" (*Derisive.*) Some intimacy!

SCHOLEM: Dora . . . please! You know what Walter once told me? Three women in his life caused him to discover three different men within him-

self. And that any autobiography would have to deal with the rise and fall of these three Walters and their compromises.

DORA (*bitterly*): Compromises and the inability to achieve them summarizes Walter's life. (*To Walter.*) So who were the three?

WALTER (*to Scholem*): Tell her.

SCHOLEM: You, Dora, were the first.

DORA (*to Walter*): The first? Is that true? (*Seeing Walter nod, she raises her hand toward Scholem.*) In that case, I don't want to hear about the others.

WALTER: I note you didn't include Gretel Adorno in your inventory.

DORA: She belongs on another list. And, except for Gretel, you wanted to marry every one of them, but only one was gullible or foolish enough to accept.

WALTER: So why did you?

DORA: Because you were the most perverse man I've ever met.

SCHOLEM: Perverse?

WALTER (*to Scholem*): Thanks for beating me to the draw. (*To Dora.*) Would you care to elaborate on your description of me as "perverse" ... but hopefully by staying outside the bedroom?

DORA: We don't need to get Gerhard involved in that ... it's too private ... even for me. I meant perversely brilliant in your written style ... as well as perversely precocious when I first met you as the twenty-two-year-old Walter ... not the later insufferable Herr Dr. Benjamin. And irresistibly charming ... when you allowed yourself to be that. (*To Walter.*) Yet where did you first bed me?

WALTER: Why these geographical minutiae?

DORA: For Gerhard's information. (*To Scholem.*) He seduced me while staying with Max and me in our villa on Starnberg See ... Mr. and Mrs. Max Pollak's villa.

WALTER (*heavy irony*): I seduced *you*, Mrs. Max Pollack?

DORA: All right. *We* seduced each other.

SCHOLEM: Poor Max.

DORA (*dismissive*): Don't waste any tears on him. By then, Max had turned into a self-effacing loser, who missed his friends more than his wife ... a living, tiresome encyclopedia of art and humanities. And who can live with an encyclopedia, however financially well endowed? It was pretty much over between us. But, for Walter and me, it was adultery ... mutual and tolerated adultery ... because while I was still married, Walter was engaged to Grete.

WALTER: Why this continuous harping on adultery?

DORA: Because there are run-of-the-mill adulterous affairs and adulterous affairs of consequence.

SCHOLEM: This is becoming too subtle for me.

WALTER: And for me.

DORA (*to Walter*): First, the lovers need to consider the consequences of their intended adultery for others—

SCHOLEM: By definition, consequences only follow once an action has been undertaken.

DORA: You can argue that out with one of your two wives, but it is too Talmudic for me and also wrong! Convinced . . . or call them . . . amoral . . . adulterers think about the consequences . . . or lack thereof . . . *before* falling into bed. With Walter and me, the consequences to the other parties were really inconsequential . . . both of us were in the process of parting from our partners. But then Walter and I got married . . . seriously so. Sufficiently so, that a year later we had a son . . . not that Walter was ever much of a father to Stefan.

WALTER: Is that what you came to talk about . . . my deficiencies as a father? I have always conceded them.

DORA: No . . . that was an unintended digression. I'm still sticking to adultery. But during that phase of our marriage, we had other affairs. For instance, yours with Jula Cohn . . . whom you continued to love for years.

WALTER: And yours with Ernst Schoen.

DORA: Exactly. Mine with our friend Ernst in London and you with Jula in Berlin. And these were not any more inconsequential because we were still very much married . . . or so I thought. Ernst was a dear enough friend of yours that when you and I got divorced, he chose to stay with you, not me. Like all your friends—

SCHOLEM: Not true of me. As late as December 30, 1959, I wrote you a long letter on your seventieth birthday . . . a letter, incidentally, that you never acknowledged. On my file copy I had made the notations: "Will she receive it? Will she answer it?"

DORA: I don't remember the letter . . . but in any event I apologize. So you're the exception that proves the rule among the Benjamin groupies.

SCHOLEM: Perhaps because we were never lovers.

DORA: Gerhard, let's be frank. I could never have visualized you as a guest in my bed . . . although rumors have it that you weren't exactly inexperienced on the extramarital front. Besides, you were probably the only

friend Walter would have dropped if you had slept with me. But not Ernst Schoen. Walter didn't just forgive him; he left *my* Klee to *him!*

SCHOLEM: Wait a moment. The Klee was left to *me!*

DORA: We are not talking about the same Klee. You are thinking of the *Angelus Novus* and I—

WALTER: I thought the topic was adultery, not Paul Klee.

DORA: The topic has turned to the consequences of adultery. At this point, we still slept together, while already sleeping with others. In other words, potentially dangerous extramarital fucking.

SCHOLEM (*severely*): Four letter words are not used up here.

DORA (*sarcastic*): Forgive this tourist lacking in Parnassian manners. (*Addresses Walter.*) But then you fell for Asja . . . and that was truly consequential. You didn't just leave our bedroom . . . you left our house. Copulating in Capri with a Latvian Bolshevik actress manqué who was in heat . . . and you getting so besotted by that temptress that the next year you followed her to Riga and then to Moscow. And then even dedicating to her one of the very few books you managed to write during your life time.

SCHOLEM: One was also dedicated to you.

DORA (*sarcastic*): Of course! Homage to mistress and to wife. No wonder, *her* book was called *One Way Street* and mine *Tragic Drama*. How subtle . . . and how obvious!

WALTER (*interrupts*): This is getting tiresome. Even our witness here (*points to Scholem*) knows that I won't quibble about the facts, although I'd use different words to describe them.

SCHOLEM (*to Walter*): Even I never forgave Asja for converting you into a specious Marxist. You have too much religiosity in you . . . simply incompatible with her unwavering radical communism. I've always told you: deep down, you're a religious anarchist and not a Marxist communist. Among Marxists, you always were marked as a queer duck.

WALTER: I see: like Gershom Scholem, the queer duck among Zionists?

DORA: Gerhard! Can't you forget those attempts of yours to "save" Walter from Marxism and for Judaism?

WALTER: Dora has a point. All of you . . . including Hannah Arendt . . . but especially you, Gerhard . . . attempted to reinterpret me, because all too often you looked at me through the lens of your own ideology—

SCHOLEM: That's unfair . . . except to the extent that a student of the Kabbalah reinterprets all the time.

WALTER: What about posthumous deletions . . . not just reinterpretations?

SCHOLEM: Are you accusing your oldest friend of deliberate deletions of your oeuvre?

WALTER: Oeuvre! A lovely word. But I didn't say deliberate. It could have been unconscious. Or was it deliberate?

DORA: Stop it! For once, stick to my agenda. I was talking about Marxist conversions in bed. Remember, Walter's own Communist brother Georg couldn't convince him. It took a Latvian Communist hussy to accomplish that through sex. (*Dismissive.*) Postcoital Marxist dialectics is what I call it.

WALTER (*ironic*): So it's back to adultery? What more is there?

DORA: For eight years we lived what they now call an open marriage. You didn't hesitate to tell me your dirty secrets; you didn't just encourage me to take lovers . . . like Lothar Brieger or Friedrich Podzus. You did it because for two years . . . we, a couple still in their early thirties . . . had become cold strangers in our bed . . . but when you proposed that Asja could live in *my* apartment . . . the apartment *I* had fixed up; the apartment *I* had furnished; the apartment for which *I* paid the rent; the apartment where *your* son and I lived, but that you occupied only now and then . . . when you suggested I take in Asja . . . a woman with whom you even wanted to have a child . . . I knew it was finished.

WALTER: Why go through all this?

2.2. Walter Benjamin and Dora Sophie Benjamin.

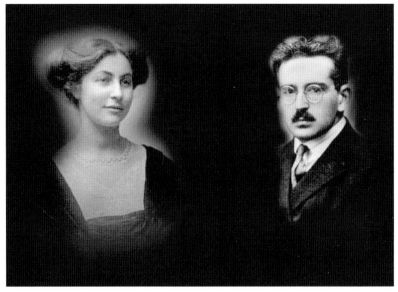

DORA: Be patient . . . it's only a preamble to the question I came up here to ask. Long after all those infidelities, we ended up in a dismal divorce in which for the first time . . . I lost respect for you, because for you it was mostly about money.

WALTER: Nolo contendere.

DORA: Is that all you have to say? And in Latin at that? In that case why not just say "Quod licet Walter, non licet Dora" and be done with it?

WALTER: You know how hopeless I was about money . . . until the day I died.

DORA: Which is probably the reason why in the end, I let you have it . . . I was ashamed for you, who had lost his shame. What you left me was your collection of children's books.

SCHOLEM: Dora . . . you knew how to survive. You did translation—

DORA: So did Walter.

SCHOLEM: But his took years. You were a journalist—

DORA: And so was Walter. And a far better one than I.

SCHOLEM: Which is why he earned less. You also wrote some novels.

DORA: At least here we differed. Walter would die rather than survive through an occasional novel.

WALTER: Not quite true. In 1933 I was so hard up I started making notes for a detective novel.

DORA: Scribbling some notes is not the same as writing.

WALTER (*bitterly*): As if I didn't know that.

SCHOLEM: You opened a pension in San Remo . . . and then rental property in London—

DORA: What is this? A tribute to my real estate talents? A survivor has to diversify.

WALTER: But you even helped me during the last ten years.

DORA (*nodding quietly*): Yes. I even helped you . . . at least when I could. Those years . . . when you visited me in San Remo because you hardly had a place to stay . . . or even the very last year in Paris . . . we behaved like friends, not just ex-spouses.

WALTER (*quietly*): I know . . . and I never forgot what you wrote me then: "Write me, dear Walter, whether I can do anything for you. There is plenty of room for you here. It would give me enormous pleasure if you could come."

DORA: So you do remember? When I learned of your suicide, I was mortified that I could not have done more for the father of my only child . . . even though I had no idea what I still meant to you. If I, Fräulein Dora Sophie Kellner, who then became Frau Pollack and then stuck to

Frau Benjamin ... even after our divorce ... was willing to become Mrs. Morser—

SCHOLEM: Morser?

DORA: Harry Morser ... a kind South African who was a guest in my pension in San Remo. Walter may remember him.

SCHOLEM: A fake marriage?

DORA: Not fake. Let us call it a compassionate marriage of convenience that got me safely to London. Why could Walter not have done the same?

SCHOLEM: Or have come to Jerusalem? I told him so myself in Paris that last year. (*Turns to Benjamin.*) Why didn't you?

WALTER (*tired*): You both know why. I am the ultimate unlucky devil— who's never learned how to swim ... with the tide or against it.

SCHOLEM: Forgive me Walter ... but that is too easy an excuse. You are the ultimate procrastinator—

DORA: Ultimate? With Walter, it was congenital.

WALTER: What's the difference? Either one meant that I was destined not to escape. (*Turns to Dora.*) But what is it you came to ask ... why I didn't marry again?

DORA: You left a note and messages with Frau Henny Gurland the night you took those morphine pills. Was anything addressed to me?

Interlude

HENNY: But Professor, why the bag?"

WALTER: It's my grip. But I'm no professor.

HENNY: Bag ... grip ... whatever. You aren't going to a lecture. You're escaping ... to a new life. Here we're climbing up the Pyrenees and you wear a tie.

WALTER: I always wear a tie ... always.

HENNY: All right, the tie doesn't weigh much. But papers (*points to briefcase*)? You need stuff to survive ... not papers.

WALTER: My passport is in my jacket.

HENNY: I'm not talking about *those* papers. Besides ... they are fakes ... right now indispensable fakes. What about underwear? Toothpaste? Your false teeth ... if you have any.

WALTER: You haven't lost your sense of humor. But all that ... even false teeth I can buy ...

HENNY: If you had the money.

WALTER: I have friends in New York ... I'm sure they know a good dentist.

HENNY: Then why the bag?

WALTER: It's my grip. It's irreplaceable. (*Pause.*) Frau Gurland?

HENNY: Yes.

WALTER: I must ask you a favor

HENNY: Yes?

WALTER: It's about this (*points to the briefcase*).

HENNY: Yes?

WALTER: If something happens to me—

HENNY: But not to us? We're all in this together.

WALTER: But suppose I get arrested . . . and not you and your son . . . or I die and you survive.

HENNY: What are you asking, Dr. Benjamin?

WALTER: Don't let that briefcase fall into other hands. Please destroy the contents—

HENNY: How?

WALTER: You must burn them. It's only paper. Can you do this for me?

HENNY: Yes.

WALTER: But one more thing. Promise not to look at the contents—

HENNY: You mean not read them? Of course, I promise.

WALTER: Don't even look at them. Nobody should know what's in there.

HENNY: But if they are so valuable that you carry them with you all the time, why destroy them?

WALTER: If anyone else saw them it would destroy my reputation.

End of interlude

SCHOLEM: The note was destroyed . . . and Frau Gurland was so terrified she remembered very little. I also wanted to know what was meant for me in that note.

DORA: I am asking Walter . . . about *me* . . . not about you.

WALTER: I don't remember. It was addressed to Teddie Adorno.

DORA: I do not believe that loss of memory. Besides, you've lied too often to me.

WALTER: I am a liar. Everything is a lie . . . including this.

DORA (*sarcastic*): Are you quoting Epimenides in 600 BC or Benjamin today?

SCHOLEM: Both of you are turning Talmudic.

DORA: In that case, let me continue. Years after your death, I learned of a will you had written in Nice.

SCHOLEM: But that was 1932 . . . when Walter first thought of suicide for his fortieth birthday.

WALTER: I then changed my mind.

DORA: But not the will.

WALTER: What do you know about the will?

DORA: One of your friends showed it to me . . . which is why I came. Remember . . . you didn't give it to anyone, but you didn't destroy it. And thanks to your friends, nothing you ever wrote has remained private.

WALTER (*to Scholem*): You showed it to her?

DORA: Who showed it to me is unimportant. The document existed at one time . . . and you're its author. That's what counts.

WALTER: I wrote it during one of my worst years . . . and you know how many worst years I've had.

DORA: Are you pleading temporary insanity . . . you the sanest crazy person I've ever met? But here is my question: You left your entire library to Stefan.

WALTER: With the exception of a few volumes—

DORA (*interrupts*): Forget the exceptions! It was a nice gesture . . . I would say almost prophetic, since you had no way of knowing that Stefan . . . then fourteen years old . . . would spend the rest of his life as an antiquarian and book collector.

WALTER: The question, Dora! What is the question?

DORA: I am almost there. You appointed Gerhard your literary executor—

SCHOLEM: And offered me ten volumes from your library of my choice.

WALTER: And Paul Klee's *Angelus Novus*. You know what that meant to me.

DORA: I am getting to that. It was clearly the most valuable item you left . . . at least emotionally so . . . and now, years later, also financially.

WALTER: Gerhard was my best and oldest friend.

DORA: While Stefan was your only son.

WALTER: I also left some pictures to him.

DORA: Sentimental claptrap. The rest of your art you left to Egon Wissing.

WALTER: At that time, my best friend.

DORA: You seem to have several "best" friends . . . but I shall let that pass. He and his wife were very kind to you.

WALTER: Dora! The question, please!

DORA: For your twenty-seventh birthday, I gave you a gift.

SCHOLEM: You mean the other Klee . . . Walter's first one?

DORA: Precisely. *Vorführung des Wunders—Presentation of the Miracle...* what a wonderful title for a gift of love.

WALTER: In that testament I left it to Ernst Schoen.

DORA: My former lover.

WALTER: My friend.

DORA: But what happened to that Klee? I, at least, always considered it far superior to your *Angelus Novus*. Of course, that one you bought yourself. Maybe that's why you wrote so much about him and nothing...absolutely nothing...not one word...about *my* Klee.

WALTER: You are talking about matters of taste.

DORA: Aren't we all...all of the time? Still, what happened to the *Presentation of the Miracle*. Ernst never got it. He probably never knew that it was even intended for him.

WALTER: I don't know.

DORA: You took it with you after our divorce.

WALTER: It was mine.

DORA: No argument about that. But what happened to it?

WALTER: I don't remember. After all, I died in 1940.

DORA: But by that time, it was already in New York. In an exhibition in October 1940...and already owned by a Dr. Allan Roos, who in turn gave it to the Museum of Modern Art twenty years later. How did it get to New York before your death?

SCHOLEM: Dora! How do you know all that?

DORA: Because I was still living then. (*To Walter*) So what happened to that Klee...that titillatingly playful and yet deeply complicated Klee...my gift of love to you?

WALTER: Nolo contendere.

DORA (*sad voice*): Coming from you, Walter...nolo contendere was frequently your answer. But it won't work this time...because I ran across a second exhibition catalog.

WALTER: So?

DORA: You remember J. B. Neumann?

SCHOLEM: The art gallery owner in Berlin...where you bought the Klee for Walter?

DORA (*sarcastic*): At least one of you has a good memory.

WALTER: Just get it over with your cross examination. What about Neumann?

2.3. Cover of exhibition catalogue, Buchholz Gallery, Willard Gallery, 1940, showing Paul Klee's *Introducing the Miracle*.

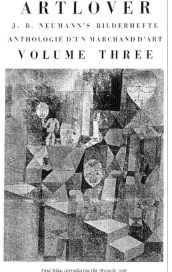

2.4. Cover of J. B. Neuman's Artlover catalogue, 1937, showing Paul Klee's *Introducing the Miracle*.

DORA: It was his Artlover catalog that had *my* Klee on its cover. In 1937 . . . in New York! And Dr. Alan Roos was one of his customers.

WALTER: So?

DORA: I conclude that Roos bought this Klee between 1937 and 1940 from Neumann. But how did *my* Klee get to the Neumann Gallery at a time when you Walter still visited me regularly in San Remo? Did I not deserve to be told that you had picked *my* gallery owner to sell that gift of mine . . . that gift of love . . . to raise some money?

WALTER (*appears to leave*): I think that's it.

DORA: Not quite! There were a few more items specified in your will. You didn't own much, so you could be precise.

SCHOLEM: Dora, is that necessary?

DORA: It isn't just necessary . . . for me it's essential. This is why I came. There was an ashtray—

WALTER: For Gretel Karplus.

DORA: Now Gretel Adorno, whom you always called Felizitas. A small blue Delft porcelain plate—

WALTER: For Jula Radt.

DORA: Formerly Jula Cohn . . . one of the entries on my list of your lovers.

WALTER: Finished?

DORA: Almost. None of your many books was named by title except one. A first edition of Goethe's *Natürliche Tochter*. For whom was that intended?

SCHOLEM: I don't remember that book.

DORA: I suspect Walter does.

WALTER: For Asja Lacis.

DORA: This brings me to my question. Why nothing to me? Why? Walter, why? Nothing for me . . . who had almost become a friend again?

WALTER: Nolo contendere.

DORA: Remember how Goethe put it in that *Natürliche Tochter* book? Not exactly one of his most famous plays, but he almost could have written this for me:

'Twas thou who taught me first the magic power
Of speech, the fine artistic web of words.
Thy lips unseal'd the world to me and gave me
The costly knowledge of my inmost heart.
This magic now thou usest to my harm . . .

In the introduction to this chapter I noted the virtual absence of any mention of their wives in the lengthy and intimate correspondence between Benjamin and Scholem. When Scholem did write about his wife Escha, it dealt mostly with factual matters that impinged on his life, rather than hers. The following excerpt from a letter dated 18 December 1935 is illustrative:

> I have been sitting here [Jerusalem] alone for some weeks, without housekeeping, since Escha had to leave Jerusalem for an extended period and is recuperating in Tiberias, where she hopes to shed her sciatica and her gall bladder troubles. Right after she left, our Yemenite maid took ill, and I began leading a student's life, which is also not very conducive to working. At the same time, Escha was fired by the library, where her position had become superfluous and unpleasant anyway, in the wake of changes in directorship following Bergman's departure (he has gone on to become the first rector of the university and must now apply himself to university affairs). The simultaneous necessity of maintaining two households and the depletion of our accustomed income is fatal.

Hence, it is all the more surprising to suddenly encounter four months later in Scholem's letter of April 19, 1936, to Benjamin an unemotional, even cold-blooded, revelation of the divorce from his wife Escha.

Without preamble, Scholem announces to his friend:

> I now inform you that a short time ago I was divorced. Separating from Escha caused very great inward and external difficulties in my personal life. . . . Carrying through the decision to separate, which I finally made last summer [a fact clearly not even alluded to in his December 1935 letter to Benjamin] cost me close to eight months. . . . Because I filed the suit for divorce, I will be placed in the rather formidable financial situation should Escha not remarry, footing the bill for two households. . . . The divorce has meanwhile been finalized, but everything else is still relatively up in the air. Escha has remained in Tiberias for the time being. By the way, we dismissed the whole matter in as congenial a manner as possible. If Bergman were to succeed in getting his divorce (which, however, is exceedingly problematic), then she would remarry.

On December 4 of the same year, Scholem wrote to his mother:

I am afraid I have some news that will disappoint you. I must inform you that I decided to marry Fanya Freud,[1] a woman whom you know but who has been unjustly and unfortunately cast in a bad light. We acted on the decision early this morning. . . . Both my wife and I have given this matter a great deal of thought, and I hope we'll be good for each other. Meanwhile, I hope you'll show as much good will toward my wife as she in fact deserves. She sends her cordial greetings. . . . Your newly married but regrettably disobedient (thank God disobedient?!) son, Gerhard.

This was followed by a second letter to Benjamin (December 29, 1936):

I have left the home where I once lived; Escha, who became Frau Bergman a short time ago, has moved back in. In this context it is only fitting to announce my recent remarriage to a young woman named Freud from the depths of the Sarmatian forest. . . . In any case, at present my private life is being thoroughly transformed. We hope for the best. We still don't have an apartment and are living in a hotel. It's difficult for me to find something suitable because my library has grown so enormous and, as a consequence, virtually immobilizes me. The largest part of it still remains in the old apartment. I don't know how things will turn out; the next few months will tell. Somehow we'll have to find a place to live. You can easily imagine what it's like, since you yourself are such a leading expert in the diasporic way of life.

Clearly some fairly traumatic events had occurred between 1935 and 1936 in the Scholem household, but the gaps in Scholem's pithy account raise several unanswered questions. Why did Scholem "demand" a divorce from his wife Escha to marry Fania Freud? Who was she? If Escha was the guilty party, what had transpired to cause Scholem feel obligated to support her unless she married Bergman? And finally, beyond being the first rector of the Hebrew University, who was Bergman? This domestic drama has received virtually no attention in the many books and articles on Scholem other than erroneous and/or sanitized descriptions. For instance, A. D. Skinner, the American editor of Scholem's diaries, writes: "Scholem's marriage to Escha ended after their next-door neighbor, the Kantian philosopher Hugo Bergmann [sic], snatched her away. He quickly married a relative of Sigmund Freud, his young student Fanya Freud." To demonstrate the historical au-

thenticity of the conversations I invented between Escha Scholem Bergman and Gershom Scholem in their posthumous confrontation on Parnassus, some factual biographical background is required.

Hugo Bergman, a childhood friend and classmate of Franz Kafka (1883–1924), was born in Prague in 1883. Whatever Zionist tendencies Kafka acquired came first from Bergman. I, a chemist for nearly half a century, cannot resist disclosing a trivial nugget of chemical esoterica related to these two humanists: when both graduated from the gymnasium and had not yet settled on a subject for further study, Bergman convinced Kafka to join him in enrolling in chemistry lectures at the Charles University in Prague. Fortunately for world literature, Kafka and Bergman survived the introductory chemistry lectures for only two weeks before turning into other directions, such as law and philosophy. The then existing German Jewish cultural climate in Prague is most succinctly summarized in Bergman's words from an interview given years later:

2.5. Hugo Bergman.

In Prague, my birthplace, there was a German theater whose manager was a Jew (an inspired man named Angelo Neumann). The greater part of the actors were Jewish and the audience was almost entirely Jewish, for there were in fact not many Germans who went to the theater. There was a standing joke in the city: The manager is a Jew, the actors are Jews and the public is Jewish—but it is called a German national theater.

Like Arnold Schönberg, Bergman served in the Austrian army during World War I. He went on to become librarian of the German Charles University of Prague as well as a passionate Zionist. In 1920 he emigrated with his pharmacist wife Else (born in 1886) to Palestine and was instrumental, three years later, in bringing first Else Burchhardt (Escha Scholem) and then Gershom Scholem to Jerusalem. A believer in Martin Buber's type of Zionism, he was a sophisticated philosopher, a passionate bibliophile, the founder of the National Library in Jerusalem, and eventually the first rector of the Hebrew University. The list could go on. What interested me about Bergman was his role in Scholem's divorce, as Scholem mentioned so discreetly in those two letters to Benjamin. I provide the most likely story in Escha's voice when she encounters Scholem for the last time on Parnassus. But first some biographical facts about Escha.

In contrast to Dora Sophie Benjamin, about whom little can be gleaned from Benjamin's writings, Gershom Scholem wrote reams about his early

2.6. Escha Scholem.

2.7. Fania Scholem (late in life).

life with his first wife. Born Elsa (Escha) Burchhardt in 1896 in Hamburg, the daughter of an Orthodox physician who died in 1927 and a mother who perished in the Theresienstadt concentration camp, she first studied medicine in Heidelberg, upon the urgings of her father. But soon she switched to studies more commensurate with her Zionist orientation and moved to Munich, where Scholem joined her. He too switched from his initial studies in matters scientific—mathematics and physics—to Jewish studies, where he focused on the Kabbalah. The year before their emigration to Palestine in 1923, Escha and Gerhard, though not yet married, managed to live in the same apartment in Munich, a remarkably avant-garde step for a young couple from such conventional households.

By 1930, only driblets of information about Escha appear here and there in Scholem's letters to his mother in Berlin and nothing in his autobiographical writings. Thus, to learn more about the period (1935–1936) that led to the collapse of Scholem's marriage to Escha and the initiation of his second marriage, to Fania Freud, I undertook research in Jerusalem. I was fortunate to receive the cooperation of numerous individuals listed in the acknowledgments, notably that of Hanna Bergman, Escha's older daughter, born in 1937. In the Scholem archives at the Hebrew University I was able to look at over one hundred letters—most of them apparently never before examined—between Scholem and his first wife, covering the terminal stages of their marriage. From Escha's side, letters went out almost daily; Escha had moved to Tiberias, and telephone contact with Jerusalem was difficult and expensive. In addition, I was able to interview persons who had known Gershom Scholem (who died in 1982) and Fania, who died as recently as 1999. During the last few years of her life Fania gave some remarkably frank, long interviews to journalists in several Israeli newspapers. Escha's words on her visit to Parnassus, though entirely composed by me, are based on factual information gleaned from the above sources.

While adultery and money were key issues in the Scholem marriage and divorce, as they had been in the Walter and Dora Sophie Benjamin relationship, there was one important difference. The Scholem divorce was conducted civilly. Neither partner ever spoke a bad word about the other in public, nor did they cut off contact after the divorce. Escha always visited Scholem with her older daughter on his birthdays, and Scholem was the first to console Escha at the time of Hugo Bergman's death in 1975. While Bergman's first wife had no contact with Escha after her marriage to Hugo, Scholem's second wife, Fania, in spite of her generally sharp tongue, had nothing but praise for Escha Bergman, whom in a newspaper interview af-

ter Scholem's death she called "a truly good woman . . . [in fact] too good for Scholem." She would make Scholem go visit Escha regularly, saying "how could he forget about a woman who had once been so intimate with him?" Scholem, not uncharacteristically, supposedly replied that he had forgotten that they ever had been intimate.

Terms such as *guilty party*, the word *adultery*, or even the question of who had initiated the divorce are not elements of the formal, public Scholem record. But we do know that his second wife, Fania Freud (supposedly a distant relative of Sigmund Freud) was born in Bouczacz, Galicia in 1909 and moved to Jerusalem when she was barely twenty. She became a student of Scholem's soon after. What happened then can only be surmised, although it seems likely that it constituted the all-too-common improper affair of a professor with an adoring younger student, which was eventually sanitized by their marriage. More brutally expressed, was it simply that the thirty-nine- year- old Scholem decided to trade in his forty-year-old wife Escha for a model twelve years younger? Or was Scholem's insistence on childlessness and Escha's desire for children—which she fulfilled in her marriage to Hugo Bergmann—a factor? As we have seen, the Scholems and Bergmans were such close family friends that by 1932 they lived in adjacent houses on Ramban Street in Jerusalem. Whatever improprieties may have transpired, they almost surely happened within a few meters of each other.

Escha Bergman (Scholem's first wife), slightly panting because of the steep climb, approaches Scholem who is sitting on his stool.

ESCHA: Well . . . I made it. But I didn't know guests were permitted on Parnassus.

SCHOLEM: They aren't . . . but I have connections.

ESCHA: That's what Dora told me when I met her on her way down from here. But why the invitation? Or is it a summons?

SCHOLEM (*conciliatory*): Eschalein!

ESCHA: You never called me that before.

SCHOLEM: Is that true?

ESCHA: You don't remember how you addressed me? In those daily letters we exchanged as I was recovering in Tiberias? The last two years of our marriage?

SCHOLEM: "Liebe Escha?"

ESCHA: That was only in the end, when our letters dealt with divorce. But before? It was always "Liebes Kind." Doesn't that tell you something, calling a wife who is one year older than you "dear child"?

2.8. Escha Scholem's letter to Gershom Scholem superimposed upon Escha and Gershom Scholem.

SCHOLEM: You used to call me that in some letters.

ESCHA: Now and then. But mostly "Liebster Fasan." (*Rather fast.*) And "Mein Herzchen," or "Mein Guter," or "Mein lieber guter Bube," . . . or on occasion even "Liebes Gehardchen." Surely that tells you how I felt.

SCHOLEM: But why "Fasan"?

ESCHA: Why not? Pheasants are brightly colored, they have a long tail . . . they strut. I meant it affectionately.

SCHOLEM: Well . . . your Fasan and mein Kind have some unfinished business.

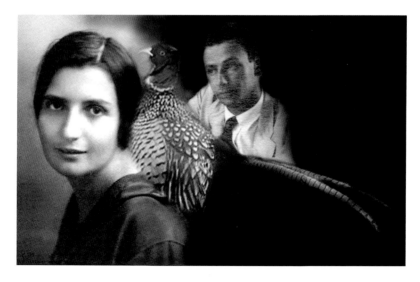

2.9. Gabriele Seethaler, *Escha and Gershom Scholem with Pheasant.*

ESCHA: There always is . . . especially after a divorce.

SCHOLEM: We should never have married.

ESCHA: Gerhard, speak for yourself. I never regretted marrying Hugo . . . and I thought you were content with Fania.

SCHOLEM: I meant us two . . . to each other.

ESCHA: I never felt that way. Otherwise, your decision to break up our marriage would never have come as such a shock. Still, in the end, I realized that our divorce taught me not to make the same mistake twice.

SCHOLEM: And what was that mistake?

ESCHA: Thinking that I would learn to tolerate barrenness with you.

SCHOLEM: I trust you don't mean intellectual barrenness.

ESCHA: How could you even think I'd accuse you of that? You have plenty of faults . . . but not on that front. But I'm a born mother and remaining childless until it was almost too late had become intolerable.

SCHOLEM (*sees Benjamin approaching*): What is Walter doing here?

ESCHA: I invited him. (*To Benjamin as he reached them.*) Thanks for coming. (*They shake hands.*)

BENJAMIN: It's been a long time.

ESCHA: I wasn't even married yet.

SCHOLEM: Legally speaking. We did share an apartment in Munich—

BENJAMIN: And you let me stay there on more than one occasion.

SCHOLEM: Walter, do you mind? (*Points to exit.*) I wanted to talk to Escha—

ESCHA (*interrupts*): So talk!

SCHOLEM: But in private.

ESCHA: Why that sudden passion for privacy? Dora told me Walter wanted you around when she came for some unfinished business.

SCHOLEM: You talked to Dora? I thought you just crossed paths.

ESCHA: What's wrong with the ex-wives comparing notes when their ex-husbands do it all the time?

BENJAMIN: And she told you everything?

ESCHA: We never told each other *everything*. Women don't do that.

BENJAMIN (*to Scholem*): Gerhard, do you want me to leave?

ESCHA: Stay! I don't think you two have kept many secrets from each other.

BENJAMIN: Perhaps not many ... but women were not the usual topic. (*Turns to Scholem.*) Gerhard?

SCHOLEM: Of course, they weren't. (*Pause.*) "What we conceal / Is always more than what we dare confide. / Think of the letters that we write our dead." An American poet wrote those lines and he was right.

ESCHA: Lovely thought, but hardly applicable to us. We're all dead ... so what is there to conceal?

SCHOLEM (*resigned*): All right, Walter. Stay.

ESCHA (*after sitting down on one of the stools*): Gerhard ... the floor is yours. Not that you ever needed any prompting to speak.

BENJAMIN (*starts to sit down*): Did Dora tell you why she came here to see me?

ESCHA (*warily*): More or less. There was the question of a testament ...

SCHOLEM: Anything else?

ESCHA (*hesitatingly*): Well ... yes.

SCHOLEM: I see. (*Uncomfortable pause.*)

ESCHA: Well?

SCHOLEM (*sits down*): That's what I wanted to raise with you.

ESCHA (*taken aback*): You mean adultery?

SCHOLEM: Yes.

ESCHA: You want to talk about *your* adultery? After all those years?

SCHOLEM: I meant yours. You knew all about mine.

ESCHA: I did not know ... I surmised. After all, I was in Tiberias all those months for treatment of my sciatica. But I did suspect what was going on in Jerusalem ... not that I was totally surprised. There were too many rumors by too many friends, thinking they were helping by sticking their nose into affairs that were none of their concern. But to make it clear ... I never committed adultery.

SCHOLEM: Ha!

BENJAMIN: I really think I should leave.

ESCHA (*turns to Benjamin*): You'll do nothing of the sort. And in contrast to you and Dora, Gerhard and I behaved rather civilly toward each other during all that messy time.

SCHOLEM (*to Benjamin*): We married the moment I got to Palestine. Remember . . . 1923?

BENJAMIN (*to Escha*): I always wondered how you immigrated before Gerhard.

ESCHA: It wasn't easy to get permission. For women, it meant marriage to a local resident . . . and for men they had to show some evidence of employment. It took some time before Hugo Bergman, who ran the National Library on a shoe string, could find a job for Gerhard. Actually a fictitious job.

BENJAMIN: So how did *you* get there earlier?

ESCHA: Not unlike how Dora got to London in 1940. As the fictitious fiancée of a kind man. In my case, Abba Houshi, the future mayor of Haifa.

BENJAMIN: Amazing what you learn about your friends only after their death.

ESCHA: If Gerhard and I had come together, I would never have stayed at the Bergmans' when I arrived in Jerusalem.

BENJAMIN: You stayed in their house?

SCHOLEM: Only until I arrived and Hugo got me a job at the library. (*To Escha.*) You think it would have been different?

ESCHA: You mean if I had not stayed in their house?

SCHOLEM: Yes.

ESCHA: Who knows? Else, his wife, was abroad during part of that time. I helped with the children.

SCHOLEM (*offended*): You never told me that! You were there . . . alone . . . Hugo and you?

ESCHA: With his two children . . . and much of the time also Hugo's mother. (*Pause.*) Hugolein was a wonderful father.

SCHOLEM: In all the years I've never heard you call him Hugolein.

ESCHA: That was only in private. And that's when he called me Eschalein. It was a pleasure to observe him with the children.

SCHOLEM: Is that where I failed you?

ESCHA: Yes. Instead of calling me, Mein Kind, there should've been real children running around.

SCHOLEM: I couldn't.

ESCHA (*to Benjamin*): I wanted you to hear that . . . one of the reasons why I wanted you here.

SCHOLEM (*to Benjamin*): You knew all about my father ... especially when he kicked me out of the house. He couldn't stomach my shifting from mathematics and physics to Hebrew ... or the way you and I felt about the war. He was more Prussian than the Prussians. I think any vestiges of potential fatherhood were permanently squeezed out of me.

BENJAMIN: Is that why you had no children with Escha or with Fania?

SCHOLEM: I asked Fania ... before we married ... to agree in writing ... that we would not have any.

ESCHA: How cruel to repeat that with another woman in her twenties.

BENJAMIN: Wait Escha. Teddie and Gretel Adorno had no children. Hannah Arendt had no children. Yet they were all married.

ESCHA: Surely you don't ascribe this to congenital infertility among Ashkenazi intellectuals ... some new type of Tay-Sachs disease?

BENJAMIN: Not congenital, but rational. Why bring children into the ghastly world we inherited?

ESCHA: You and Dora had a son.

BENJAMIN: Call it inadvertent fatherhood.

SCHOLEM: The Bergmans made up for it. The year before I arrived, Else Bergman had a third child. (*To Escha.*) Is that when your maternal instincts were aroused?

ESCHA: Why bring up the third child?

SCHOLEM: Why not?

ESCHA: You didn't know?

SCHOLEM: Know what?

ESCHA: Hugo may not have been the father.

SCHOLEM and BENJAMIN (*startled*): What?

ESCHA: Enough! You didn't ask me up here to tattle about other people's marital affairs?

SCHOLEM: True. I wanted to talk about our own.

BENJAMIN (*to Escha*): And you became Bergman's secretary as soon as you and Gerhard married?

SCHOLEM: That's when it started, didn't it?

ESCHA: Yes.

SCHOLEM: For twelve years before I asked for the divorce!

ESCHA: Actually it was thirteen.

BENJAMIN: How is that possible? You lived in adjacent houses!

ESCHA: Not right from the beginning. Only later on.

BENJAMIN (*to Scholem*): And you didn't notice?

SCHOLEM: They were discreet. That's why I wanted to speak once more to Escha.

ESCHA (*to Benjamin*): You have no idea how far we carried discretion. When I was in Tiberias, I studied German shorthand—even though we spoke mostly Hebrew. That's how Hugo and I . . . two Jewish lovers . . . wrote to each other . . . in some sort of German secret code.

SCHOLEM: When I first met Hugo in Bern, he . . . the librarian from Prague . . . always took notes in shorthand when I, a twenty-one-year-old student, spoke with him. I was too shy to ask him why.

BENJAMIN: Take it as a compliment. For Hugo Bergman, important words had to be preserved in writing. No wonder he founded your National Library. (*Turns to Scholem.*) But why did you, rather than Escha, initiate the divorce? You wrote me that you might have to support two households unless Escha remarried.

2.10. *Fania Scholem and Gershom Scholem (1897–1982) Commemorative Exhibition, March 1987* (ed. M. Cohn and R. Plesser), the Jewish National and University Library, Jerusalem 1988.

SCHOLEM: I suppose it was noblesse oblige.

ESCHA (*angry*): Nonsense! You committed adultery with a twenty-five-year-old student of yours, Fräulein Fania Freud, and then you wanted to marry her. It was guilt—not noblesse.

BENJAMIN: I must defend Gerhard. Falling in love with another woman after thirteen years of ... (*Falls silent.*) You know what.

ESCHA: Years of what? Go on ... say it!

SCHOLEM: That is what I wanted to ask. How far back did the *real* affair between you two start?

ESCHA: I would not call it an affair, but I already told you ... thirteen years.

SCHOLEM (*outraged*): You had sex with Hugo Bergman before you and I were even married?

ESCHA: There never was a sexual affair.

SCHOLEM: So what would you call it? Discreet cuckolding?

ESCHA: It was deep friendship between two adults.

SCHOLEM: That was all?

ESCHA: And love.

SCHOLEM: But no sex?

ESCHA: None. Not until October 27, 1936. Two days after Hugo finally got divorced from Else ...

BENJAMIN: But you and Gerhard were already divorced in March!

ESCHA: At which time it was not at all clear that Else would agree to a divorce from Hugo.

BENJAMIN: And why did she finally consent?

ESCHA (*turns to Scholem*): Because Hugo finally moved out of their house. But you might as well know how desperate I had become. I urged Hugo to threaten Else that if she did not agree, he should insist on a blood test of their third child.

BENJAMIN: And he did that?

ESCHA: Of course not. Hugo was not the vindictive type ... he was much too gentle ... even with people who weren't gentle to him. Besides, he loved the boy.

SCHOLEM: I thought the delay in their divorce was due to financial haggling.

ESCHA: Like Walter and Dora ... or even like you with me?

SCHOLEM: How can you say that?

ESCHA: You wanted to get half of our house ... even though I had paid for it all from an inheritance of mine. (*Turns to Benjamin.*) In the end Ger-

hard paid me rent for half a year, while I continued to live in Tiberias until Hugo was free to marry me and we moved into *my* house, next door to where he and Else used to live. Two days after his divorce we were married and finally got to know each other biblically. (*Turns to Scholem.*) So, you see, there was never any adultery on my side ... or on Hugo's. Never! (*Turns back to Benjamin.*) Which was also the reason that Hugo and I never hesitated to remain on good terms with Gerhard ... and even Fania ... at least as much as she allowed. We always visited the Scholems' for Gerhard's birthday ... and when my Hugo died, Gerhard was the first to console me.

2.11. Escha and Hugo Bergman (late in life).

BENJAMIN: Escha ... I'm sorry you asked me to come. This conversation should have been between the two of you.

ESCHA: I disagree. You had learned part of the story through Gerhard's letters ... so why not the rest from me? (*To Scholem, but gently.*) Gerhardlein, is that why you wanted to see me once more? Revisit our marriage? Or was there another question?

SCHOLEM: Just one. When did you find out about Fania Freud and me?

ESCHA: Right away. Jerusalem at that time was too small to hide such secrets.

SCHOLEM: Why didn't you confront me?

ESCHA: You know from some of my letters from Tiberias how deeply hurt I was. That I was too old and unattractive to you.

SCHOLEM: I didn't say that.

ESCHA: You didn't *say* it, but you showed it. But after the initial shock, I was relieved when you asked me for a divorce so that you could marry Fania. That meant that Hugo could do the same and marry me. Otherwise, it would have been too late.

SCHOLEM: For what?

ESCHA: Motherhood. I was forty-two, when I had Hanna and forty-four with my second daughter. A dangerous age ... for which I paid a penalty ... as you well know. (*To Benjamin.*) My younger daughter had problems all her life. (*To Scholem.*) I wish you had met Fania earlier ... it would have been all that much easier.

BENJAMIN (*to Scholem*): Perhaps I shouldn't ask, but why exactly did you want to see Escha now? Just to learn the date of her sexual intimacy with Hugo? Why didn't you face that during the divorce?

SCHOLEM: Accusing each other of adultery ... the way you and Dora did? Before a judge? I couldn't.

2.12. Escha and Hugo Bergman (early in their marriage).

ESCHA (*to Scholem*): My dear Fasan. Are you now relieved there was no prior adultery on my side?

SCHOLEM: On the contrary. I now see how serious a love affair it really was . . . waiting for thirteen years!

ESCHA: That it was. And now, Shalom to both of you. I must return.

She exits.

Up to this point, the dialogs between the marital partners in the Benjamin and Scholem households mainly concerned adultery. With the Benjamins, it involved multiple partners on both sides in what in current terms would be called an "open" marriage, whereas in the Scholem family it most likely was a single event occurring in a much more conventional marriage. But in each instance the consequence was divorce.

Not so with Gretel and Theodor Adorno. He was in many respects a "womanizer," but of a rather special breed. He had sexually consummated affairs throughout his life until the year before his death. These were not "one-night" stands, but relationships in which he invested some emotion. Moreover, Adorno did not hesitate to cuckold friends and acquaintances. He kept very few secret from his wife or from his parents, although some details recorded in his diary—masochistic indulgences, for instance—he did not disclose to them. In at least one instance he dictated to Gretel love letters to another woman, because the intended recipient claimed to be unable to read Adorno's terrible handwriting and preferred receiving typed versions! The almost bizarrely self-centered nature of most of Adorno's liaisons merits at least one little-known illustration because of its hilarious aspects.

During his years in Los Angeles, Adorno had a passionate and mutually satisfying sexual affair with Charlotte Alexander, the wife of a friend in San Francisco whose marriage was on the verge of dissolution. Adorno's fear was that upon her divorce his paramour would move to New York to marry again, although no prospective husband was as yet in sight. On October 4, 1945, Adorno wrote to an old friend, Hermann Grab, in New York City:

Today, I am writing about a request—a very great and urgent one, with whose fulfillment you would do me a fantastic favor. The matter is so urgent that favor is actually not the right word. . . . It deals with information about a man, who knows me as little as I know him and who

> under no circumstances must learn that I or you or whoever is making
> inquiries about him. I know only little about him. His name is . . .

Whereupon Adorno proceeds to list in a manner that would shame the
nosiest matchmaker intrusive and deeply personal details that he wished to
learn, regarding age, appearance, intellect and financial status, and "espe-
cially his erotic situation: is he really a bachelor; are there many women's
tales about him and especially now; if he has currently a permanent lover
in New York; whether she is a lady or a kept woman." After filling over half
a page in a similar vein, he concludes: "This should not cause you to write
something derogatory if something positive is justified, which is perfectly
conceivable. In any event, he is totally innocent in terms of the role that he
is playing in my life—he hardly knows of my existence."

Adorno's real motivation can be discerned from a second letter, dated
October 27, dispatched in response to a detailed report from his friend about
the man in New York. "For the past year, I have had a relationship with a
woman on which I depend enormously, without, however, affecting in any
way my relationship to Gretel, who, of course, knows everything. She is truly
beautiful, incredibly charming, loving . . . and represents a sort of screen on
which I can project all kinds of things, which she then reflects in the most
magical way." For the next three single-spaced A4-sized pages, Adorno pro-
ceeds to speculate as to what would happen if his paramour married this man
for money and status, but not sex, and would thus be willing to continue their
liaison cross-country. Adorno ends with "Much love to you and Blanche, also
from Gretel who disrespectfully nearly died laughing about my epistle. We
both learned your letter by heart and I can hardly separate myself from it."

The above letters indicate the degree of Adorno's investment in his
sexuality, his solipsistic sense of humor, and the extraordinary nature of
the rapport between husband and wife. But truly remarkable is the nearly
total faithfulness of Gretel Adorno throughout their long engagement and
subsequent marriage. In many respects it was a deeply committed bond in
which the idea of divorce was never raised by either party, although they
slept in separate bedrooms throughout their entire premarital and mari-
tal life. Gretel Adorno's single presumed sexual transgression involved
Egon Wissing, Benjamin's cousin, close friend, and participant in hashish
experiments, and occurred prior to the Adorno marriage, when the affi-
anced were frequently separated. Although far from good-looking, Adorno
was a charmer who attracted female as well as male disciples through his

enormous intellectual charisma, insatiable curiosity, breadth of interests, and talent as a fabulous lecturer. His extraordinary productivity was aided by his wife Gretel, to whom he even dictated most of his manuscripts and books before he would trouble himself with entering revisions on her typescript. In many respects Gretel Adorno was Theodor's invisible coauthor, whose name appeared all too rarely in the final published texts. As Lotte Tobisch von Labotyn remarked so perceptively, the Adornos were like Siamese twins: mutually nourishing and totally interdependent. The aptness of this metaphor may also be the key to their sexual relationship.

Born in Berlin in 1902 as Gretel Karplus, she studied chemistry; in contrast to Kafka and Bergman, she continued with chemistry until she obtained her doctorate. She met Adorno in 1923, and Benjamin and related philosophers and literati a few years later. During the first three years (1933–1936) of the Nazi regime she managed a leather glove concern. When such business ventures became more and more difficult for Jews, she joined Adorno in England. They married in 1937 and then emigrated in 1938 to the U.S. Devastated by Adorno's death in 1969, she immersed herself in editing with Rolf Tiedemann the twenty-three-volume collected works of her husband and then attempted suicide. Remarkably, in spite of being a professional chemist, instead of using cyanide—the usual means of rapid and guaranteed suicide favored by chemists—she botched her own self-poisoning, and lived for two decades partially disabled in Frankfurt until her death at age ninety-one.

Was jealousy totally absent in this emotionally committed but sexually flawed marriage? I have chosen this as the topic for their last encounter on Parnassus, which requires one more explication: Both Teddie and Gretel—indeed the entire Adorno household including his parents—indulged through much of their lives in an extensive family correspondence where they dubbed one another with zoological pet names of a type that must be unique among German bourgeois intellectuals. I have chosen to illustrate this bizarre but rather charming family idiom through Gabriele Seethaler's photographic artistry in the following dialogue.

Adorno enters, a book in one hand, while leading his wife Gretel by the elbow. They stop and face each other.

GRETEL: Parnassus seems to agree with you. It's good to see you in such fine fettle. Almost like at our last holiday in Switzerland—

ADORNO: Which I did not survive. But why be surprised? Back in 1968, the students whom I had taught to think radically demonized me . . . one of

the founders of the Frankfurt School where radical thought first flourished. If it weren't for you, Gretel, I don't know how I'd have managed my last year down there. But demonization is not allowed . . . one of the true fringe benefits of Parnassus.

GRETEL: You seem to have influence around here. How did you manage to arrange my entry?

ADORNO: Occasionally, the local authorities permit one last visit . . . they call it recapitulation time.

GRETEL: I have been warned about that.

ADORNO: By whom?

GRETEL: Dora and Escha, with whom I chatted under a tree.

ADORNO: I hope they were discreet. But I have a surprise for you.

GRETEL: A pleasant one I trust?

ADORNO: That depends on your viewpoint. Surprises always contain an element of danger, which makes them so exciting.

GRETEL (*points to the book in his hand*): Is that it?

ADORNO: Partly.

GRETEL: Something you have written on Parnassus?

ADORNO: I'm not the author. Besides, we can't write anything new up here.

GRETEL: So what's the other part of the surprise? The author?

ADORNO: One of the authors. (*Points to Benjamin who slowly approaches them.*) There he is.

BENJAMIN (*opens his arms, about to embrace her*): Gretel!

ADORNO: You must mean Felizitas.[2] (*Benjamin stops in his tracks.*)

GRETEL: Walter!

ADORNO: Don't you mean Detlef? (*Gretel looks startled.*)

BENJAMIN: Teddie! This sounds like an accusation. What's wrong with "Detlef Holz?" You know I used that name in the 1930s when I was naive enough to still want to publish in a German newspaper that would not have accepted something from a Jew.

ADORNO: I'm talking about my wife, not Nazis—

GRETEL: We weren't married yet then.

ADORNO: All right . . . my fiancée. (*To Gretel.*) Why not just "Walter"?

GRETEL: You all called him that. I wanted something more personal . . . yet something Walter had picked for himself.

ADORNO (*to Benjamin*): So how did you come up with Detlef?

BENJAMIN: It sounded dashing. The sort of name I could see in a fighter pilot.

ADORNO (*laughing*): You . . . a fighter pilot? You're hardly a fighter and of course too nearsighted for a pilot. But you also had other pseudonyms. Remember when you wrote to me in 1934 about O period E period Tal?

BENJAMIN: Yes, read backwards it becomes LATEO, meaning "I am concealed" in Latin. But isn't the purpose of pseudonyms to disguise and to fool?

GRETEL: I would never have addressed you as "Lieber Lateo" or "Herr O. E. Tal."

BENJAMIN: I had others. "Anni M. Bie" . . . an anagram for Benjamin, but then why would you address me as a woman? There were more . . . for instance, "K. A. Stempflinger," "C. Conrad," and, in my teenage years, "Ardor." I don't even remember why I toyed around with them.

GRETEL: Teddie, don't forget that you also indulged in pseudonyms.

ADORNO: Only two: a couple of times as "Hektor Rottweiler" and once as "Castor Zwieback." Carl Dreyfus and I used that one for a collaborative piece in the *Frankfurter Zeitung* back in 1931.

GRETEL (*to Benjamin*): A reconciliation after Teddie cuckolded Dreyfus by having an affair with his wife Ellen.

ADORNO: Enough about pseudonyms!

GRETEL: You started it with your Detlev-Felizitas inquisition. (*Turns to Benjamin.*) Did you know that my husband once addressed me in a postcard as "Geliebte Hundemaid 'Rüdin'"?

BENJAMIN (*to Adorno*): You called your wife "Dearest bitch bitch"? Or "Dearest bitch squared" for short?

GRETEL (*laughing*): I must defend Teddy. *Rüdin* may be a term for "bitch" in German, but it is also a rather good Swiss vineyard. Don't forget that the Wiesengrunds were wine merchants and Teddie a connoisseur of wine . . . and women.

BENJAMIN: And what about *Hundemaid*? "A bitchy maiden"?

ADORNO: The critic Walter Benjamin is jumping to conclusions. What about "bitch-maiden," which in my vocabulary would be a sexual compliment? I know Gretel got the backsided message.

GRETEL (*laughing to Benjamin*): There were other backsided compliments. We called each other Hottilein and Rossilein.

ADORNO: In that case, why don't you confess to Walter that you signed your letters to my parents as your "Giraffe Gazelle with the little horns"—

GRETEL (*to Adorno*): While you always addressed your mother "Wondrous She-Hippo," and your father "King of Boars." (*laughing*): And what about your signature as "Hippo-King Archibald?"

on opposite page, left to right

2.13. Gabriele Seethaler, *Hottilein and Rossilein with Gretel and Theodor W. Adorno's Faces.*

2.14. Gabriele Seethaler, *Gretel Adorno as Giraffe Gazelle with the Little Horns (Giraffe Gazelle mit den Hörnchen).*

2.15. Gabriele Seethaler, *Theodor W. Adorno's Parents with Wondrous She-Hippo (Wundernilstute) and King of Boars (Wildschweinkönig).*

2.16. Gabriele Seethaler, *Hippo-King Archibald (Nilpferdkönig Archibald).*

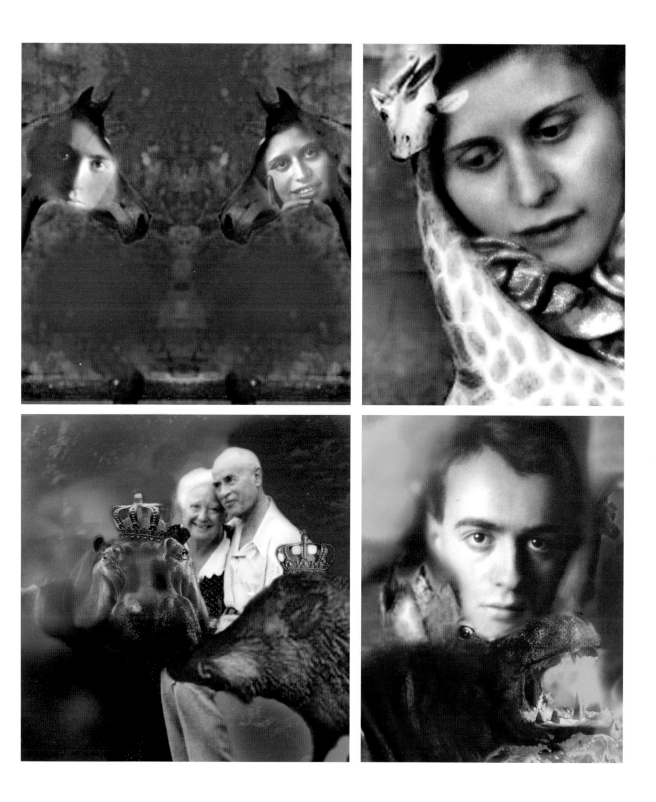

BENJAMIN (*amused*): You certainly were zoologically inclined.

ADORNO: In a bantering sort of way. But bantering was never *your* style. (*Beat.*) So tell me, Walter, why did you always address Gretel as Felizitas?

BENJAMIN: Felicity was something that escaped me all my life . . . and probably also Gretel's.

ADORNO: So it was your idea to call my wife Felizitas?

GRETEL: Not entirely. Why not give your wife some of the credit? Remember, William Speyer's play, *A Coat, a Hat, a Glove*?

ADORNO (*to Benjamin*): The one you collaborated on with Speyer?

BENJAMIN: We first called it *Der grosse Advocat.* A prophetic title since I could have used a great lawyer . . . if I could've afforded one. I was supposed to get 10 percent of the royalties. I received nothing . . . not even an acknowledgment in the published text. Instead of suing Speyer, I dropped him as a friend.

GRETEL: Still . . . there is a Felicitas in it. And since I was not just a Ph.D. chemist by education but also the manager of a leather glove factory, what's wrong with borrowing the name Felicitas from a play dealing with leather gloves?

ADORNO: Don't I recall that in that play, Felicitas leaves her husband for a younger lover? Is that related to the choice of the name?

BENJAMIN: I think we are moving onto a very slippery slope. As an anonymous collaborator, I remember that play very well. The lover was not only younger, but dashingly handsome and physically daring . . . none of which applies to me.

ADORNO: Admitted.

BENJAMIN: And not very smart! The husband was the clever one! Maybe that's why on occasion even you called Gretel Felizitas.

GRETEL: Enough of this silly contretemps. (*To Adorno.*) What's the real reason for this last rendezvous? Surely not jealousy? Is that even practiced on Parnassus?

ADORNO: Not only practiced . . . it flourishes because up here it transcends time. Digging up wounds from the past . . . looking for new ones . . . and doing it all posthumously!

BENJAMIN: And why not? Jealousy is a form of flattery.

ADORNO: Precisely!

GRETEL: In that case, flatter me. I wonder which old scab you are about to scratch.

ADORNO: This one! (*Raises the book he has been holding in his hand.*) I'd like to talk about this book.

GRETEL: We've talked about books all of our lives... after reading them—

ADORNO: Or writing them—

BENJAMIN: And especially after critiquing them!

GRETEL: So what's so special about this book?

ADORNO: Here...take a look. (*Hands it to her.*)

GRETEL (*takes it and opens it to title page*): Oh my God! (*Quickly turns some pages.*) Oh my God!

ADORNO: You see?

BENJAMIN: May I look at it?

GRETEL: Here. (*Gives it to him.*)

BENJAMIN (*quotes title*): "*Gretel Adorno Walter Benjamin. Briefwechsel 1930–1940.*" (*Beat.*) But these letters were written three quarters of a century ago! You two weren't even married yet.

ADORNO: Even worse.

GRETEL: How did you get hold of a book up here on Parnassus that has only been published in 2005?

ADORNO: You have no idea how this place has been modernized since the time of Apollo. And I'm not just referring to the plumbing! I can order any book I want through www.parnassus-libris.dei.

GRETEL (*astonished*): D E? You mean Germany?

ADORNO: D E I ...the gods.

GRETEL: Amazing fringe benefits you men have up here. But why be jealous about a collection of letters between two friends? You and Walter corresponded for years... and so did Walter and Gerhard Scholem. (*Turns to Adorno.*) And then you published them all.

ADORNO: There are letters... (*pause*)... and then there are *letters*! These here (*holds up the book*) belong to the second category.

GRETEL: Teddie, you're being cryptic, which is not typical of you. Convoluted or complicated? Invariably...but never cryptic. Of course, you are verbose. But there are times when saying less says more. This is one such time. Why not just say "a letter is a letter is a letter?"

ADORNO (*irritably*): Stop the sophistry! That was never your forte. Let's talk about *content!* And it is the content's subtleties that distinguish one letter from another.

GRETEL (*amused*): You don't say!

ADORNO (*opens book, shuffles a few pages before speaking*): Here...page 15... a letter dated March 30, 1933. And do you know how it starts? "Walter Benjamin, lieber."

2.17. Gretel Adorno puts on her green dress.

BENJAMIN (*puzzled*): What's wrong with that?

ADORNO: Wrong? It isn't wrong, but it's different. "Walter Benjamin *comma* lieber" is very different from "Lieber Walter Benjamin" without a comma! (*Turns to Benjamin.*) Agreed?

BENJAMIN (*nods*): Nuances are important . . . including the placement of a comma.

ADORNO: Or the sequence of words.

GRETEL (*impatient*): Surely you didn't invite me to Parnassus for a discussion of one comma or the order of three words?

ADORNO: Not entirely. So let me quote from another part of that same letter. "I would like to keep you company in this somewhat primitive fashion. I've put on my green dress and even though the hair cut dates from the year 1931, you'll surely forgive that." (*Pause.*)

GRETEL: So? Keeping company was meant in spirit . . . not physically. Walter was then in Ibiza and I in Berlin—

ADORNO (*interrupts*): With me!

GRETEL: More or less. We used separate bedrooms connected by a common bathroom. Eventually a lifelong habit. And it wasn't because one of us snored too much! But what's the problem?

ADORNO: The next sentence! "To assist your fantasy, I am enclosing a small swatch of material . . . to be caressed!" (*Louder and angrily.*) Caressed . . . by long distance! How kinky can you get?

GRETEL: "Kinky?" (*To Benjamin.*) Look who's talking! (*To Adorno.*) What about your "*extreme excesses*" with your favorite Masochist, Carol, in New York? This was not kinkiness by correspondence, but in the flesh!

BENJAMIN: I wish you two wouldn't continue . . . at least not in my presence. And Teddie . . . if you are concerned about physical intimacy, ask! Don't beat around the bush.

ADORNO: All right . . . no beating around the bush. What about that dazzling shift from *Sie* to *Du* and back to *Sie*? (*To Benjamin*) You and I wrote to each other for decades—

BENJAMIN (*quietly*): Not decades. Eight years . . . unless you include earlier driblets, which would barely make it a dozen.

ADORNO (*stops, surprised*): My God, you are right. I guess I counted all the letters I composed to you in my mind after your death . . . especially when I edited your correspondence. But still . . . eight years will suffice to make my point. By 1936 we were *Lieber Teddie* and *Lieber Walter*, but always *Sie!* (*Beat.*) *Sie! Sie! Sie!*

BENJAMIN: If that bothered you, why didn't you accept my offer to *Du* me?

ADORNO: What offer?

BENJAMIN: When I wrote you from France. I said, after all you had done for me . . . and then even a visa to America . . . isn't it high time we switched to Du after having moved to a first name basis years earlier? But you never replied.

ADORNO (*looks at Gretel*): You always handled my correspondence. Do you remember such a letter?

GRETEL (*quietly*): Yes.

ADORNO: Yes? Then how come I don't?

BENJAMIN: Your memory is slipping.

ADORNO: Nonsense. (*To Gretel.*) Gretel, answer me. How come?

GRETEL: I decided not to show it to you.

ADORNO: Do I hear right? (*Sarcastic tone.*) "I decided not to show it to you!" What makes you think you had the right to censor my letters?

GRETEL: I was your secretary, your housekeeper, your appointment watchdog, your general factotum . . . in other words, your wife. I also handled your correspondence and this was the only letter I ever "censored" as you call it.

ADORNO: And what would you call it if not censorship?

GRETEL: An act of self-preservation. I dedicated all my waking hours to you . . . and did so willingly during all those years, in the process giving up every vestige of independence. I, a Ph.D. chemist . . . an industrial manager . . . a woman with a reasonably sharp mind . . . gave it all up . . . for you. It was only those years of secret letter writing to Walter . . . even my financial support of him . . . that made me feel like a woman in my own right. Our *Du* relationship . . . Walter's and mine . . . confirmed this . . . when even you and Walter still addressed each other as *Sie*. Why should I give up this last vestige of intimacy that you had not shared until then with Walter? Do you now understand why I had to burn that letter?

ADORNO: You *burned* it?

GRETEL: I burned it, because I didn't want to see it appear some day in a book dealing with your or Walter's correspondence.

ADORNO: I see. But we're going off on a tangent. I want to return to your *Du-Sie* business. (*Turns to Gretel.*) Here (*opens book and searches for a page*): March 29, 1933. "Lieber Walter Benjamin, Ich danke Ihnen . . . in other words, in proper *Sie* style." (*Pause.*) April 15. "Walter writes you already per *Du*." (*Pause.*) June 17. You reciprocate in the same fashion to your "Lieber Detlef." (*Pause.*) Ten days later, it is back to *Sie* and after another ten days back to *Du*. We're talking about the same year . . . not about eight

years of correspondence! (*Turns some more pages.*) And after four months of this *Du/Sie* ping-pong, you write, "No one knows of Detlef and Felizitas."

GRETEL: But—

ADORNO: Wait, I'm not finished. In the same letter, you write, "For the moment, I don't even know where Teddie is . . . but he knows nothing of our *Du*." (*Louder.*) And to top it all, you two decide to number your letters for posterity . . . in other words, *you* two wished to see your correspondence published some day, so you decided to simplify matters for some future editor of your correspondence! What was going on? *Du* letters for each other and *Sie* letters also to be shared with others . . . like yours truly with whom you were then living.

GRETEL: More or less.

ADORNO (*infuriated*): You mean *Sie* when it was "more" and *Du* when it was "less?" Was that why you wrote (*turns pages in the book to find the correct page*), "I thought that if you didn't mind we should remain in our private letters on a *Du* basis. I love a trace of secretiveness . . . "

GRETEL: More or less.

ADORNO: You are repeating yourself.

GRETEL: No, I'm just being precise. But Teddie, comma, *mein lieber* . . . I don't believe for a moment that this is the reason for this cross-examination. You were chronically and openly unfaithful to me. I could cite chapter and verse since you never hid it. How about Ellen Dreyfus, Renée Nell, Charlotte Alexander, Arlette Pielmann, the New York masochist Carol, and God knows who else? All but Charlotte and that Frankfurt lawyer Eva . . . and maybe the masochist . . . were actresses . . .

ADORNO: Mostly actresses manqué—

GRETEL: Not all. Take Lotte Tobisch. (*To Benjamin.*) A real Viennese actress . . . easily the most beautiful of Teddie's inamorata . . . and one of his all-time favorites . . . as well as mine.

BENJAMIN: Favorite what? (*To Adorno.*) Teddie, how would you refer to your "liebstes Lotterl"?

GRETEL (*astonished*): You knew her?

ADORNO (*taken aback*): Impossible! She was barely fourteen when you died. And I didn't meet her until 1962.

BENJAMIN (*reaches in his pocket*): Not personally. Just her letters.

ADORNO (*startled*): What letters?

BENJAMIN (*produced a book from his pocket and hands it to Adorno*): Here, take a look . . . both of you. (*Gretel leans over to read the title at the same time as her husband.*)

2.18. Lotte Tobisch von Labotyn.

ADORNO: *"Theodor W. Adorno/Lotte Tobisch"*—

GRETEL: *"Der private Briefwechsel." (To Benjamin.)* Their private correspondence? How on earth did you get it?

BENJAMIN: The same book source as Teddie's.

ADORNO *(reaches for the book and opens it)*: Published in 2003! I never knew those letters had been published.

BENJAMIN: By a small Austrian publisher. You must have overlooked it among the flood of books published on the occasion of your centenary. That's why I'd brought it along.

ADORNO *(quickly turns some pages)*: How did the editors get hold of her letters to me?

GRETEL: I returned them to Lotte after your death!

ADORNO: Why did you do that?

GRETEL: They meant more to her than me. Remember, she couldn't read your awful handwriting, so you dictated all of your letters to me and I typed them.

BENJAMIN *(surprised)*: I thought I knew you two well... but dictating love letters meant for another woman to your wife? Isn't that overdoing an open marriage?

GRETEL: Oh... I don't know about that. Teddie always dictated his dreams to me. For instance, one about ending up in an American brothel where he first had to fill out a complicated questionnaire. Or the one when he found himself in bed with two delicious women. Or...

ADORNO: Wait a moment! Walter doesn't need to know about my dreams... not here on Parnassus. But why call my letters to Lotte Tobisch love letters?

BENJAMIN *(reaches for the book, while searching for appropriate pages)*: Why not let me read some the way you analyzed Gretel's and my letters. Your first letter to her, starts with "Sehr verehrte gnädige Frau" and ends with "Ihr aufrichtig ergebener Theodor W. Adorno." And then she answers with "Sehr verehrter Herr Professor" and ending simply with "Ihre Lotte Tobisch."

ADORNO: What's wrong with that?

GRETEL: Of course! How could I forget? *(Breaks out laughing.)* I know what's coming.

ADORNO: I repeat: What's wrong with that?

BENJAMIN: Wrong? It isn't wrong, but it's different as you... who has never switched in all the years from *Sie* to *Du* with me... said just a few minutes ago. It's different because your very next letter to her starts with "Lotte,

comma, Liebes!" What about your use of that subtle comma and your spectacularly quick shift from *Sie* to *Du*? (*Chuckles as he turns some pages to find one for March 31, 1969.*) You said there were letters and then there were letters. How about Lotte Tobisch's letter a few years later: "Lieber, *comma*, lieber, *comma*, lieber Teddie" and ending with "Für heute tausend Küsse! Dein Lotterl." One comma may be subtle, but two successive ones? And a thousand kisses?

ADORNO (*grinning*): I shall respond with my friend's favorite reply: nolo contendere.

GRETEL: You're both exaggerating. I believe all those thousand kisses were meant for your cheeks alone. I was very fond of her. But with the other actresses . . . manqué or real . . . it was all about sex and consummation. A need for beauty and for variety, which no wife of yours could ever satisfy.

ADORNO: Because we're talking about hormones. I couldn't help it.

GRETEL: It's pheromones, not just hormones. You, Teddie, are living proof for the existence of human pheromones.

ADORNO: My wife, the chemist, showing off in the one discipline in which she surpasses her husband. But why not expand on this cryptic chemical message?

GRETEL: For one thing, you're not exactly a handsome man—

ADORNO: I've never made such a claim. But where on your scale of handsomeness does Detlef . . . excuse me, I mean Walter . . . fall?

GRETEL: Not far from yours. What you people secrete . . . and both of you in inexhaustible abundance . . . is a form of intellectual aura that attracts intelligent, well-educated women, like Dora and me . . . like moths to a burning candle. On your hundredth birthday celebration, one of your former students raved about you on the radio. "Watching him philosophizing in front of female students was simply fantastic. All he wanted was to convince them how unbelievably vital, how profound, how enthusiastic, how significant his lectures were. All that was left for these women to say was, Holy shit, Adorno!"

ADORNO (*grinning*): Sounds impressive! What was her name?

GRETEL: It was a man's observation! (*Turns to Benjamin.*) Just imagine how women responded to this verbal eroticist. (*Back to Adorno.*) I said you were not handsome, but do you know how this same man described you on the radio program?

ADORNO (*grinning*): I can hardly wait.

GRETEL: "He had the genius mark of all times: huge eyes. Deep, enormous black eyes, which simply dominated the face . . . and then a body, which

though chubbily bourgeois, was capable of immense agility when he dealt with young women. A late passage through puberty," he called it. (*Laughs.*) No wonder that in spite of all your extracurricular sleeping around . . . your so-called love affairs . . . and all of them ultimately unhappy ones . . . I stuck around.

ADORNO: Why did you?

GRETEL: Because I know how short spontaneous chemical reactions last. Only covalent bonds persist.

ADORNO: Again the chemist speaking?

GRETEL: Why not also the romantic? Bonding has many meanings.

ADORNO: And it's bonding that's also behind this? (*Again waves book.*)

GRETEL: Bonding and dependence!

ADORNO: What kind of dependence are you talking about?

GRETEL: For me it was emotional . . .

ADORNO (*to Benjamin*): And for you?

BENJAMIN: The same.

ADORNO: Not financial?

GRETEL: I helped . . . gladly . . . and am not ashamed to admit it.

BENJAMIN: I've been ashamed . . . so long and so deeply . . . that I've lost all shame. I accepted that money . . . until I killed myself.

ADORNO: I'm sorry . . . I went too far.

GRETEL: Yes, you did. But you do this from time to time. I'm an expert. No wonder I used to call you my *Sorgenkind*.

BENJAMIN: And me your *Adoptivkind*.

GRETEL: Exactly. Remember when I first called you that and told you that I am adopting you in place of the child that I shall never have?

BENJAMIN: I know I shouldn't ask, but a recent conversation up here prompts me to do it.

GRETEL: I know what you are going to ask. On my way up, I met Escha Scholem. She told me about Scholem's feelings. But you shouldn't blame my Teddie. We both decided against children . . . we just couldn't imagine bringing somebody into the horrible world in which we found ourselves.

BENJAMIN: And you regret it now?

ADORNO: We both did by the time we had returned to Frankfurt after the war.

GRETEL: By then I was too old. And now it's time to go.

ADORNO: Gretel, before you leave, one last question . . . out of curiosity, not jealousy.

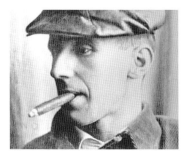

2.19. Bertold Brecht

GRETEL: Why not? Your curiosity was always one of your most engaging traits.

ADORNO (*quickly riffles through the book to find the precise quote*): As late as August 1938, you asked Walter a question that seems to have remained unanswered.

BENJAMIN: Now I'm becoming curious. I thought I had answered every one of Gretel's questions, even those she only thought about but never mentioned. So what was it?

ADORNO (*quoting*): "Would you please send me a copy of Brecht's pornographic poems for the inauguration of the first apartment of our own?"

BENJAMIN: Is that what it says? I knew Brecht better than any of you and he never wrote pornography. Erotic poems? Of course . . . he was that sort of man. Take this stanza from his "Sonnet no. 11":

I love my unfaithful women:
They notice my eye fixed on their box
As they hide from me their overflowing cunts
(I feel lusty as I watch them).
With another man's flavor still in her mouth
She's forced to make me horny
Smiling lecherously with that mouth
In her cold cunt still another cock![3]

Would you call that pornography?

GRETEL: Some women would say so.

ADORNO: And most certainly their husbands.

BENJAMIN: I totally disagree! Erotica and pornography are topics that have interested me for years, so I refuse to see them confused . . . even by you two.

GRETEL: Walter, never mind about that distinction. But Teddie is right, you never did reply. Is that one of the poems you meant for me?

BENJAMIN: No.

ADORNO: Do you still remember which ones you would have sent?

BENJAMIN: Of course. (*Long pause*).

GRETEL: Well?

BENJAMIN: You want me to do this . . . in front of Teddie?

ADORNO: Why not? Embarrassment on Parnassus is pointless.

BENJAMIN: Even posthumous embarrassment?

ADORNO: What's that supposed to mean?

BENJAMIN: Just listen to the first one I would've sent. Brecht's "Sonnet no. 19" written in 1934.

> My one requirement: that you stay with me.
> I want to hear you, grumble as you may.
> If you were deaf I'd need what you might say
> If you were dumb I'd need what you might see.
> If you were blind I'd want you in my sight
> For you're the sentry posted to my side:
> We're hardly half way through our lengthy ride
> Remember we're surrounded yet by night.
> Your "let me lick my wounds" is no excuse now.
> Your "anywhere" (not "here") is no defense
> There'll be relief for you, but no release now.
> You know whoever's needed can't go free
> And you are needed urgently by me
> I speak of me when us would make more sense.

GRETEL: My God!

BENJAMIN (*looks at Adorno*): Well, Teddie? Do you now understand what I meant by posthumous embarrassment?

ADORNO (*quietly*): Yes . . . for all three of us.

They all exit.

We are left with one more encounter, that of Arnold Schönberg and his first wife, Mathilde von Zemlinsky. In that household with two young children, divorce was never an option. However, the adultery—in this instance exclusively on the wife's part—was sufficiently grotesque that Schönberg's response was, to put it mildly, unexpected: he forgave her. He was probably relieved that, after a brief fling, she was prepared to resume her duties as wife and mother, enabling Schönberg to focus on his creative work.

Schönberg is considered one of the most original composers of the twentieth century, primarily as the founder, together with his disciples,

Alban Berg and Anton v. Webern, of the second Viennese school of music that replaced melodic romanticism with atonality. Less well known are his activities as a largely self-taught painter. Wassily Kandinsky appreciated his talents, but the painter Richard Gerstl was a more important influence. Gerstl lived in the same Viennese apartment house as the Schönbergs and Schönberg's brother-in-law, the composer and conductor Alexander von Zemlinsky. Beginning in 1906, Gerstl gave painting lessons to Schönberg and his wife, herself a well- trained musician, and in turn absorbed a great deal of musical knowledge from them.

The intimacy arising from mutual admiration developed into such friendship that, in 1908, the Schönbergs invited Gerstl to spend his summer with them on the Traunsee. The thirty-one-year-old Mathilde Schönberg and the twenty-five-year-old Richard Gerstl embarked on a scandalous love affair that summer. Mathilde abandoned Schönberg and her children to join Gerstl in Vienna. After several weeks, Schönberg's friends convinced her to return. Gerstl destroyed most of his paintings and then committed suicide. As Mathilde Schönberg was heard to say, "Schönberg needs me to combat his loneliness and Gerstl declares that he wants only a woman who tastes bitter, because she has already experienced much."

The Schönbergs resumed their conventional marriage, with Mathilde keeping the home fires burning while her husband composed his music. Schönberg demonstrated forgiveness by dedicating some compositions to his wife. But there are hints that Mathilde's eye continued to wander. She is said to have become obsessed with Schönberg's student Hugo Breuer, who was twenty-two years her junior, through a connivance of Helene Berg, Alban Berg's wife. Even the notorious Alma Mahler, wife of Gustav, who had numerous extramarital affairs herself, described Mathilde in her diary as being man-crazy during that time.

Mathilde Schönberg died in 1923 at age forty-six, with only a few letters between her and her husband existing in archives. The following year Arnold Schönberg, then fifty, married Gertrud Kolisch, the twenty-six-year old sister of the musician Rudolf Kolisch, one of Schönberg's greatest musical supporters. That second marriage apparently was a conventionally successful one in the best sense of that word. It brought Schönberg three more children and established that Schönberg was no philanderer—in contrast to his student, Alban Berg, whose marriage strikingly resembled that of Theodor and Gretel Adorno. Though emotionally firmly married to his wife Helene, Alban Berg had numerous affairs that were not unknown to his wife; in at least one of them Adorno was the messenger (*postillon d'amour*) of Berg's love letters.

Yet the notoriety of Mathilde's adultery has grown posthumously. Years after the death of both Arnold and Mathilde Schönberg, musicological research, which was always titillated by the numerological and anagrammatic features in Schönberg's and Berg's music, uncovered evidence in Berg's *Chamber Concerto* that Mathilde may have been involved in one last affair that even Schönberg could not have forgiven. I shall let husband and wife broach that subject in their own words on Parnassus.

Mathilde (von Zemlinsky) Schönberg enters and sits down next to Arnold Schönberg.

MATHILDE: Another meeting? After so much time? I was surprised . . . but then, on the way up, I met three women. They told me in one word what to expect.

ARNOLD: And what was that word?

MATHILDE: *Recapitulation.* Actually two words: *Pointless recapitulation.*

ARNOLD: There was something I wanted to ask you . . . something I never raised down there . . . something that is hardly pointless.

MATHILDE: But why use Wiesengrund to smuggle me in?

ARNOLD: Up here, he likes to be called Adorno. At least that was the name on his Parnassian visa. (*Points to Adorno standing in the distance.*) There he is.

MATHILDE: You asked him to be present?

ARNOLD: He came to Vienna in 1925 to study with Berg.

MATHILDE: What has that to do with us? I died in 1923!

ARNOLD (*embarrassed*): How could I forget?

MATHILDE: And you remarried almost immediately.

ARNOLD: Immediately? It was one year later. But I wanted to talk about Alban Berg. And here, Adorno might have something to add.

MATHILDE: May I start first? For once!

ARNOLD: I suppose so.

MATHILDE: But in his presence?

ARNOLD: Why not? (*Waves to Adorno to join them and addresses him.*) Mathilde has no objections.

MATHILDE (*bitter laugh*): You never asked whether I had any objections. You just assumed ... as always. But if you are not embarrassed—

ARNOLD (*interrupts*): Posthumous embarrassment? Up here? And what is there still to be embarrassed about between us?

MATHILDE (*suddenly laughs*): Do any of your other Parnassian laureates know why you never parted your hair?

ARNOLD (*slightly embarrassed*): Why should they?

MATHILDE: It would've told them something about you.

ARNOLD: They've only seen me bald ... so the subject hardly would have come up.

MATHILDE: What if they knew that it was only because of your French teacher telling you that nice boys don't part their hair in the middle?

ADORNO (*laughing*): This is too good not to tell others ... Arnold Schönberg, music's greatest *enfant terrible*, wanting to be a good boy. But don't let me interrupt.

MATHILDE: So here is my question ... and hardly a pointless one: Arnold ... why did no less than three of your friends refuse to be best men at our wedding? What was wrong?

ARNOLD: You never asked before.

MATHILDE: Because at that time I didn't want to know ... and then you painted the answer. Here, I brought some photos.

ARNOLD: Family snapshots?

MATHILDE: In a way. Look at this one.
 How old was I?

ARNOLD: Let me see. (*Studies the image.*) A few years after our marriage.

MATHILDE: And this one?

ARNOLD (*taken aback*): It's Gertrud!

MATHILDE: Of course . . . but when was it painted?

ARNOLD: A few years after I married her.

ADORNO: The year after you got married. It was shortly after I arrived in Vienna.

MATHILDE: Now compare the two. Why did you paint me that way?

ARNOLD: I paint what I see.

MATHILDE: True of all artists. What about this?

ADORNO (*surprised, addresses Schönberg*): I didn't know you painted nudes.

ARNOLD: Of course not. This isn't mine.

MATHILDE: I know you couldn't have painted it. But who is this woman?

ARNOLD: Do I know her?

MATHILDE: It's me . . . and painted shortly before *your* portrait of me!

ARNOLD: Don't tell me it was—

MATHILDE: Of course he was the artist. Except that he was six years younger than I . . . and nine years younger than you, my loving husband. Yet that is how *he* saw me. (*Pause.*) Now look at his self-portrait . . .

ADORNO: Is that Richard Gerstl?

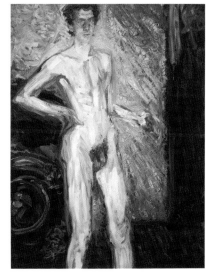

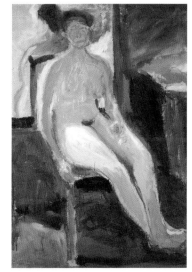

clockwise from the top

2.21. Arnold Schönberg, *Mathilde Schönberg*, 1907–1909.

2.22. Arnold Schönberg, *Gertrud Schönberg*, 1925?

2.23. Richard Gerstl, *Sitting Nude Woman*, 1907/1908.

2.24. Richard Gerstl, *Nude Self-Portrait*, 1908.

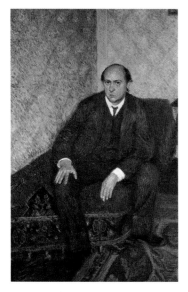

2.25. Richard Gerstl, *Portrait Arnold Schönberg*, 1906.

2.26. Hanna Fuchs-Robettin.

MATHILDE: Who else?

ARNOLD: Was that reason enough to abandon me and our children?

MATHILDE: For me . . . at that time it was an overpowering reason . . . a question of survival. Just look at Gerstl's portrait of you.

I think he painted you exactly as I, your wife, would have . . . if I had been a painter. Now compare it with his self-portrait! Which artist would you prefer?

ARNOLD (*sharply*): I presume you are not asking for a painterly critique!

MATHILDE: No . . . just for psychological understanding.

ARNOLD: So when Anton Webern, Alban Berg, and other friends used psychological persuasion . . . you did come to your senses—

MATHILDE: You mean I returned to the children—

ARNOLD: And to me! And thank God for that.

MATHILDE: Whereupon Richard killed himself.

ADORNO: You should not blame yourself.

MATHILDE: Whom should I blame? Circumstances?

ARNOLD: You mentioned Alban Berg. That brings me to *my* question.

MATHILDE: You do not wish to hear the rest?

ARNOLD: Berg first. It is related.

ADORNO: Maestro. Are you certain you wish me to stay?

ARNOLD (*sharply*): Stay! When you came to Vienna to study with Berg, you were barely twenty years old.

ADORNO: Twenty-two . . . and ready to study composition.

ARNOLD: Your readiness may be a matter of opinion . . . but the point is that you came to work with Berg . . . not me.

ADORNO: But Maestro—

ARNOLD (*cuts him off*): Never mind the reason.

MATHILDE (*annoyed*): What has all this posturing got to do with me. I was already dead for two years when Herr Adorno appeared on the scene.

ARNOLD: True. But did you know that he wasn't just a student of Berg's, but also his messenger—

ADORNO: Maestro!

ARNOLD: Of passionate letters from Alban Berg to his paramour in Munich.

MATHILDE (*sharply*): Who was that?

ADORNO: Frau Schönberg . . . it does not matter. You were already dead.

MATHILDE: When it comes to such questions, I am posthumously curious!

ADORNO (*reluctantly*): Franz Werfel's sister.

MATHILDE: Of course! Hanna Fuchs-Robettin! Why did I even ask?

ARNOLD (*pointing to Adorno*): Wiesengrund's presence here isn't just needed as Berg's former *postillon d'amour*... it's his knowledge of Berg's music. So let me proceed. (*To Mathilde.*) You also had a first-class musical background—

MATHILDE: And why not? As a Zemlinsky... and sister to Alexander who taught us both... we started on the same footing. Of course marrying you was not the ideal strategy for pursuing a musical career.

ARNOLD: Motherhood is a nobler calling than a musical career.

MATHILDE: And marriage... meaning servitude... to a musical genius its death knell.

ARNOLD: That isn't fair!

MATHILDE: It isn't? As I already mentioned, on the way up, I met three ladies resting under a tree. They asked me to take a break from the steep climb. You know who they were?

ARNOLD: How could I know?

ADORNO: I'm afraid I can guess.

2.27. Gabriele Seethaler, *Meeting of the Four Women Under the Tree: Escha Scholem, Mathilde Schönberg, Dora Sophie Benjamin, and Gretel Adorno.*

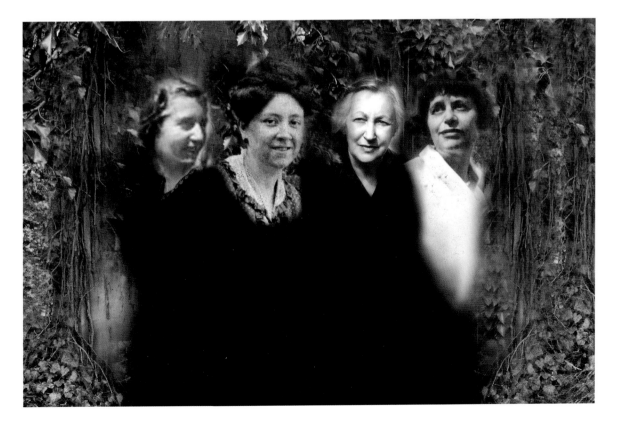

MATHILDE: Frau Dora Sophie Benjamin and Frau Escha Bergman, formerly Escha Scholem. (*To Adorno.*) And your wife. But why be afraid?

ADORNO (*shrugs.*) Ascribe it to premonition.

ARNOLD: What happened under the tree?

MATHILDE: We started chatting...the moment I heard that they were also the former wives of geniuses...who have been meeting them on Parnassus.

ADORNO: What did they tell you?

MATHILDE: Oh...they were discreet. But when they learned I was heading up to the top for a last rendezvous with my former husband, they couldn't resist mentioning their husbands' outrage (*raises her fingers to indicate quotation marks while mimicking the tone of the men*): "that isn't fair!" Surprisingly, in each instance, the subject matter appeared to be adultery. So what did you want to talk about...where Herr Adorno's presence was required?

ARNOLD: Adultery!

MATHILDE: I thought we had just covered that subject.

ARNOLD (*dismissively*): I don't mean your affair with Richard Gerstl. When you left me, I started to make notes for a last will...one I never showed to anyone. But now I have to quote from it.

ADORNO: Maestro! I really ought to leave.

ARNOLD: You will do nothing of the sort, because you must hear those words to understand why I really wanted you here. Now listen carefully...both of you. I wrote the following, "He who sticks to facts will never get beyond them to the essence of things. I deny facts. They have no value to me, for I elude them before they can pull me down. I deny the fact that my wife betrayed me—"

ADORNO (*interrupts, astonished*): You deny that?

ARNOLD (*forcefully*): I do! Because I also wrote, "She did not betray me, for my imagination had already pictured everything she has done."

MATHILDE: In that case, what more is there to be said on the topic of adultery? Or do you also have something to confess?

ARNOLD: A musical confession...dealing with Berg.

MATHILDE: With you, Arnold, music and sex were never much distinguishable.

ARNOLD: In this instance, they may be even indistinguishable.

ADORNO (*clearing his throat*): You still wish me to stay?

ARNOLD: Absolutely! Your presence is vital...not as a witness, but as an interpreter. But first I want Mathilde's take on Berg's *Chamber Concerto.*

MATHILDE: So we do move from sex to music. But what take? I died shortly after Berg started on it.

ARNOLD: Just pay attention to what I have to say. (*Turns to Adorno.*) And feel free to interrupt.

ADORNO (*laughing*): Maestro! You've never made such an offer before.

ARNOLD: I have a reason: I want to be sure that I'm not suffering from a composer's paranoia. (*To Mathilde.*) Berg dedicated the *Chamber Concerto* to me. "As a monument to our twenty-year-old friendship," he wrote in 1925.

MATHILDE: Too bad I was already dead. I would have liked to have heard it . . . or at least studied the score.

ARNOLD (*to Adorno*): Wiesengrund, you have written a lot about Berg and you know that concerto well.

ADORNO: Of course I do. I was present at its gestation . . . or shall we say delivery? Back in 1925, Berg asked me to buy him some special nibs for his pen . . . a few dozen . . . so that he could complete a clean copy.

ARNOLD (*impatient*): Don't get lost in minutiae. Just describe the piece to Mathilde.

ADORNO: It was the closest Berg ever came to write something resembling a symphony. This one was for piano, violin, and thirteen wind instruments. (*Very rapid.*) Scored for piccolo, flute, oboe, horn, E-flat clarinet, B-flat clarinet—

MATHILDE: That will do. What was the music like?

ADORNO: It was his first attempt at twelve-tone music, but not in all three movements.

ARNOLD: Just tell her about the adagio.

ADORNO: Berg wrote it as a 240 bars long palindrome, the second 120 bars a mirror image of the first.

ARNOLD: The middle please! The middle!

ADORNO: That's quite exquisite: twelve low notes by the piano . . . the tolling of the midnight bell.

MATHILDE: You mean signifying death?

ARNOLD: Yes, but whose? Wiesengrund, tell her!

ADORNO: It's only supposition.

ARNOLD: So are most interpretations of musical meaning. (*To Mathilde.*) It was Gerstl's suicide.

MATHILDE (*cries out*): Impossible! I thought this work was dedicated to you!

ARNOLD: Berg left too many clues.

MATHILDE: Is that another example of your obsession with musical ana-
grams and numerology?

ARNOLD: Numerology was Berg's obsession, especially the number 3. Just
take this chamber concerto. Three movements, three principal motives
associated with three men—

MATHILDE: I can't believe, if you're one, that Richard Gerstl would be one
of the remaining two!

ARNOLD: That's not the issue. The others were Webern and, of course, Berg.
Even the number of instruments—fifteen in all—was divisible by three
or the number of bars in the musical palindrome. (*Turns to Adorno.*) But
this is why I asked you to join us. I want Mathilde to hear the evidence
through a third party. Please (*gestures to Adorno*), proceed.

ADORNO (*sighs*): I shall do so, but reluctantly. As I said . . . it is supposition.

ARNOLD (*sharply*): Please!

ADORNO: All right. There is little doubt that the piece celebrates the friend-
ship of the great trio: Schönberg, Webern, and Berg. And that the choice
of fifteen instruments represents homage to Maestro Schönberg's *Cham-
ber Symphony No. 1,* which contained the same number fifteen.

MATHILDE: But as you said . . . this is all supposition.

ADORNO: Actually there is more. More than one sophisticated musician . . .
and I pride myself on belonging to that group . . . has analyzed Berg's
musical codes, in which he represents the people closest to him, and the
numerological craftiness—

MATHILDE (*interrupts*): *There* you have it: craftiness! In other words,
hocus-pocus.

ARNOLD: I object.

ADORNO: And so do I. By arty, I meant subtle as well as cunning. Berg's
concerto features enormous technical complexity by being threaded
through with ciphers and numerical ideas.

ARNOLD: Threads that can be tied into a knot that stays tied. Wiesen-
grund . . . show her!

ADORNO: Basically, Berg translated the three names into notes. Of course,
you'd have to look at the actual score, but you just need to focus on the
initials that correspond to musical notes and that H in the German nota-
tion is B-natural and that S or Es is E-flat. What you then find is ArnolD
SCHönBErG, Anton wEBErn and finally AlBAn BErG. (*To Mathilde.*) You
follow me?

MATHILDE: Of course. I'm not musically illiterate.

ARNOLD: So you accept the fact that the names of Webern, Berg, and Schönberg are woven into the piece?

MATHILDE: Yes . . . they probably are . . . in spite of the missing letters.

ARNOLD: I shall now take over. Berg named the three movements "Friendship," "Love," and "World," with the "Love" adagio clearly intended for you and me. Because if one examines the notational system more carefully, one can also find your name in it.

MATHILDE: Mathilde?

ARNOLD: Indeed. What caught my attention was Berg's posthumous notes on the adagio in which he referred several times to a MATH theme and then associated the musical notation A-H-D-E with it. All you need to do is eliminate the duplication of A and H and what have you got left? M A T H D E. Can you accept that?

MATHILDE: Reluctantly.

ARNOLD: For the present purposes, even "reluctantly" is good enough for me. So let me continue. Couldn't the palindrome format of this love theme refer in the first 120 bars to our marriage, the twelve-tone death notes to its interruption when you left me for Gerstl, and the final 120 bars to the resumption of our marital love?

MATHILDE: Go on. I suspect there is more to come.

ARNOLD: Your suspicion is justified. Do you know what Gertrud told me after your death? That you consulted a fortune-teller—

MATHILDE (agitated): I never told our daughter that I had gone to a fortune-teller.

ARNOLD: But you went to one?

MATHILDE: So what? You believe in numerology . . . I in fortune-telling. We both have our weaknesses. But why should I tell this to my daughter?

ARNOLD: I was referring to Gertrud Kolisch . . . my second wife.

MATHILDE: Oh, her!

ARNOLD: And that the fortune-teller predicted that two of your lovers would die—

ADORNO (interrupts): You don't need a fortune-teller for that. We all die eventually. Just take a look at us up here.

ARNOLD: Dying? Of course. But how? The prediction was that one would kill himself and the other would die from an infection caused by an insect bite.

MATHILDE: Arnold! Why torture us both? I've admitted my affair with Richard Gerstl, and when I returned to you, you forgave me.

ARNOLD: What about the second man—

MATHILDE: What about him?

ARNOLD: Of course you couldn't know that, but Alban Berg died in 1935 from an infection caused by a mosquito bite!

MATHILDE: Good God!

ARNOLD: Do you now understand why I had to meet with you once more?

ADORNO: Maestro Schönberg! I beg you not to continue.

ARNOLD: I must.

ADORNO: In that case I must leave. (*About to exit.*)

ARNOLD: One moment. You, Herr Wiesengrund, more than anybody else, knew about Berg's affairs. You were the messenger between him and Hanna Fuchs-Robettin . . . another married lover of his. You've even written an analysis of Berg's *Lyric Suite*, pointing out how he had woven his name and that of his mistress into the score.

ADORNO: I am leaving. (*He departs.*)

MATHILDE (*after a long pause*): Well?

ARNOLD: Well . . . did you?

MATHILDE: Was that question the reason for the summons?

ARNOLD: Yes.

MATHILDE: After all those years . . . after having forgiven me for my infatuation with Richard Gerstl . . . and my mistake, years later, with Hugo Breuer . . . you ask me whether I committed another marital indiscretion? Why? To forgive me a third time . . . posthumously?

ARNOLD: An affair with Alban Berg would be unforgivable.

MATHILDE: Why? Because you were jealous of Berg's successes and Berg envied you your failures?

ARNOLD: Because he could not have done that. Otherwise, it would've been as if I'd double-crossed myself.

MATHILDE (*rises and starts to leave*): You geniuses are all alike. You only want to know what other geniuses think of you . . . how other geniuses treat you. But all of them are men. I was only your wife. But, as you once wrote, "We've never even really spoken to each other, that is, communicated. We only talked." (*She starts exiting as the lights dim.*) And now it's too late for that.

END OF SCENE 2

3. ONE ANGEL (BY PAUL KLEE)

AN IMPORTANT thread that ran for many years through the friendship of Benjamin, Scholem, and Adorno was a preoccupation with a drawing by Paul Klee, the *Angelus Novus* of 1920. Benjamin owned this drawing; after his death it passed to Adorno and then to Scholem. Klee, who died in the same year (1940) as Benjamin, created over nine thousand works in his lifetime, but while the *Angelus Novus* is both aesthetically appealing and conceptually intriguing, artistically it is by no means one of Klee's major works. Yet the *Angelus Novus* is among Klee's most famous creations, because Benjamin featured it in an influential essay on the philosophy of history where he attributed to the drawing a host of metaphorical meanings.

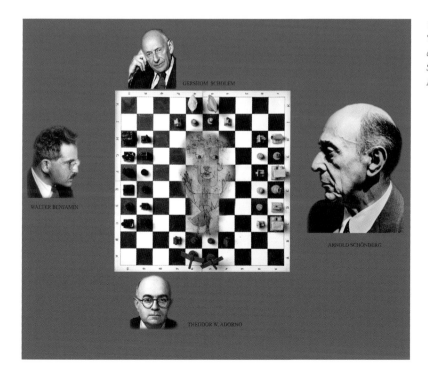

3.1. Gabriele Seethaler, *Arnold Schönberg, Theodor W. Adorno, Walter Benjamin, and Gershom Scholem Around Arnold Schönberg's Coalition Chess with Paul Klee's Angelus Novus.*

I have been an avid collector of Klee's works for over forty years and have seen and studied hundreds upon hundreds of examples of his artistic output. As a collector of art, the process of canonization of works of art has long intrigued me, so much so that in 2004 I wrote a play on the subject entitled *Phallacy*.[1] My interpretation of the manner in which first Walter Benjamin and then Gershom Scholem promoted Klee's *Angelus Novus* led me to a totally revisionist view of this famous drawing. I put in Arnold Schönberg's mouth my view that Benjamin's success in appropriating the meaning of Klee's image represents an inapt canonization in art. But why use a surrogate rather than express these opinions directly in my words?

First, only Schönberg, among the four, with an output of over two hundred paintings and drawings, could claim some competence as a visual artist. Although an autodidact ("I had no theoretical and very little aesthetic training"), Schönberg in his early thirties benefited greatly from his close contact with the painter Richard Gerstl—next to Klimt, Schiele, and Kokoschka among the most important Austrian painters of the early twentieth century—that ended only when the intimacy with Schönberg turned into an adulterous relationship with Schönberg's wife Mathilde. Schönberg's first public exhibition in 1910 in Vienna was panned by the critics—as much of his music had been—yet the following year he was prepared to paint portraits for a living. His rationale was expressed with real chutzpah in a letter to his publisher: "Don't tell people that they will like my paintings. Instead, make it clear that my pictures must appeal to them because they have been praised by experts and especially because it's much more interesting that they are painted by a composer of my reputation." After listing his prices, he concluded, "This is really a bargain if one considers that in twenty years these pictures will be worth ten times and in forty years one hundred times that sum." One of the experts praising Schönberg was Wassily Kandinsky, who strongly encouraged Schönberg and saw in him a raw talent that merited inclusion in a Blaue Reiter exhibition in Munich in 1911. The following year Paul Klee joined the Blaue Reiter, and while Schönberg was no particular fan of Klee's—perhaps because Klee, a superb classical musician, had been very critical in reviewing the first performance of Schönberg's *Pierrot lunaire*—he clearly was familiar with his work.

Second, in the context of Klee's *Angelus Novus*, I want to discuss the way musical works are subject to canonization and are also exploited as sources of metaphor. In that regard, Schönberg's figure fit ideally, since his master-disciple connection with Adorno, an important musicologist for much of his life, was real and required no deus ex machina manipulation on my

part; nor did the hitherto unknown familial connection between Schönberg and Benjamin, which I disclosed in chapter 1.

Third, I have Schönberg, the painter, make the case regarding how inappropriate the canonization of Klee's *Angelus Novus* was, because, in the final analysis, a work of art should be canonized only on the basis of its aesthetic and artistic merits and not because a famous owner happened to have written about it. Through Schönberg's words I speculate on what Klee actually might have had in mind when he created the work twenty years earlier. In that connection I address the point first raised by Johann Konrad Eberlein (University of Graz)[2] that Paul Klee may well have thought of Adolf Hitler as the *Angelus Novus*—the ultimate irony for a work so beloved by three Jewish owners in succession that now resides in the Israel Museum in Jerusalem. As a consequence, and as a challenge to Benjamin, I have Schönberg support my revisionist arguments about what Klee might have painted, had he wished to illustrate Benjamin's essay, through specially created pseudo-Klee images by Gabriele Seethaler.

Last, I wanted to shed light on the extraordinary effect Klee has had on other composers. For this purpose I manufacture a professional debate between Adorno and Schönberg and illustrate it with some actual musical compositions inspired by the *Angelus Novus*, including one especially composed by Erik Weiner for this chapter. In the course of the somewhat contentious exchanges of my four protagonists, I document the missing portions in the hitherto incomplete provenance of the *Angelus Novus*, notably how it finally ended up in Scholem's hands before being passed along to its permanent resting place, the Israel Museum in Jerusalem.

BENJAMIN: So let's talk about the angel.

ADORNO: Not again!

BENJAMIN: Again? When did you and I last talk about him?

ADORNO: Haven't you written enough about him? (*Declamatory tone.*) "A Klee painting, 'Angelus Novus,' shows an angel looking as though he is about to move away from something he is fixedly contemplating. His eyes are staring—..."

BENJAMIN: That's enough. After all I know what I wrote. But that was 1936. You have a good memory...quoting verbatim.

ADORNO (*laughs*): I'm a good reader. Furthermore, you are addressing the person who edited your papers...and made your reputation.

BENJAMIN (*leans over and pretends to kiss his hand*): Otherwise I wouldn't be up here. But what about Hannah Arendt? That's how the Americans

3.2. Paul Klee, *Angelus Novus*, 1920.

learned about me. But right now I want to talk about the Klee ... not my reputation.

ADORNO: The two cannot be separated.

SCHÖNBERG: Bravo!

BENJAMIN (*looks annoyed at Schönberg before addressing Adorno*): I said I want to *talk* about the picture ... not about what I once *wrote* about the image.

ADORNO: I still say, they can't be separated. But what's there still to talk about?

SCHOLEM: Let Walter finish. I'm always interested in angels—

ADORNO (*interrupts*): Kabbalist!

SCHOLEM: I don't like the tone in which you said that.

ADORNO: Everyone today seems hypersensitive. *Kabbalist* is not an insult.

SCHOLEM: The problem with that word is that it smells of disrepute ... especially to some Jews, who consider the Kabbalah untransmitted Hebrew literature and hence untransmittable in terms of Jewish tradition.

ADORNO: Don't include me among those critics. I'm not that sort of a Jew.

SCHOLEM: We all know that, Herr Wiesengrund. I have not ... under any circumstances... become a Kabbalist. It's not the Kabbalah that needed me (*quotes in exaggerated tone, perhaps also drawing quotation marks in the air*), "it is only the misty wall of history that surrounds it that must be penetrated. To penetrate it—that is the task I have set for myself." That's what I wrote in 1937 ... and it's still true today! But, in the process, I have made such studies reputable.

ADORNO: My apologies. I shall never again call you that. But what about *angelist* or *angelologist?* After all, you also have written too much about this particular angel. (*Turns to Benjamin.*) What else is there to say that hasn't been flogged to death about your angel? You (*turns to Scholem*) even called him the Angel of Death—*Der Angelus Satanas.*

SCHOLEM: But that was an anagrammatic interpretation of one of Walter's noms de plume!

SCHÖNBERG: That's rather clever. By no means as simple as my calling my son Ronald as an anagram for *Arnold.*

BENJAMIN: Please! No anagrams—

SCHOLEM: I do have something to say about that anagram—

BENJAMIN: Later! And no philosophizing! Right now, let's focus on the facts.

ADORNO: We all know the facts ... and especially Gerhard.

SCHOLEM: Gershom! How often do I need to correct you?

ADORNO: It was a joke.

SCHOLEM: A tired one.

ADORNO: All right… I apologize. But now to the angelic facts. (*Turns to Benjamin.*) Which facts?

BENJAMIN: I bought the drawing in 1921… the year after Klee finished it… I paid 1,000 Marks…

ADORNO: Now we would say $14.

3.3. Paul Klee, *Presentation of the Miracle,* 1916.

SCHOLEM (*sarcastically*): A posthumous… inflation adapted… conversion… and of course into dollars… now the currency even on Parnassus.

BENJAMIN (*impatient*): Marks… dollars. What's the difference? It wasn't much, since even I could afford it, the recently anointed Dr. Walter Benjamin. Not yet thirty, still impecunious and still freelancing… but already father of a young son.

SCHOLEM: Your wife was not impecunious.

BENJAMIN: True. The year before, she even bought me another Klee… the 1916 *Vorführung des Wunders* for my birthday.

SCHÖNBERG: Strange that nobody is talking about that one any more. Klee is not exactly my cup of tea, but I think that one is far superior.

SCHOLEM: Walter used to think so himself. "This is the most beautiful of all his paintings I have seen," he wrote me in 1920.

BENJAMIN: God! Those friends of mine who never threw away anything I ever wrote.

SCHOLEM: And remembered what was in it. Lucky for you.

ADORNO: He is right. Otherwise, you'd never have found yourself up here.

BENJAMIN: Stop interrupting. Right now, the subject is *Angelus Novus*… not my admission to Parnassus. The drawing was with me until the year of my death.

SCHOLEM: Not all the time. Right in the beginning, I stored it for you.

BENJAMIN: Only until I had four walls of my own.

SCHOLEM: It was the only art on your walls—otherwise surrounded by books up to the ceiling.

BENJAMIN: You… better than anyone else… knew what that Klee meant to me. That's why I left it to you in my testament.

SCHOLEM: Ah yes…that testament of 1932. Why did you never tell me about it?

BENJAMIN: I'm about to get to that. In 1940, when I fled Paris, Georges Bataille hid it with some of my books and papers in the Bibliothèque Nationale… hardly a place the Gestapo would search.

ADORNO: And if they'd found it, they'd have paid little attention to it. It was probably worth $500.

BENJAMIN: More money than I ever had at any one time in those final years. But now comes the question. Who got it out of Paris?

ADORNO: Pierre Missac got it to New York in 1947.

BENJAMIN (*turns to Scholem*): How did you finally get it?

SCHOLEM: You mean you don't know?

BENJAMIN: How could I? I'm different from you three. A huge blank in my memory . . . between my death in 1940 and my arrival here. You ascended to Parnassus the day you died.

SCHÖNBERG: I got up here while still alive down there.

ADORNO: Let me confess something . . . to all of you.

BENJAMIN: Well, well! Posthumous confessions are the best.

ADORNO: The expert speaking.

BENJAMIN: Any lawyer will tell you that the dead cannot be libeled. Ergo . . . the logician in me concludes that the dead have lost all shame. Our conversation up here seems to confirm that.

SCHOLEM: Well spoken! Almost Talmudic. So let's hear the confession.

ADORNO: In 1961 I wrote to your son.

BENJAMIN: I am beginning to see why you call that a confession. Go on.

ADORNO: I wrote him about our Klee.

BENJAMIN and SCHOLEM (*simultaneously*): *Our*?

ADORNO: Klee's *Angelus Novus* used to hang in my apartment for years . . . probably occupying more space on our wall than on yours. So why not *our* Klee?

BENJAMIN: You were always too presumptuous, Teddie . . . too possessive. But what exactly did you write to Stefan? I didn't even know that you two were in contact.

ADORNO: It wasn't done behind your back. It was posthumous correspondence. Dealing with publication of your work . . . how to make you famous.

BENJAMIN: Mea culpa. It's retrospective guilt, not jealousy, that made me ask. I was never much of a father.

SCHOLEM: Let's hear the confession. What did you write Stefan?

ADORNO: You know that I had arranged to get all your papers from Paris. The trunks also contained the *Angelus Novus*. I replaced the copy on our wall by the original.

BENJAMIN: I never knew that.

ADORNO: You don't grant me intellectual . . . or aesthetic . . . or especially historical rights to the *Angelus?*

BENJAMIN: Is that what you wrote Stefan?

ADORNO: I told him that when you bought it, it was worth very little . . . monetarily speaking. But given its importance in your life, it became invaluable to me as the guardian of your work.

SCHOLEM: *One* of the guardians. Don't act as if there weren't others.

ADORNO: But by that time . . . we are now speaking twenty years after your death . . . all works by Klee had sufficiently appreciated that the monetary value of the *Angelus Novus* could not be ignored anymore.

BENJAMIN: Is that what you wrote Stefan?

ADORNO: That's what prompted me to write. I told him that I was loath to part with that work, but, since he clearly was the legal owner of your estate, legally the Klee was his.

SCHOLEM: That's not what it says in Walter's will!

ADORNO: None of us . . . not you, not I, and certainly not Stefan knew anything about that testament. Not in 1961. He didn't even know what had been written about the *Angelus.*

BENJAMIN: That I am surprised to hear.

ADORNO: That's what he wrote me.

BENJAMIN: I'd have thought Stefan would have read that by age forty-three. But go on.

ADORNO: I asked whether he would let me keep it as long as I lived, but that I would provide him with a notarized statement of his ownership

BENJAMIN: Stefan accepted that?

ADORNO: Not only that. He even offered to pay for its annual insurance and modified his will so that I would become its owner if he predeceased me.

BENJAMIN: Owner?

ADORNO: I am not talking about legal ownership . . . of course that Klee was yours. I'm talking about disposition. You never thought me a candidate for the *Angelus* in your will?

BENJAMIN: Never!

SCHOLEM: Since you intended it for me, you're paying me a compliment!

ADORNO: By insulting me! And to think that I am the one who nearly got you to the States!

BENJAMIN: I fail to see the connection to the *Angelus.*

ADORNO: I am talking about *our* connection . . . the disposition of the Angelus would then only have been a consequence.

SCHÖNBERG: Stop all this posturing and arguing about the *Angelus Novus*.

BENJAMIN: Wait! Now I'm getting interested. Teddie ... what happened next? How did the *Angelus* get to Gerhard in Jerusalem?

ADORNO: You're asking me? I died in 1969. (*Turns to Scholem.*) I think it's your turn.

SCHOLEM: It's not the most pleasant story. (*To Benjamin.*) Do you really want to know?

BENJAMIN: Now that you've both made me curious ... of course I do. So let's hear it.

SCHOLEM (*addresses Adorno*): I immediately flew to Frankfurt for your funeral—

ADORNO: Let me thank you ... posthumously ... for that courtesy. Did you speak there?

SCHOLEM: Not a chance! Except for some personal remarks by Max Horkheimer, since there were no religious rites—

ADORNO: Thank God!

SCHOLEM: They made up for it by very deferential ... if not utterly hagiographic speeches by German officialdom ... starting with the culture minister of Hessen.

ADORNO (*ironic*): I'm impressed. And then what?

SCHOLEM: A big reception in your publisher's home.

BENJAMIN (*to Adorno*): Teddie, I understand your interest in your funeral—

ADORNO: But?

BENJAMIN: But what happened to my *Angelus Novus*?

SCHOLEM: I'm getting to that. At the reception in Siegfried Unseld's home, I met your son. (*Pause*).

BENJAMIN: And?

SCHOLEM: I raised the question of the *Angelus*. (*Pause.*)

ADORNO (*impatiently*): What does raising the question mean?

SCHOLEM: I told him it was really mine ... after all, by that time I'd read Walter's 1932 will, where he'd left it to me ... and I asked Stefan to instruct your wife to hand it over to me. I thought that I could personally take it back to Jerusalem.

BENJAMIN: And Stefan agreed?

SCHOLEM: He most certainly did not!

BENJAMIN (*surprised*): What?

SCHOLEM: He felt that since you had not killed yourself in 1932—

BENJAMIN: Now that is pretty cold-blooded—

SCHOLEM: No, no! He didn't mean it that way. He just felt that since you did not commit suicide and did not publish or legalize your will in any way, it was null and void. And that you hadn't left a new testament upon your final demise—

BENJAMIN: What a discreet way of putting it.

SCHOLEM: I'm just using your earlier terminology. Anyway, he felt that the 1932 will had no legal standing and that the Klee was now his legal property. (*To Adorno.*) Wasn't that the sum and substance of your earlier agreement with Stefan?

ADORNO (*even more impatient*): Come on, Gerhard! So what happened? Tell us.

SCHOLEM: Your wife Gretel wrote to the famous Kornfeld und Klipstein auction house in Bern for an estimate, and when she received it, it was clear to everyone that by 1969 we were talking about the most valuable item in Walter's estate. We all argued for nearly three years … during which the Klee remained in Gretel's home … until Stefan died in 1972. So the poor man never really could enjoy that drawing.

3.4. Letter of Gretel Adorno to E. W. Kornfeld, September 29, 1969.

3.5. Letter of E. W. Kornfeld to Gretel Adorno, October 4, 1969.

DR. THEODOR W. ADORNO
O. Ö. PROFESSOR

FRANKFURT AM MAIN 29. 9. 69
KETTENHOFWEG 123

Herrn
K o r n f e l d

B e r n
Laupenstr. 49

Sehr geehrter Herr Kornfeld,

Ihre Adresse verdanke ich Herrn Daniel-Henry Kahnweiler, Paris. Ich habe als Leihgabe von Herrn Stefan Benjamin, London, dem Sohn des Philosophen Dr. Walter Benjamin, ein frühes Werk von Klee aus dem Jahre 1920 "Angelus Novus". Das Bild ist abgebildet: 1. in Wilhelm Hausenstein, Kairuan oder die Geschichte vom Maler Klee, München 1921; 2.in Herman Meyer, Zarte Empirie, Studien zur Literaturgeschichte, Stuttgart 1963.

Wäre es möglich, daß Sie mir eine Expertise anfertigen, das heißt den Wert des Blattes bestimmen, ohne daß ich Ihnen das Bild schicke, was ich gerne vermeiden möchte.

Mit bestem Dank im voraus und

freundlichem Gruß

Ihre ergebene

Dr. Margarete Adorno

P.S. Das Bild hat die Maße ca. 24 auf 31 1/2 cm.

Bern, den 4. Oktober 1969

Frau Prof. Margarete Adorno
Kettenhofweg 123

6 Frankfurt a/M

Sehr geehrte Frau Professor Adorno,

Es ist sehr schwierig ein Bild auf seine Echtheit zu prüfen und zu schätzen ohne das Original vor sich zu haben. Auch wenn die Echtheit des Aquarells nicht in Frage steht wird die Preisfestsetzung sehr stark von der Farbfrische und der Erhaltung beeinflusst.

Im Prinzip handelt es sich um ein sehr schönes Werk aus Klee's gesuchtester Zeit, dessen Wert, Echtheit und gute Erhaltung vorausgesetzt, sich sicher auf ca. Fr. 80'000.- beläuft, eventuell auch mehr.

Sollten Sie gegebenenfalls an einen Verkauf denken, so käme bei uns einerseits ein Ankauf für das Lager oder aber auch die Aufnahme in die nächste Auktion moderner Kunst mit entsprechender Limitierung in Betracht. Zu Ihrer Orientierung schicke ich Ihnen den letzten Auktionskatalog und unsere Auktionsbedingungen zu.

Mit den besten Grüssen

Ihr

ADORNO: And then?

SCHOLEM: I persuaded Siegfried Unseld ... after all he had published most of our books and was paying Stefan's estate royalties ... to be the middle man. He went to London, settled with Stefan's widow, and got the picture from Gretel. A few months later ... on July 15 and 16 ... Unseld organized a major event on the occasion of Walter's eightieth birthday. Most of Walter's friends and the many Benjaminologists, which by then had multiplied like lemmings, were there ... with the *Angelus Novus* hanging on the wall so that everyone could see it. They even had placed photographs of it on every chair.

ADORNO: And?

SCHOLEM: Unseld was ill, so Habermas spoke in his place ... and of course so did I.

ADORNO: The *Angelus*! What happened to the *Angelus*?

SCHOLEM: I took it with me to Jerusalem. Actually I sewed it into the lining of my jacket!

BENJAMIN: Why on earth did you do something so crazy?

SCHOLEM: I was worried about the Israeli customs. Do you realize what they could have charged me ... now that there existed an official valuation of over eighty thousand Swiss francs from Kornfeld? Anyway ... it's now at the Israel Museum so the public can finally see it ... nearly seventy years after Klee painted it!

SCHÖNBERG: Are you finally ready to get back to the *Angelus*—the image— and away from its disposition?

ADORNO: With all due respect ... and you do know how much I have for you ... where do you come in? Klee was never one of your favorites and I've never even heard you mention the *Angelus*.

SCHÖNBERG: You will now.

ADORNO: About a work of Klee, whom you never cared for?

SCHÖNBERG: Your evidence?

ADORNO: Rumors ... based on something you were supposed to have told Kokoschka.

SCHÖNBERG: I didn't tell him, I wrote him in 1946 that Klee wasn't exactly one of my gods.

ADORNO: Because you weren't one of his?

SCHÖNBERG: Again ... your evidence?

ADORNO: Your 1912 premiere of *Pierrot lunaire*—

SCHÖNBERG: Hearsay evidence. You were then nine years old.

ADORNO: Written evidence. In 1913 in his diary, Klee complained, "Even Schönberg is being performed . . . the mad melodrama, *Pierrot lunaire*"—

SCHÖNBERG: A masterpiece.

ADORNO: You know I agreed . . . and did so in writing when I was old enough to express musical opinions. But Klee disagreed . . . also in writing. Don't you recall his review? (*Mimics nasty, critical tone.*) "Monotonous series of delicacies . . . melodramatic settings of the Pierrot-Lunaire poems . . . amusing, bizarre, funny and grotesque..." That's what he wrote, and, remember, he wasn't just a painter . . . he was also a musician.

SCHÖNBERG: For whom music ended with Mozart. And a far superior painter than musician.

SCHOLEM: I must interrupt.

SCHÖNBERG and ADORNO: Why?

SCHOLEM (*to Schönberg*): The subject was Klee's *Angelus Novus* . . . not your *Pierrot lunaire*.

SCHÖNBERG: Patience. I'm almost there. But I can't leave this critique unchallenged. Here, listen (*assumes sarcastic tone*) to some "amusing, bizarre, funny and grotesque monotonous series of delicacies."

They all listen for about one to two minutes to poem 9 ("Gebet an Pierrot") from Schönberg's Pierrot lunaire, *followed by polite applause.*

SCHÖNBERG: Well? You just listened to one of my works that got me up here. Now let's see what Herr Klee did with the *Pierrot lunaire.*

That's what he produced . . . twelve years later. I concede that it can also be called "bizarre and grotesque," but hardly amusing or funny.

BENJAMIN: A matter of taste.

SCHÖNBERG (*pounces*): Exactly! But if you want to know anything about the *Pierrot lunaire* in Giraud's poems—you won't get it from Klee's image.

SCHOLEM: I can't say that I got much from your music.

SCHÖNBERG: Because you are musically illiterate! You focus too much on the words . . . without listening to the music—

SCHOLEM (*interrupts*): Except for the beginning, "Pierrot! Mein Lachen hab ich verlernt!" I couldn't hear the words . . . because of the music.

SCHÖNBERG: My usual problem with musical plebeians as Herr Professor Wiesengrund Adorno can tell you. But now to your *Angelus Novus*. When did Klee complete it?

3.6. Paul Klee, *Pierrot lunaire, 1924.*

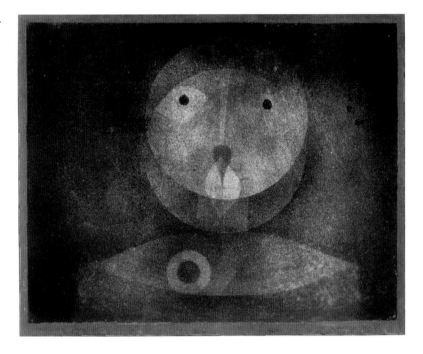

BENJAMIN: 1920.

SCHÖNBERG: Exactly. And then he lived another twenty years.

BENJAMIN: As did I. We both died in 1940. But what's your point?

SCHÖNBERG: During those two decades he probably produced another seven thousand or more works.

SCHOLEM: Which only shows how productive he was.

SCHÖNBERG: But do you know that he drew at least another fifty angels ... over half of them in 1939?

BENJAMIN: I had no way of knowing that ... not in 1939, the second worst year of my life.

SCHÖNBERG (*conciliatory*): It so happens that 1939 was also the second worst year of Klee's life ... because he knew he would die soon. But which of Klee's fifty odd angels is the most famous ... and by a wide margin? Your *Angelus Novus*! And yet exhibited or even reproduced much less than many of the others. So why is it the most famous?

BENJAMIN: It's a great work.

SCHOLEM: A fabulous one.

ADORNO: First-class.

SCHÖNBERG (*to Adorno and Scholem*): Forgive me if I discount your opinions. You are interested parties ... one the self-anointed and the oth-

er the eventual owner. (*Turns to Benjamin.*) But you're different. You bought him and then you *used* him.

BENJAMIN: Define that word for me.

SCHÖNBERG: Well, for one . . . "*Angelus Novus*" was the title of a literary journal you founded.

BENJAMIN: Indeed. (*Draws quotation marks in the air.*) "We are touching now on the ephemerality of this magazine, for it is the just price to be paid for promulgating genuine topicality." That's what I wrote in the prospectus.

SCHOLEM: I was going to be its specialist for Judaism.

SCHÖNBERG: The operating words are *going to be*. *Angelus Novus* never reached the public . . . a literary stillbirth.

SCHOLEM: You are unfair. The reasons were economic.

SCHÖNBERG (*laughs*): Whatever the reasons . . . it was still the purest *ephemerality* . . . to use Herr Benjamin's precious word for stillbirth.

BENJAMIN: And why did I choose the title? Because Gerhard, the Talmudic scholar—

SCHOLEM: *Gershom* the Talmudic scholar!

BENJAMIN: Because Gershom . . . steeped as he is in angelology . . . pointed out that, according to the Talmud, angels are created all the time . . . just to utter praise before God . . . and then to disappear into nothingness. One issue of our magazine after another.

SCHÖNBERG (*ironic*): I see! And the magazine would then have made the reputation of the Klee drawing, especially if the image had appeared every month on the cover of a real magazine . . . but it didn't. So what *did* accomplish its fetishization?

BENJAMIN: A word I dislike.

SCHÖNBERG: Which, as the premier critic of our time, you should know does not change its aptness in this instance. You wrote something else about the angel.

SCHOLEM (*to Benjamin*): Long before then . . . in the year you spent your $14 on it . . . I wrote you a birthday poem, "Greetings from *Angelus*." Remember?

BENJAMIN: How could I forget? (*He quotes.*) "My wing is poised to beat / but I would gladly return home / were I to stay to the end of days / I would still be this forlorn."

SCHÖNBERG (*dismissive*): Charmingly juvenile lines, but hardly sufficient to affect the value of this drawing. You both know what I am talking about (*to Benjamin*), your "Theses on the Philosophy of History."

BENJAMIN: The ninth thesis. (*He quotes.*) "There is a painting by Klee called *Angelus Novus*. It shows an angel who seems about to move away from something he stares at. His eyes are wide, his mouth is open, his wings are spread. This is how the angel of history must look."

SCHÖNBERG: One moment. Now really look at him. It is true his eyes are wide and his mouth open, but what made you write, "This is how the angel of history must look?"

BENJAMIN: Please let me continue. I then wrote, "His face is turned toward the past. Where a chain of events appears before us, he sees only single catastrophe, which keeps piling wreckage upon wreckage and hurls it at his feet."

SCHÖNBERG: Okay… understood. But what do these words have to do with Klee's image? I don't see the angel's face turned toward the past! I see no wreckage before his feet! And how are you going to convince me that his hapless *Angelus* sees a catastrophe? *You* may see one, but Klee's *Angelus*?

BENJAMIN (*becoming irritated*): You must simply let me finish quoting my own essay. "The angel would like to stay, awaken the dead, and make whole what has been smashed. But a storm is blowing from Paradise and has got caught in his wings; it is so strong that the angel can no longer close them. This storm drives him irresistibly into the future to which his back is turned, while the pile of debris before him grows toward the sky. What we call progress is this storm."

SCHÖNBERG: And you see all that in this image? I don't see any storm. I don't think his wings are caught in it … I don't see him driven anywhere. I didn't see any debris at his feet … and I certainly don't see any rising toward the sky. I see an angel, looking timidly sideways toward God, raising his wings to his praise—

BENJAMIN: That's all?

SCHÖNBERG: That's all. Now I do not question the text of your "Theses on the Philosophy of History" … not even this rather emotional ninth one. All of us, including Klee, have passed through this type of history, but putting these words into the image of this *Angelus*? You needed a metaphoric illustration and because this is the only Klee you owned—

BENJAMIN: Not the only one.

SCHÖNBERG: I forgot! Your wife had bought you *Vorführung des Wunders*. Actually, if I had to choose, I like that one better. But, of course, even you could not extract your ninth thesis from this drawing.

SCHOLEM: You are wrong. Walter could do it.

SCHÖNBERG: Well, don't try, because it does not affect my argument.

ADORNO: Finally! I was wondering whether you'd ever get to it. So what is the argument?

SCHÖNBERG: That particular Klee . . . like this particular set of theses on the philosophy of history . . . rested almost unknown . . . except for a small group, the majority of which sits right in front of me . . . for years beyond the death of the author and the painter. I hope I am not insulting you, Herr Benjamin, but when I died I was already up here. It took some twenty years before you ascended to Parnassus—after they pushed you up here.

BENJAMIN: They?

SCHÖNBERG: Your friends right here as well as others such as Hannah Arendt. But I digress. I do not mean that you do not belong here. But it was *they* . . . *their* efforts, their publishing and translating your works . . . that made you famous . . . posthumously.

BENJAMIN: I know all that. But what is your point?

SCHÖNBERG: My point is the reputation of this particular Klee . . . the *Angelus Novus*. You became famous for the *content* of your writing . . . your *own* writing. Your friends just spread it around. But this Klee only became famous because your essay became famous . . . reproduced and re-reproduced and re-re-reproduced . . . often without even the accompanying figure of the angel.

BENJAMIN: And you blame me?

SCHÖNBERG: Only indirectly, because your fame and your essay's fame was created by others. Yet what I find so intriguing is that it was the name, Walter Benjamin, that put this *Angelus Novus* on such an extraordinary pedestal. It practically became your logo. Not because you were the drawing's owner . . . although that helped . . . but because of what you wrote about it. You had a second Klee . . . at least as attractive a one . . . but you have written nothing about it. How many people talk about it now? (*Pause.*)

ADORNO: I hate to take the maestro's side at the expense of Klee—

SCHÖNBERG: In that case, let's hear it.

ADORNO (*to Schönberg*): What's your least popular composition?

SCHÖNBERG (*laughs sardonically*): Least popular . . . with "popular" referring to the "plebs"? Impossible to say. Almost all my works are unpopular. Most musical plebeians consider me a musical wild man with some sort of grudge against melody.

ADORNO: You are too tough on yourself.

SCHÖNBERG: That goes with the job of inventor of the twelve-tone method.

ADORNO: In that case, what is your least significant work?

SCHÖNBERG: I have never composed insignificant music.

ADORNO: I mean by Schönbergian standards. Take your *Pierrot lunaire*. It may not be wildly popular, but it's certainly iconic. Or the *Gurre Lieder*—

SCHÖNBERG: Or *Verklärte Nacht* . . . or *Moses and Aron* . . . or—

ADORNO (*raises his hand*): Agreed. Totally agreed. But there must be some minor contributions.

SCHÖNBERG: Name one.

ADORNO: What about your *Mannesbangen* of 1899?

They listen to all 1:02 minutes of Mannesbangen.[3]

SCHÖNBERG (*conciliatory*): Well . . . it's my shortest composition. Not exactly in the category of the *Gurrelieder*.

ADORNO (*triumphant*): Or *Verklärte Nacht*. But, suppose that in 1939 Herr Dr. Walter Benjamin had written a dense but highly complimentary article about your *Mannesbangen* and twenty years later, Scholem and I . . . and a few others we need not mention . . . had published it and gotten it into the mainstream of academic discourse—

SCHÖNBERG: Thus making *Mannesbangen* my most popular work . . . with most people, however, never even having heard the music?

SCHOLEM: You can't blame Walter for the result.

BENJAMIN: I know what's coming. "The Work of Art in the Age of Its Technical Reproducibility."[4]

SCHÖNBERG: Exactly.

BENJAMIN: It's a good title, but it's starting to feel trite . . . it's been so overused by people who don't even know what I meant by that.

SCHÖNBERG: Well I hope that you won't consider my comment trite. Your essay passes brilliantly over the various forms of reproduction . . . from wood cuts to lithographs to photography and film . . . all of them making multiple copies that in one way or another also affect the image itself. You have some great sentences in that essay, which have been repeated many times—

BENJAMIN (*smiles*): Coming from the great Schönberg, I am prepared to hear them once more.

SCHÖNBERG: How about this one? (*Uses slightly affected quoting tone.*) "The technique of reproduction detaches the reproduced object from the domain of tradition. By making many reproductions it substitutes a plurality of copies for a unique existence." (*Raises his hand.*) And one more quote: "That which withers in the age of mechanical reproduction is the aura of the work of art."

BENJAMIN (*pleased, laughs*): You are a good reader, Mr. Schönberg.

ADORNO: But the maestro has a point. The canonization of Art through repeated publication—

SCHÖNBERG: Of *irrelevant* facts! Don't forget that! It is crucial to my argument. What your irrelevance has done is . . . to paraphrase your own essay . . . a withering of the aura of the work of art. . . . In this instance Paul Klee's *Angelus Novus.*

BENJAMIN: There is nothing irrelevant about my text.

SCHÖNBERG: Don't take it personally. Irrelevance is inevitably in the eyes of the beholder . . . never in those of the author . . . and especially one like you who has been praised . . . or dare I say damned faintly . . . on your uncanny ability to complexify almost any topic. Hasn't it been said of you, not so long ago, that you're "one of the most perfectly citable authors of all, because one can quote you reverently without having to figure out what you actually said" . . . something of an academic equivalent of the purely ritual move, like a ballplayer's sign of the cross?

SCHOLEM: I think we are now entering dangerous territory.

SCHÖNBERG: Not quite. It is more difficult to ascribe irrelevance to a text about music, because it does not deal with images . . . like Klee's *Angelus Novus.* Hearing allows much wider latitude than visual imagery. Maybe that's why I concentrated on my music rather than on my painting.

ADORNO: That is where I would disagree. You were a genius in music, but in art—

SCHÖNBERG (*laughing*): True. I was good . . . but not a genius.

BENJAMIN: Klee was a genius.

SCHÖNBERG: But your history essay has virtually nothing to do with his *Angelus.* If you wanted to use Klee to illustrate your metaphoric prowess, then use appropriate works of his. Even when you wrote your essay, there were several thousand to choose from. You had one Klee at hand and you used it . . . inappropriately in my opinion. Let me give you some examples.

ADORNO: This from the Schönberg who seemed to have so little regard for Klee?

SCHÖNBERG: I never said that. He was not one of my gods . . . that's all . . . because I wasn't one of his . . . in other words simple reciprocity. But he's certainly up here on Parnassus and deserves to be so. Remember, I was also a painter . . . and especially of faces. I did exhibit . . . as well as pay attention to other artists. And don't forget how Kandinsky appreciated my work. Although that is another story.

BENJAMIN: And you will now illustrate my ninth thesis on the philosophy of history with other Klees?

SCHÖNBERG: Why not? For instance, right at the outset you write, "His eyes are wide, his mouth is open, his wings are spread." You want eyes open wide? How about this one, painted by Klee just a few weeks before your *Angelus Novus*?

BENJAMIN: But his mouth isn't open.

SCHÖNBERG: Instead of an open one . . . let me offer a much more threatening mouth . . . one that Klee had already drawn a year earlier.

SCHOLEM: What a face!

SCHÖNBERG: It's of Klee himself . . . and with an expression that to me seems much more appropriate to Herr Benjamin's view of history.

SCHOLEM: Walter described an angel. Where are the wings?

SCHÖNBERG: Here you are. An angelic Paul Klee with wings.

BENJAMIN (*laughs*): He does have wings—

SCHÖNBERG: Which is what you ordered.

Below left to right

3.7. Paul Klee, *Baroque Portrait*, 1920.

3.8. Paul Klee, *Absorption (self-portrait)*, 1919.

3.9. Carl Djerassi and Gabriele Seethaler, *Variant of Paul Klee's Angelus Novus with the eyes of Paul Klee's Baroque Portrait (fig. 3.7) and the mouth of Paul Klee's Absorption (fig. 3.8).*

BENJAMIN: Quite an amusing romp through Klee's oeuvre, but hardly applicable to my essay.

SCHÖNBERG: Of course it is *your* essay ... and so is the occasionally turgid language. So let us jointly search for some more appropriate visual representations for it. There are at least another forty Angels by Klee to choose from ... and most of them hardly joyful. With names like *Angelus Militans* or *Angelus Dubiosus*. I could go on ... several dozen times more ...

ADORNO: You're getting carried away.

BENJAMIN: I agree. What have these images to do with my essay on the philosophy of history?

SCHÖNBERG: As little ... or as much as your own *Angelus Novus*. I wanted to demonstrate that if Klee had really wanted to paint an angel that evokes the dark and pessimistic view you expressed, he could have done so. Parts of *your* description could be found in many of his works, but not the one you owned.

ADORNO: Maestro, you are becoming repetitive.

SCHÖNBERG: Indeed I am. So I shall end with a surprise. Here ... let me show you another angel ... one I might call *Angelus Benjaminianus* ...

BENJAMIN: Good God. I have never seen that one before!

SCHÖNBERG: I was sure none of you had. But this one does do justice to your labored interpretation. Notice how as you say, "His eyes are wide ... his wings are spread." But these wings are really spread and come from another Angel by Klee, which he also created in 1920.

3.10. Carl Djerassi and Gabriele Seethaler, *Angelus Benjaminianus.*

Below left to right

3.11. Paul Klee, *A Spirit Serves a Little Breakfast, Angel Brings What Is Desired,* 1920.

3.12. Paul Klee, *Ruins of the Barbarian Temple,* 1934.

But then you also wrote, "His face is turned toward the past," and neither the *Angelus Novus* nor this *Angelus Benjaminianus* really does turn, so we shall have to do something about that. And when you write that some event "keeps piling wreckage upon wreckage and hurls it at his feet," there really is wreckage in this *Angelus Benjaminianus*, whereas I see none in your *Angelus Novus*. In fact *this* pile of debris before him does indeed grow toward the sky as you claim.

SCHOLEM: But where did you find this Klee?

SCHÖNBERG: Before I tell you, let me make one last point . . . really Klee's point if he were here. For instance, Klee really knew about wreckage. In this drawing . . . all you see is wreckage . . . and of a barbarian's temple at that, which I'd consider rather apt for your sense of history. But to continue: you have made no real selection . . . you picked one angel out of one . . . rather than out of fifty . . . or fifty-three, to be precise . . . and converted him into a fetish. Klee himself had a private code to indicate which work he preferred. He marked it S Cl . . . "Special Class." Only 341 of all of his thousands of works were so anointed. Your *Angelus Novus* is not among them.

BENJAMIN, ADORNO, and SCHOLEM: So which angel was?

SCHÖNBERG: Will you be surprised if I tell you *none* . . . and that maybe, for your *Angelus Novus*, he didn't even care if he was a true angel?

SCHOLEM: I repeat. Where did you find that Klee you just showed us?

SCHÖNBERG: I didn't find it . . . since it does not exist . . . beyond the imagination of the historian, Walter Benjamin. Just call it "Variations on Themes of Paul Klee" by Arnold Schönberg. Remember, I am also a painter. Do you want to see some more? With a threatening or open mouth and staring eyes . . . but now also a turned head . . . surrounded by wreckage . . . just as you imagined it, but as Klee had never drawn it?

BENJAMIN: There are more?

SCHOLEM: There can't be more!

ADORNO: I have a feeling you two don't know the maestro.

SCHÖNBERG: Herr Wiesengrund is correct. How about this one? (3.13.)
Or this one? (3.14.)

SCHOLEM: Stop!

SCHÖNBERG: You, who are steeped in the Talmud, ask me to stop? You, who claims that angels appear in droves . . . one after another . . . only to then disappear? I insist you look at this one. (3.15.)
And this (3.16)
(*almost hysterically*) or this . . . (3.17)

BENJAMIN (*pleading*): Please! I beg you to stop. I am starting to see faces.

ADORNO (*to Schönberg*): He is right. You have destroyed an illusion. Don't overdo it. (3.18.)

BENJAMIN: Good God!

SCHOLEM: And why is my face there?

SCHÖNBERG: Homage to *your* Talmudic interpretation of angelhood: multitude and ephemeral character.

ADORNO: Maestro, forgive my comment, but you have gone too far.

SCHÖNBERG (*slightly irritated*): Why do you keep calling me maestro? You never did that in Vienna.

ADORNO: Then I was twenty-two ... and intimidated.

SCHÖNBERG: You, intimidated? Impossible.

ADORNO: Of you ... not of others. And my *Meister* was Alban Berg ... not you. I came to *him* to study composition.

SCHÖNBERG: And who was Berg's *Meister*?

ADORNO: I can't call you *Grossmeister* ... it's too Wagnerian. Here on Parnassus maestro suits you. Besides it's more melodic.

SCHÖNBERG (*pacified*): Considering the beating I received down there about the perceived lack of melody in my work ... I shall consider this a compliment rather than flattery. Especially from you, who hardly ever paid me one before.

ADORNO: I'm making up for it now.

SCHÖNBERG: Are you? Rather than commenting on my *Angelus* variations ... on Schönberg, the painter ... you say I've gone too far. How does art ever go too far?

ADORNO: Because, in the process, you demeaned Klee's work... the *Angelus Novus*. Art can attack ... contradict ... even flatter! But it should not demean or it crosses the line into caricature.

SCHÖNBERG: If I demeaned this Klee, it was only in the sense that it had little to do with Herr Benjamin's ideas. In other words, it was Benjamin's fault ... not Klee's.

BENJAMIN: And what do *you* think Klee had in mind when he drew this angel and called it *Angelus Novus*?

SCHÖNBERG: A fair question ... and one to which I gave some thought ever since I learned of your obsession with this work. Do you happen to know where Klee painted it?

BENJAMIN: Munich?

SCHÖNBERG: Exactly! And what other painters might he have encountered in Munich?

BENJAMIN (*dismissive*): All the Blaue Reiter, of course. Kandinsky . . . Franz Marc . . . Gabriele Münter . . .

SCHÖNBERG (*impatient*): Of course . . . and Alfred Kubin . . . and Jawlensky . . . and so on and so forth. We all know their major exhibition in Munich. I was there . . .

BENJAMIN: What has your being at that exhibition got to do—

SCHÖNBERG (*irritated*): I wasn't just *at* that exhibition . . . I was *in* it! As a painter . . . not as spectator! But what other painters were in Munich around that time? Minor ones, very minor ones. In 1920!

BENJAMIN: How would I know? Ask Scholem. He was living there then.

SCHÖNBERG: A very minor one . . . who later became notorious . . . actually infamous.

BENJAMIN: No idea.

SCHÖNBERG: Just think about it for a moment. Very minor . . . and then infamous throughout the world.

SCHOLEM (*startled*): You don't mean . . . ?

SCHÖNBERG: Precisely!

BENJAMIN: Who are you talking about?

ADORNO: I think he means Adolf Hitler.

BENJAMIN: Hitler?

SCHÖNBERG (*nodding*): Adolf Hitler. And what did he use to wear all the time?

SCHOLEM: A trench coat.

SCHÖNBERG: Exactly—like this miserable one—when he still tried to support himself as a small-time painter of street scenes while fantasizing about becoming an architect. And now compare Hitler, arms raised, in that trench coat with Klee's *Angelus Novus.* Even the way their feet resemble each other.

BENJAMIN: Preposterous! Why would Klee have picked Hitler for this wonderful drawing?

SCHÖNBERG: You are now switching to art ... whereas I'm focusing on psychological verisimilitude ... even metaphoric interpretation. If you permit yourself that luxury in your essay on history, why not extend that same privilege to me? You fell in love with your *Angelus Novus* ... you wrote about him in the 1930s and again in 1940. You could not depart from your romantic infatuation with this drawing—

SCHOLEM: Never mind! What about Klee's vision?

SCHÖNBERG: He was the cynic realist ... the visionary... who may well have encountered Hitler ... still the disappointed, unsuccessful painter, but already ranting. Remember, it was late 1919 and 1920 when Hitler had just turned into a full-time political agitator and haranguer on the Munich beer hall fringes. Could Klee not have used *angelus* in the Hebrew sense of "messenger" and *novus* in the bitter fearful way as the new messenger of the Germany to come—the equivalent of the Roman *homo novus*—the parvenu? Not so long ago, a scholar even called the image "a caricature of a priest pretending to be a hobo."

3.21. Paul Klee, *detail of Bird Comedy, 1918.*

SCHOLEM: Do you have any proof for this wild hypothesis?

SCHÖNBERG: Not any more ... or any less than Herr Benjamin for his wild view of the angel of history ... and hardly a more plausible one than the Hitler likeness I just put forth. It's not as if Klee had never drawn any images looking like Hitler. Just look at these two: Even the title of the second ... *Demonry* ... tells you what Klee saw in that face.

ADORNO: It's an intriguing ... as well as revolting idea.

SCHOLEM: I'm tempted to look for him. After all, he's up here on Parnassus.

ADORNO: And confront Klee with the question whether Hitler inspired him to create this devilish angel? Not a bad idea.

3.22. Paul Klee, *detail of Demonry, 1925.*

SCHÖNBERG: But hardly necessary. Klee was not the only artist who recognized what Hitler was all about that early on. Take Otto Dix, who only a couple years later drew Hitler as a pimp. Just take a look.

ADORNO: I take your point.

BENJAMIN: What point?

SCHÖNBERG: That there are times when artists are more prescient than politicians.

SCHOLEM: But Walter is standing before us. Do you think Walter would have written his famous essay if he had not been inspired by his Klee?

SCHÖNBERG: I would have said *enamored* rather than *inspired*. But you should ask him.

3.23. Otto Dix, *detail of Pimp and Girl, 1923.*

BENJAMIN: You are asking an unanswerable question. The experiment cannot be repeated.

ADORNO: In that case, let me rescue the reputation of Klee's *Angelus Novus* through music, rather than leave it tainted by this Hitlerian interpretation.

SCHÖNBERG (*laughing*): I can hardly wait.

ADORNO: You, for one, never wrote any music on Klee's work.

SCHÖNBERG: Why should I have? I never cared for his style. Too playful. And he certainly had no use for twelve-tone music: "too contrived, too rational, and not sufficiently inspired," he called it. (*Disdainfully.*) Well, he didn't inspire me . . . at least not as a composer.

ADORNO: Lots of other composers were inspired by Klee's works.

SCHÖNBERG: Lots?

ADORNO: Several hundred.

SCHÖNBERG: Impossible!

ADORNO: More than 330 composers producing over 500 compositions! If you don't consider this inspiration, then I don't understand the meaning of the word.

SCHÖNBERG: Over five hundred compositions . . . all based on Klee?

ADORNO: A minimal estimate, since several of them didn't deal with just one but several works of Klee in one composition. Gunther Schuller based his on seven works, Douglas Young on twelve, and the Argentine Roberto Garcia Morillo had a single one based on no less than twenty-one works of Klee! If you add up all the individual Klees that inspired musicians, you'll exceed eight hundred.

SCHÖNBERG (*taken aback*): What?

ADORNO: I said eight hundred.

SCHÖNBERG: I knew you were a musicologist . . . but aren't you carrying this to quantitative extremes?

ADORNO: A habit I acquired only up here . . . when I started to wonder whether quantity was at times more important than quality to bring one to Parnassus.

SCHOLEM: Long before the Kabbalah, I started as a mathematician, and my interest in numbers never left me. So I also looked into the quantitative aspects of admission to Parnassus. That's when I came across Google—a mechanical device for counting unfiltered tidbits under a person's name—

SCHÖNBERG: Unfiltered tidbits? A euphemism for garbage.

SCHOLEM: Perhaps. But don't they say that "no publicity is bad publicity?" Guess what I found: 1,230,000 entries for Walter compared to 138,000 for me!?! They can't all be garbage.

ADORNO (*curious*): And where did I come in?

SCHOLEM: Better than me, but still much worse than Walter.

ADORNO: The number! What was the number?

SCHOLEM: 373,000.

SCHÖNBERG: Did you look me up?

SCHOLEM: No.

SCHÖNBERG (*irritated*): I see. So 330 or more composers creating 500... or is it 800... musical pieces (*derisively draws quotation marks in the air*) "inspired" by Klee's drawings or paintings or sketches or whatever proves what?

ADORNO: It's certainly a world record for any visual artist.

BENJAMIN: And who is number 2 in this musical derby?

ADORNO: Aha! So you're also becoming interested in numbers... now that you are shown to be the champion among us.

BENJAMIN: You started this, not I. But yes... I'm curious.

ADORNO: Picasso... with nearly two hundred compositions.

SCHOLEM (*shakes his head*): Theodor Adorno... collector of so many useless facts.

ADORNO: This is useless?

BENJAMIN: Neither useless nor useful. But interesting. So who *is* number 3?

ADORNO: Any guesses?

SCHOLEM: Chagall?

SCHÖNBERG: Chagall was my witness in Paris when I reconverted to Judaism. He would have told me.

ADORNO: You're all in the wrong century.

SCHÖNBERG: Strange... I, a composer who is also a painter, was never stimulated to write music about a painting. Poetry? Yes... like so many others. But paintings? So who is number 3?

ADORNO (*somewhat braggingly*): Hieronymus Bosch... many inspired by his *Garden of Earthly Delights*. With around 150 musical works.

SCHÖNBERG: What exactly got us to pursue this silly topic?

BENJAMIN: Your question whether it was really Klee's *Angelus Novus* that caused me to write my theses on the philosophy of history.

ADORNO: So let us finish with a quantitative musical analysis of the *Angelus Novus*.

SCHÖNBERG: You mean count the composers inspired by *that* specific Klee? I suspect that the fingers of one amputated hand will suffice.

ADORNO: That was nasty … and also dead wrong. So far, I have located thirteen composers.

SCHÖNBERG: More than a dozen composers inspired by the *Angelus Novus* to serenade him with their musical homage? Are you pulling my leg?

ADORNO (*ironically*): Maestro Schönberg! I wouldn't dare.

SCHÖNBERG: In that case, prove it.

ADORNO: Martin Bresnick … Vinko Globokar … Matteo d'Amico … Alex Nowitz … Erik Weiner—

SCHÖNBERG: Stop! I've never heard of any of them.

ADORNO: You asked for the names of composers … not friends of yours. Besides, they came after your death.

SCHÖNBERG: Then let me hear some of that angelic music.

ADORNO: You mean all thirteen?

SCHÖNBERG: Three will do.

ADORNO: All right. Let's start with this.

Play about one minute from the beginning of Claus-Steffen Mahnkopf's Angelus Novus.[5]

SCHÖNBERG (*interrupts*): This sounds almost Schönbergian! Who wrote that?

ADORNO: Claus-Steffen Mahnkopf. He called his *Angelus Novus* a "music theater" based on Walter's interpretation of Klee's *Angelus Novus*.

3.24. Score of the beginning of Claus-Steffen Mahnkopf's *Angelus Novus*, a "music theater" based on Walter Benjamin's interpretation of Klee's *Angelus Novus*, together with a portrait of Claus-Steffen Mahnkopf.

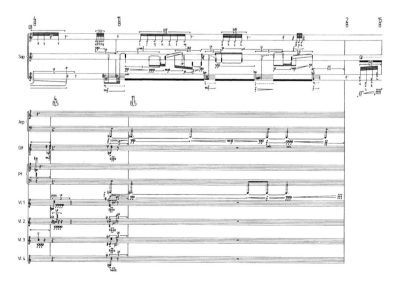

SCHÖNBERG (*laughs*): This music certainly passed muster, but I wager he never even saw the image. At best, I'd call it music inspired by Walter Benjamin ... not by Klee.

BENJAMIN (*sarcastic*): Thank you for the compliment.

SCHÖNBERG: I repeat: I didn't criticize your writing ... only its inapplicability to the drawing. (*Turns to Adorno.*) Anything else you can offer us?

ADORNO: How about a solo trombone piece from Japan, composed by Hiroshi Nakamura?

Start from the beginning of Hiroshi Nakamura's Angelus Novus *for solo trombone where for the first twenty seconds only a single note is played.*

SCHÖNBERG: You mean there's only one note? (*Laughs.*) Isn't that carrying simplicity too far?

ADORNO: You're too impatient. Just wait.

Continue the music for another thirty seconds until it turns more complicated.

SCHÖNBERG: And who was that?

ADORNO: Barrie Webb ... the English trombonist.

3.25. Score of the first twenty seconds of Hiroshi Nakamura's *Angelus Novus* for solo trombone, together with a portrait of Hiroshi Nakamura.

3.26. Part of the score of Hiroshi Nakamura's *Angelus Novus* for solo trombone, together with a portrait of Barrie Webb.

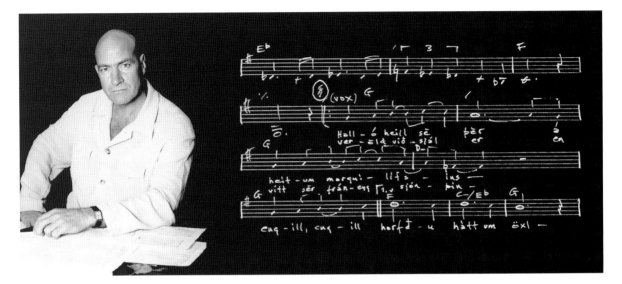

3.27. Score from the beginning of the vocal section of Egill Ólafsson's *Angelus Novus*, together with a portrait of Egill Ólafsson.

SCHÖNBERG: This is becoming interesting.

ADORNO: And now let's move to Iceland to show you how far our *Angelus*'s musical inspiration has reached.

Play about one minute from the beginning of the vocal portion of Egill Ólafsson's "Angelus Novus."[6]

SCHÖNBERG *(surprised)*: What on earth is this?

ADORNO: An Icelandic pop song by Egill Ólafsson.

SCHÖNBERG: What is a pop song?

ADORNO: Call it post-Schönbergian Lieder style.

ADORNO: But since you are interested in new musical genres, let me offer you one more that will really surprise you. Written in what, in the beginning of the twenty-first century, has become the second most popular form of music in America.

Play Erik Weiner's "Angelus Novus Rap of 2006."

There is a painting by Klee called Angelus Novus
And Benjamin interprets it and he supposes
That the angel moves away from what he sees ahead
Eyes wide, mouth open, and his wings are spread

This is how the angel of history must look
After war has been waged or the Earth has shook
When a series of events result in tragedy
The angel sees only one catastrophe
And feels responsible for all the bloodshed
And he'd like to stay, to awaken the dead
And make everything whole and make everything nice
But a cold storm is blowing from Paradise
And the wind in his wings is so strong he can't close them
Away from the horror, the angel's been chosen
To head to the future, more tasks to perform
And what we call progress—that is this storm
The wings of the angel and this chapter closes
"There is a painting by Klee called Angelus Novus."

3.28. Text of Erik Weiner's *Angelus Novus* rap, together with a portrait of Erik Weiner: www.erikweiner.com.

BENJAMIN: Whose words are these?

SCHÖNBERG: First … what kind of music is this?

SCHOLEM: Whose voice is that?

ADORNO: Erik Weiner's. He's the composer and artist. It's called a rap … or, more precisely, hip-hop rap and was commissioned by none other than yours truly!

SCHÖNBERG (*ironic*): And which Professor Adorno will now define for us.

ADORNO (*laughs*): Since you're urging me, why not? It's a lyrical form that doesn't just make use of rhyme but also of alliteration and assonance … and, of course, lots of percussion.

SCHÖNBERG: And you're claiming that rap is now the second most popular music style in America? What's the most popular? Jazz?

ADORNO: Rock. Jazz in contemporary America has fallen below classical music.

SCHÖNBERG: I'm relieved to hear that! Does that include my music?

ADORNO: Why not? If assonance works in rap, why not dissonance in Schön-bergian classical music?

BENJAMIN (*to Schönberg*): In that case, why don't *you* compose an ode to the *Angelus*?

SCHÖNBERG: Odes are too deferential. The first and last one I ever wrote was to Napoleon, but certainly not to celebrate him. But composing something on an angel theme? In 1912 I started on what I thought would be a major religious work, *Die Jakobsleiter*—the ladder from humanity to

God and back. I even have one angel in it . . . Gabriel, who is guarding the ladder.

They listen to twenty seconds of the first section of Die Jakobsleiter *where Gabriel's voice is first heard: "Ob rechts, ob links, vorwärts oder rückwärts . . . man hat weiterzugehen, ohne zu fragen, was vor oder hinter einem liegt." Whether right or left, forward or backward . . . one must continue without questioning what lies ahead or behind.*

ADORNO: Shall I tell them how you started?

SCHÖNBERG: Go ahead . . . your colleagues might as well learn about the travails of some composers.

ADORNO: In 1914 the maestro envisaged a work with a chorus of 2,000 and an orchestra of 270—

SCHÖNBERG (*laughing*): You forgot the 6 soloists.

ADORNO: I was about to mention them. Three years later, he reduced the chorus to a mere 1,000—

SCHÖNBERG: Whereupon the war broke out and I was drafted into the Austrian army.

BENJAMIN: That was tough luck. You should have seen to what extremes I went not to be drafted—

SCHOLEM: I went even further. I faked mental illness after two months in the army until they dismissed me. My father was so humiliated he never forgave me.

SCHÖNBERG: At that time, I would probably have been on your father's side—

SCHOLEM: But now?

SCHÖNBERG: On yours. But do you realize I intended to have angels of the Swedenborg variety appear in my *Jakobsleiter* . . . at least in the chorus?

ADORNO: We're now talking about 1921, by which time the projected chorus had shrunk to 360 and the orchestra to 138.

SCHÖNBERG: Thirty years later it was reduced to triple woodwinds and a chorus of 32. (*Bitter laugh.*) No wonder I died the following year.

SCHOLEM: But what attracted you to Emanuel Swedenborg . . . that eighteenth-century corruptor of the Kabbalah?

SCHÖNBERG: His angels . . . as creations of humans who had passed through the three stages of love: self-love, then love of the world, and finally love of God.

SCHOLEM (*sarcastic*): I wonder whether my friends here are aware that, for Swedenborg, the highest form of self-love was that of the genius.

Ergo . . . there would seem to be plenty of self-love here on Parnassus. (*To Schönberg.*) I apologize for interrupting, but Swedenborg cannot be left to go unchallenged.

SCHÖNBERG: I shouldn't have brought him up. But since you three have now gotten me to think about angels—

SCHOLEM: You mean argue about angels!

SCHÖNBERG: With me, *think* and *argue* are often same. Of course, I could come up with some proper music . . .

BENJAMIN: And compose it here?

SCHÖNBERG (*laughs*): I could be tempted . . . provided it's about one of *my* angels I just showed you. Of course, not an ode.

ADORNO: The rules, Herr Schönberg! The rules! Once up here, nothing new can be created. It's too late.

SCHOLEM: If Paul Klee had listened to these duels (*points to Schönberg and Adorno*) he probably would have said that he had already drawn you two. At least the title fits you: *Two Men Meet, Each Supposing the Other to Be of Higher Rank.*

3.29. Paul Klee, *Two Men Meet, Each Supposing the Other to Be of Higher Rank (invention 6), 1903.*

ADORNO: Touché!

SCHÖNBERG: Nonsense!

END OF SCENE 3

4. FOUR JEWS

A s is already clear from the title of my book, Jewish identity is the key theme. In this chapter I address the nuanced question of what it means to be a Jew in the nonreligious sense: to the non-Jewish outsider and, even more important, to the specific Jew under the magnifying glass, where Jewish identity can range from proud acknowledgment or tacit admission to devious denial. The topic is debated from the viewpoints of four very verbal and very different Jews, as well as that of a fifth silent "Jew." In many respects, it is the meaning of the quotation marks around that last word that forms the crux of their arguments.

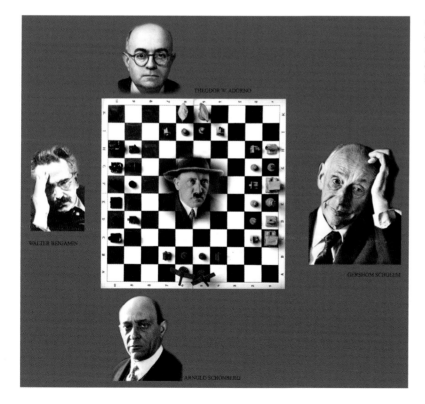

4.1. Gabriele Seethaler, *Gershom Scholem, Arnold Schönberg, Walter Benjamin, and Theodor W. Adorno Around Arnold Schönberg's Coalition Chess, with Adolf Hitler*.

It now also becomes clear why I chose these four men to illuminate the issue of Jewish identity in the absence of a common religious label: Theodor W. Adorno as the prototypical German Jewish non-Jew; Walter Benjamin as a complicated, vacillating German Jew or Jewish German; Gershom Scholem as the committed German Zionist Jew; and Arnold Schönberg as the Austrian Jew, converting to Protestantism for whatever reasons, who returned to Judaism when he recognized the futility of such all-too-common conversions. And finally a category of Jew that arose especially around the turn of the last century, the central European non-Jewish Jew, of which Paul Klee represents the example par excellence. Discussing him in this context is especially fruitful after having covered in such detail his famous *Angelus Novus* in the preceding chapter.

There is, of course, another overriding presence, namely, that of Carl Djerassi. As I already stated in the book's foreword, I belong to the same subset of secular, middle-class Austrian and German Jews of the pre–World War II generation as my four protagonists. After my immigration to the U.S. at age sixteen as a fugitive from Nazi Austria, I was totally focused on assimilation. Flaunting or even hinting at my Jewish origin was far from my mind—not unlike Adorno upon his arrival in the U.S. Decades passed before I, the typically nonreflective, workaholic scientist, acquired a taste for introspection. With it arose questions about Jewish identity that I am attempting to answer in this chapter through the putative words of Adorno, Benjamin, Scholem, and Schönberg. Thus, while the biographical facts attributed to them are rigorously documented, what they say and how they say it had to pass through the fine mesh of my own psychic filter.

There is one topic in this discussion of secular Jews from Vienna, Berlin, and Frankfurt of the earlier half of the twentieth century that cannot be swept under the rug, namely, their dislike of the *Ostjuden,* the Yiddish-speaking and mostly also religious Jews who had come from Poland and Russia. It is too complicated a topic to discuss fairly within the confines of my rather narrow biographical sketches of Adorno, Benjamin, Scholem, and Schönberg, but I flag it at the conclusion of the book with the appearance of Hannah Arendt, who was equally guilty of this intra-Jewish prejudice.

Benjamin and Scholem enter together, each bearing a stool. They start sitting down next to each other.

BENJAMIN: I'm glad you didn't walk out on us. There is so much more to talk about.

SCHOLEM: We never broke off our correspondence down there. So why wouldn't I resume a conversation up here on Parnassus? Besides, we have plenty of time.

BENJAMIN: Thanks. What about the others?

SCHOLEM: I don't know about Schönberg, but Teddie Wiesengrund certainly will show up.

Adorno enters, carrying his stool.

BENJAMIN: Ah! Here you are. Sit next to me.

ADORNO: Across from you is better. I prefer eye contact … something you used to avoid.

SCHOLEM: It's too late to do anything about that. I remember when I saw Walter pontificating before some fellow students … he in his early twenties and I still in my teens. It was an astounding talk … yet he only addressed a spot near the right corner of the ceiling. I could never catch his eye.

BENJAMIN: I do look at women when I speak to them.

ADORNO: You do even better when you write to them. Just ask my wife.

BENJAMIN: I would prefer to discuss something else. (*Looks at his watch.*) You think Schönberg will join us?

ADORNO: He promised … (*to Benjamin*) he's curious about you.

Schönberg enters carrying a stool. Adorno points to the unoccupied side of Benjamin.

SCHÖNBERG (*to Adorno*): Would *you* mind sitting there? I'd like to face Herr Benjamin.

Adorno shrugs, moving his stool next to Benjamin, while Schönberg occupies his former space.

SCHÖNBERG: Have I missed anything interesting?

ADORNO: Not yet. But at least the *Angelus Novus* is one topic we exhausted.

BENJAMIN: *We* may be exhausted, but I don't think my *Angelus Novus* is.

SCHÖNBERG: You still persist in calling him *my*? I know you owned the drawing, but surely not the meaning of the image.

SCHOLEM: I suggest we set Klee's picture aside—

SCHÖNBERG: Including my interpretation?

SCHOLEM: All of it. Instead, let's address a more pertinent issue: Why should four Jews be so preoccupied with an angel? Of course, angels started in the Old Testament, but by now the goyim have taken them over. The man in the street would call it a Christian topic.

ADORNO: So what is it you want to address? Angels in general? Frankly, I've had it up to here (*raises one hand to his nose*) with them.

SCHOLEM: I'm surprised that you of all people didn't catch my point.

ADORNO: Which was?

SCHOLEM: I said "four *Jews*." But just looking around these few square meters (*waves hand around the space*), "Jew" clearly doesn't refer only to religion. Let's start with something we all have in common: none of us follows all 613 biblical commandments ... one definition of an Orthodox Jew.

BENJAMIN: I didn't even know there were 613.

ADORNO: Neither did I. But I'm sure that all of us have violated some. For instance, working from time to time on a Saturday.

SCHOLEM: Rabbinical law defines 39 kinds of work with 39 subcategories—some even tolerated on a Sabbath.

ADORNO: My work is writing—

BENJAMIN: Of which there are clearly more than 39 categories.

SCHOLEM: We better stop or you'll all prove me wrong ... debating like Talmudic scholars. Not only are there no Orthodox Jews here—

ADORNO: With a Catholic mother, they wouldn't consider me a Jew at all.

SCHOLEM: Correct. And none of us follows kosher dietary laws.

ADORNO: So?

SCHOLEM: So, let's not debate about the 613 commandments and 39 categories. Let's get to something more basic: When does a Jew look like a Jew?

ADORNO: Other than in terms of clichés, this question has no operational meaning. I learned this the hard way. Back in 1945 I proposed to Max Horkheimer that we collect photographs of leading anti-Semites with emphasis on their most repulsive or ludicrous features and then publish them in a booklet, linking their facial characteristics with those of certain types of criminals or lunatics.

SCHOLEM: What happened?

ADORNO: Nothing. It was naive of me to suggest that we could discern racial characteristics of anti-Semites. I hardly ever quote Jean-Paul Sartre approvingly, but it's worth remembering that he thought a Jew was a mosaic in which each element is a pebble that we can take out and place in another pattern ... that a Jew is not an indivisible totality. But that's also true of anti-Semites.

SCHOLEM (*ironic*): You don't say! Let's just see what we can do with such Jewish pebbles. When Adrienne Monnier ... much too sophisticated a

French writer to spout clichés... first met Walter in Paris in 1930, she claimed that he was the first German Jew she had ever confronted.

ADORNO: And then proceeded to describe him?

SCHOLEM: Exactly. To her, Walter was "a Jew because of his intelligent face where cunning and cleverness can be discerned, together with a curious mixture of shyness and good-naturedness."

BENJAMIN (*laughing*): Those may not be clichés... but they certainly don't answer your question about when a Jew looks like a Jew.

SCHOLEM: You are taking the word *look* too literally. But instead of citing a French writer who had never met a German Jew before, here is what a German Jew... specifically Moritz Goldstein... had to say when asked the question whether Jews could be picked out on account of their physical appearance. According to him, when a gang of Berlin Nazis set out to beat up all Jews on Kurfürstendamm during Yom Kippur of 1932, quite a few of their victims were "Aryans" who seemed to look Jewish, whereas a lot of Jews were left unmolested because they looked "Aryan." But let's consider us four... at a Nazi police lineup. Here... you three... just stand against the wall. (*Seeing them hesitate.*) Come on... just humor me.

(*With dismissive shrugs, Benjamin, Schönberg, and Adorno stand next to each other against a wall.*)

(*Addressing Benjamin*) Walter, what is your most distinguished trait?

BENJAMIN (*pats his stomach*): I've gained a lot of weight.

ADORNO (*laughing while patting his stomach*): Middle-aged spread is hardly a Jewish characteristic. Just think of Goering's massive waist. Better think of something else.

BENJAMIN: Clearly my moustache. Most people have never seen me without one.

SCHOLEM: Forget about it. What Nazi can object to a moustache?

BENJAMIN: My thick glasses.

SCHOLEM: Take them off.

BENJAMIN (*taking off his glasses*): I guess my eyes.

SCHOLEM: Now listen to how Adrienne Monnier described you: "The eyes were hidden behind his glasses and even more so behind his lids, which barely permitted his piercing look to penetrate. His mouth was almost hidden by a thick moustache with drooping ends; what one saw of his mouth were not too fleshy lips, typical of a sensitive epicurean. Benjamin would have looked much more Jewish if he had worn a beard, even though his eagle nose was not highly developed."

(*Turns to Adorno.*) So there you are. Now what about you, Teddie?

4.2. Walter Benjamin.

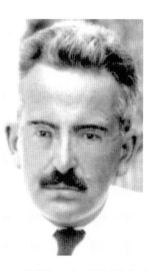

4.3. Carl Djerassi and Gabriele Seethaler, *Walter Benjamin Without Glasses.*

4.4. Theodor W. Adorno.

4.5. Arnold Schönberg.

4.6. Theodor W. Adorno and
Arnold Schönberg.

ADORNO: Most women would say it's my eyes. At least, that's what they said when I was young... when I still had some hair.

BENJAMIN: Most men would agree about your eyes.

ADORNO: Or my mouth.

BENJAMIN: Only in terms of what came out of it. Otherwise I'd call it unremarkable.

ADORNO (*laughing*): Modesty restrains me from quoting what some women had to say about my mouth.

BENJAMIN: You are talking about taste, whereas I am referring to appearance.

SCHÖNBERG (*interrupts*): When it comes to appearance, I would say it's now your bald head.

ADORNO: Naturally *you* would say that. But I'm sure there were plenty of bald Nazis. Have you noticed my flat feet?

SCHÖNBERG: I had not. But flat feet... Jewish? It's always the face. Besides, just think of Goebbels and his clubfoot.

ADORNO: Goebbels? He disproves every possible generalization about Aryan appearance. Articles... even chapters have been written about the Jewish foot. Sigmund Freud, in his work on fetishism, considers the foot a substitute for the penis.

SCHOLEM (*guffaws*): Before the conversation turns to circumcised feet... (*Turns to Schönberg.*) What about you, Herr Schönberg?

SCHÖNBERG: No hair... but strongly focused eyes... same features as Wiesengrund.

ADORNO: My face is rounder! More like a teddy bear.

SCHÖNBERG: Nobody ever called me a teddy bear. Just compare my mouth and jaw with yours!

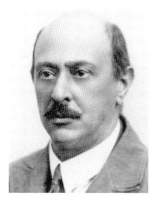
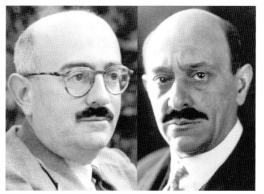

SCHOLEM: For a lark, how about trying on Walter's moustache?

SCHÖNBERG: A bad idea. I once grew one when I was in my fifties, but my wife hated it. Frankly, as usual she was right.

SCHOLEM: Just for a lark ... please!

SCHÖNBERG: All right.

ADORNO: And you call that an improvement?

SCHOLEM: My aim was not improvement. But tell me, why don't any of you mention your nose?

Adorno, Benjamin, and Schönberg touch their noses.

BENJAMIN: Nothing special. Remember what you had Monnier say about my nose: "his eagle nose was not highly developed."

ADORNO: Nor is mine.

SCHÖNBERG (*keeps feeling his nose*): I suppose mine is more developed. (*Laughs.*) On a Jew, it's called a crooked nose ... but on an eagle? There it's so sanitized that he became the Austrian and German coat of arms!

SCHOLEM: Aha! Now we're getting somewhere!

SCHÖNBERG (*steps forward and moves Scholem into his previous spot in the lineup so that now Schönberg faces the three men*): Let's take you, Herr Scholem. What about you?

SCHOLEM: My nose? (*Touches it.*) I suppose somewhat Semitically eagle shaped.

SCHÖNBERG (*laughs*): In your case, the ears trump the nose.

ADORNO: Careful! You know what Hannah Arendt had to say on that topic? "Scholem is so self-preoccupied that he has no eyes and not only that: no ears!"

SCHÖNBERG: Why would she say that?

SCHOLEM: Wait! Why bring up Arendt?

ADORNO (*laughing*): To provoke you. (*To Schönberg.*) She wrote: "Scholem thinks the midpoint of the world is Israel; the midpoint of Israel is Jerusalem; the midpoint of Jerusalem is the university and the midpoint of the university is Scholem. And the worst of it is that he really believes that the world has a central point." In other words, for such self-preoccupation you need neither eyes nor ears.

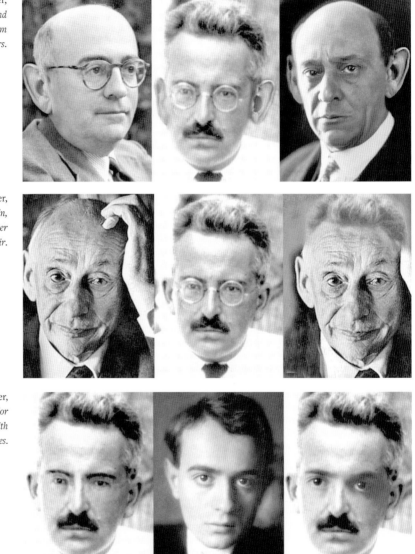

4.11. Carl Djerassi and Gabriele Seethaler, *Theodor W. Adorno, Walter Benjamin, and Arnold Schönberg, Each with Gershom Scholem's Ears.*

4.12. Carl Djerassi and Gabriele Seethaler, *Gershom Scholem, Walter Benjamin, and Gershom Scholem with Walter Benjamin's Hair.*

4.13. Carl Djerassi and Gabriele Seethaler, *Walter Benjamin Without Glasses, Theodor W. Adorno, and Walter Benjamin with Theodor W. Adorno's Eyes.*

SCHOLEM: I shall pretend I never heard this. (*To Schönberg.*) You were referring to my ears. Was it their size?

SCHÖNBERG: Yours are not only huge, but their angle! They really stick out.

SCHOLEM: And that makes me a Jew?

SCHÖNBERG: No . . . its sui generis. Just imagine if we three had your ears.

SCHOLEM: Let's see whether we can assemble a "Jewish" look with the raw material at hand. For instance, how about borrowing *your* (*points to Benjamin*) hair for *my* face?

BENJAMIN: I'm beginning to see Gerhard, the entertainer, turning into Gershom, the manipulator.

SCHOLEM (*smiling*): Well?

BENJAMIN (*laughing*): Gerhard . . . you certainly look improved, but I don't know about me.

SCHOLEM: I told you, I'm not out for improvements . . . I've something else in mind. (*To Benjamin.*) Suppose we gave you Teddie's most distinctive trait . . . his eyes . . .

ADORNO (*laughing*): A definite improvement . . . for both of us!

SCHÖNBERG: I suppose I am next in line.

SCHOLEM: Of course. (*They exchange positions.*) But why not adorn you with Teddie's eyes as well as my ears?

SCHÖNBERG: In that case, why not also borrow some hair from Benjamin?

SCHOLEM: I shall lend you his moustache.

SCHÖNBERG: I don't like it . . . I want his hair.

SCHOLEM: Impossible! Since three of us are bald, we'll have to cover our collective head. How about this?

BENJAMIN: This is turning sinister.

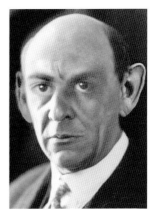

Clockwise from top

4.14. Carl Djerassi and Gabriele Seethaler, *Arnold Schönberg with Theodor W. Adorno's Eyes and Gershom Scholem's Ears.*

4.15. Carl Djerassi and Gabriele Seethaler, *Arnold Schönberg with Theodor W. Adorno's Eyes, Gershom Scholem's Ears, and Walter Benjamin's Moustache.*

4.16. Carl Djerassi and Gabriele Seethaler, *Arnold Schönberg with Theodor W. Adorno's Eyes, Gershom Scholem's Ears, Walter Benjamin's Moustache, and Adolf Hitler's Hat.*

4.17. Adolf Hitler.

ADORNO: Where did you find such a hat up here on Parnassus?

SCHOLEM: The costume shop of the local theater.

ADORNO: Stop joking.

SCHOLEM: Well . . . I certainly didn't get it from the owner. He isn't up here. Just take a look (fig. 4.17).

And now compare him with our hatted composite (4.18).

And then imagine if Walter had trimmed his moustache a bit and our maestro Schönberg had tightened his mouth (4.19).

SCHÖNBERG: Why are you doing this? A mad kabbalistic vision of the golem?

SCHOLEM: Not *the* golem . . . but perhaps *a* golem . . . with one more touch: a cap rather than a hat (4.20).

SCHÖNBERG: Your point?

(*After pause, with raised voice after Scholem does not answer.*)

I said, what is your point? That we all look a bit like Hitler? It's obscene!

BENJAMIN: Obscene and sickening. The image of a Jew in an age of mechanical extermination!

SCHOLEM: No! No! No! It is the absurdity . . . or perhaps obscenity of it all . . . to claim that somebody looks (*draws quotation marks in the air*) "Jewish." (*Pause.*) Instead, why not conclude that every Hitler . . . every ditto anti-Semite . . . has something Jewish in them? He hates that in himself . . . whether in appearance or behavior . . . and by calling it Jewish tries to deflect it from himself.

ADORNO: And thus implying that anti-Semitism will never be eliminated, because self-hate is so powerful an emotion?

SCHOLEM: Exactly!

SCHÖNBERG: Hence meaning that anti-Semitism is inevitable?

ADORNO: Max Horkheimer and I seriously addressed that issue already in the mid 1940's—

SCHOLEM: Wait, wait! This is not to the time or place to replay anti-Semitism dialectics. Let's keep it simple and personal . . . not intellectual. In other words, not typically Jewish! And don't replay the broken record about the impossibility of writing poetry after Auschwitz—

ADORNO: If you are going to quote me, quote me correctly. When I wrote, "After Auschwitz, writing poetry is barbaric," I meant its inadmissibility, not its impossibility. But I soon modified it. "Perennial suffering has as much right to expression as a tortured man has to scream." So don't quote me out of context. Everybody can make mistakes.

SCHOLEM: True. Even the occasionally too impetuous Adorno. But let's face it. These days, anti-Semitic really means anti-Jewish. And before even thinking about changing that cultural abomination, we would first have to question our assumptions.

SCHÖNBERG: Assumptions about what?

SCHOLEM: Is a Jew the same as a Jew in quotation marks? And can that person even choose to remove the quotation marks? I am not referring to

4.18. Carl Djerassi and Gabriele Seethaler, *Adolf Hitler, Arnold Schönberg with Theodor W. Adorno's Eyes, Gershom Scholem's Ears, and Walter Benjamin's Moustache, and the Same Image with Adolf Hitler's Hat.*

4.19. Carl Djerassi and Gabriele Seethaler, *Adolf Hitler, Arnold Schönberg with Theodor W. Adorno's Eyes, Gershom Scholem's Ears, and Walter Benjamin's Moustache (Trimmed), and the Same Image with Adolf Hitler's Hat.*

4.20. Carl Djerassi and Gabriele Seethaler, *Adolf Hitler, Arnold Schönberg with Theodor W. Adorno's Eyes, Gershom Scholem's Ears, and Walter Benjamin's Moustache (Trimmed), and the Same Image with Adolf Hitler's Cap.*

the Nazi terror when the quotation marks became first a yellow star on their clothing and then an indelible mark on their skin, but before. Already in 1832 Ludwig Börne wrote: "Some reproach me with being a Jew, some praise me because of it, some pardon me for it, but all think of it." So what does it mean to be a Jew?

ADORNO: But to whom? The Jew hater or the Jew himself?

SCHÖNBERG: For years Kandinsky and I were friends who corresponded warmly, until I detected an anti-Semitic undercurrent. Here's what I wrote him in 1923: "I finally got it and I'll never forget it, namely, that I'm no German, no European, barely a human being—at least the Europeans prefer the dregs of their compatriots to me—but a Jew. And with that I am satisfied."

ADORNO: I know how you felt ... even a quarter of a century later. When you and Thomas Mann finally made up for that imagined insult you saw in his *Dr. Faustus*—

SCHÖNBERG (*angry*): Imagined? Who's the hero of that novel? Adrian Leverkühn—a mélange of Nietzsche, Hitler, Berlioz, Tchaikovsky, and God knows who else—who composes in some twelve-tone manner. And who, Herr Wiesengrund, advised Mann about twelve-tone music for his golem? Didn't Mann acknowledge your role by calling you his *Wirklicher Geheimer Rat* ... his true secret counsel? To us Viennese, that's very different from the title *Geheimrat* ... a privy councilor.

ADORNO: Maestro! You should be grateful rather than angry. Imagine what musical monstrosities Leverkühn would have committed in that book if I hadn't counseled Mann.

4.21. Excerpt of letter of Arnold Schönberg to Wassily Kandinsky, April 19, 1923.

Arnold Schönberg
Bernhardgasse 6
Mödling bei Wien 19.IV.1923

Denn was ich im letzten Jahre zu lernen gezwungen wurde ,habe
ich nun endlich kapiert und werde es nicht wieder vergessen.
Dass ich nämlich kein Deutscher,kein Europäer,ja vielleicht kaum
ein Mensch bin(wenigstens ziehen die Europäer die schlechtesten
ihrer Rasse mir vor),sondern,dass ich Jude bin.
Ich bin damit zufrieden!

SCHÖNBERG (*still angry*): What you call *counseling*, I called *adorning*.

ADORNO: That is unfair! Mann called me his "helper, counselor, and participating instructor." And he showed me the letter you wrote to him. (*Declaims.*) "For the Germans I am a Jew ... for the Romans I'm German ... for the Communists I'm a bourgeois ... and the Jews are for Hindemith and Stravinsky."

SCHÖNBERG: I should've added, "But Schönberg ... the Jews ignore."

SCHOLEM: Please, both of you! Forget about Schönberg the composer and stay focused on Schönberg the Jew. Why did you write this to Thomas Mann? He was no anti-Semite!

SCHÖNBERG (*calmer*): True. And in retrospect, Kandinsky wasn't one either. He tried to make up by writing to me, "It's no great luck to be a Jew, Russian, German, or European. It's better to be a man. But we should strive to be a superman ... that's the duty of the few."

SCHOLEM: And what was your answer?

SCHÖNBERG: There was nothing to answer. Kandinsky could afford to make that statement, because quotation marks around the words *Russian, German,* or *European* do not exist! But I still saw them around the word *Jew.* Do you know what I wrote later to Alban Berg? "I know perfectly well where I belong. Now I proudly call myself a Jew, even though I recognize the burdens that go with it."

SCHOLEM: In that case, why not start with what the word *Jew* ... but without quotation marks ... means to each of us? But, remember ... in the nonreligious sense! Up here on Parnassus we ought to have a wider perspective.

BENJAMIN: This is a dangerous topic even on Parnassus.

SCHOLEM: Dangerous, but also intriguing. Let's start with Paul Klee. After all, he's been the silent companion of our earlier conversation.

SCHÖNBERG (*surprised*): You mean Klee was Jewish?

ADORNO: Klee doesn't sound Jewish. What was his name before?

SCHOLEM (*laughs*): There you are! You two have already satisfied one criterion of what it means to be Jewish: Not only is a Jew someone who continues to ask himself what it means to be a Jew, but he then always wonders whether the other person is Jewish—and immediately suspects another name behind the current one if that one doesn't sound Jewish.

SCHÖNBERG: So was Klee Jewish or was he not?

SCHOLEM: As early as 1919, when he applied for a position at the Stuttgarter Kunstakademie, he was spurned as Paul Zion Klee. And when the

Nazis dismissed him in 1933 from the Kunstakademie in Düsseldorf, some called him a Galician Jew and others a Swiss Jew.

SCHÖNBERG: But that doesn't make him one. People also called him the Bauhaus Buddha, but that didn't make him a Buddhist.

SCHOLEM: I'm surprised to hear you say that. Our friend Wiesengrund . . . or should I now call him Adorno? . . . was baptized a Catholic at birth. For religious Jews he wasn't even a Jew, since his mother was a Corsican Catholic. Yet, when Hitler came to power, Herr Wiesengrund Adorno left Germany for Oxford and then the U.S. because he couldn't get a teaching job in Frankfurt. For the Nazis he'd become the Jew Wiesengrund. Or what about you, Herr Schönberg? You converted to Protestantism when you were twenty-four.

4.22. Carl Djerassi and Gabriele Seethaler, *Paul Zion Klee* (*Paul Klee's Jewish Symbols from Figures 4.25–4.31 and Nazi Yellow Star Superimposed Upon Paul Klee's Face*).

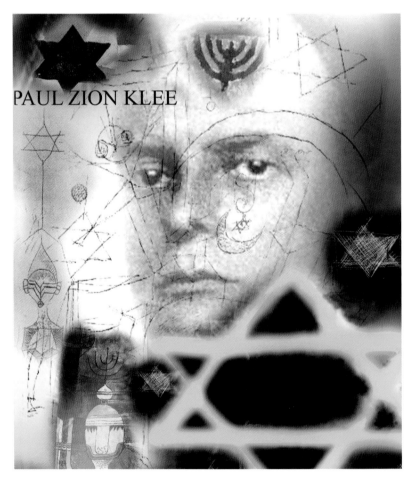

PAUL ZION KLEE

SCHÖNBERG: So?

SCHOLEM: Why? For a better job? Like Gustav Mahler becoming a Catholic in order to serve as opera director in Vienna?

SCHÖNBERG: Conversion is generally based on conviction.

SCHOLEM (*with irony*): But conviction for what? A better life? Your children, born in Austria, were Protestants at birth. But the anti-Semites called all of you Jews, which made you a Jew.

ADORNO (*to Schönberg*): Way back in 1921, when you spent your vacation in Mattsee near Salzburg, weren't you told that Jews were not welcome?

SCHÖNBERG: We left . . . and I never returned. In 1933, before immigrating to California, I reconverted in Paris . . . in the true sense of the word . . . with Chagall as my witness. I found it was not too late to recognize that by restoring my Jewish self-confidence I also restored faith in myself and my creative capacity.

SCHOLEM: It took you thirty-five years to learn that once a Jew, always a Jew. To the true Jew haters neither baptism nor conversion ever counted. . . . And especially not if you don't take the precaution of also changing your name . . . preferably a generation or two earlier.

BENJAMIN: In Germany? Name changes were a pointless exercise . . . at least in our time. About as permanent and effective as a fig leaf.

SCHOLEM: In that case, why did you, my dear Teddy Wiesengrund, change yours?

ADORNO: When I became a naturalized American citizen, I legally sanitized my name to Theodore Adorno.

SCHOLEM: You went to all that trouble?

ADORNO: It was no trouble. Our American immigration cards and photos read Theodore Ludwig Wiesengrund and Margarete Wiesengrund. But on November 26, 1943, when I became an American citizen, I signed my naturalization certificate Theodore Adorno. I even spelled Theodor with an *e* at the end. You can call it American baptism—as easy as sprinkling some holy water on your head. Why did I do that? Because Americans are more gullible . . . or perhaps less intrusive. Name changes upon immigration were often de rigueur . . . and not only among Jews.

BENJAMIN: You just said you "sanitized" your name. Not exactly the word I would use—

ADORNO (*quick*): You're right . . . it was a poor choice . . . Or perhaps also a Freudian slip.

SCHÖNBERG: I never considered changing my name.

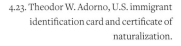

4.23. Theodor W. Adorno, U.S. immigrant identification card and certificate of naturalization.

ADORNO: Because you couldn't. Schönberg was then already more than a name . . . it was a concept. But Theodor Wiesengrund or Theodor Wiesengrund Adorno . . . the name under which I'd started to publish . . . was basically unknown in America. My colleague Horkheimer warned me not to stoke American prejudice against German Jews among some of the East Coast academics by flaunting the name Wiesengrund.

A non-Jewish-sounding one like Adorno was sufficient to pass for a non-Jew.

SCHOLEM: I wonder how your father felt.

ADORNO: It bothered him … and frankly it bothered me, especially when I wanted to add the middle initial *W.* during my naturalization, and somehow even that minute concession didn't go through. One miserable letter! Still, Theodor W. Adorno became my nonlegal authorial signature until my death.

SCHOLEM: A cheap compromise.

BENJAMIN: Don't be so tough, Gerhard. Name changes are an all-too-common stigma among Jews.

SCHOLEM: Surely it's no stigma when a Jew changes his name to emphasize that he is a Jew.

BENJAMIN: Gershom, with you I stand corrected.

ADORNO (*bitter laugh*): But I forgot to change my accent. (*Seriously.*) We all know that it wasn't a matter of forgetting … it was the impossibility of not forgetting German … the language in which I continued to dream.

BENJAMIN: Kafka put it well when he talked about the three impossibilities of confronting us German Jewish writers: "the impossibility of not writing; the impossibility of writing in German; and the impossibility of writing in another language." (*Points to Adorno.*) That was our problem … yours and mine. (*To Schönberg.*) At least composers don't have that problem … or painters.

SCHÖNBERG: You're wrong. Richard Wagner … eventually a virulent anti-Semite … went out of his way to dismiss composers like his former mentor Meyerbeer as Jewish ones … even though in typically hypocritical fashion he didn't mind insisting that Hermann Levi … the son of a rabbi … be the conductor of *Parsifal.* For Wagner, individual creativity was insufficient. The composer also had to be inspired by the tradition of the national group to which he belongs, and he never granted a Jewish composer in Germany … not even Mendelssohn … such national participation. For him, a Jew could not also be a German. Or you should have talked to Alban Berg. His name may have sounded Jewish, even though he was a 100 percent Gentile. Yet to many his music was always degenerate and Jewish. I'm sure his association with me didn't help. You should have heard him complain that, since the Reichstag fire, "not a single note of mine has been heard in Germany although I am not a Jew." You're also wrong about painters. Just take your favorite, Paul Klee.

On following page

4.24. Paul Klee, *detail of Bird Comedy, 1918.*

4.25. Paul Klee, *Angelus descendens, 1918.*

4.26. Paul Klee, *Small Vignette to Egypt, 1918.*

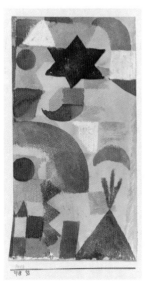

SCHOLEM: He wasn't Jewish. I was only testing you and Wiesengrund.

ADORNO: I think you meant provoking, not just testing. But how do you know he wasn't at least partially Jewish?

SCHOLEM: I was sufficiently curious to do some research. Like all of us here, his letters were published. Just listen to what he wrote to his wife on April 6, 1933 . . . just after Hitler came to power and Klee lost his job in Düsseldorf: "If they demand officially that I prove my Christianity, I'll do it. But I find it unworthy to respond voluntarily to so crude an accusation. Even if it were true that I was a Galician Jew, it would not affect by one iota my worth as a person or my accomplishments. A Jew or a foreigner is not inferior to a German."

BENJAMIN: What a decent man!

SCHÖNBERG: And an interesting example of a non-Jewish Jew . . . the mirror image of some of the Jewish non-Jews that are sitting here.

ADORNO: Maestro . . . since you're looking at me, you better define your terms.

SCHÖNBERG: I meant Jew in the cultural sense. At least for a number of years, you . . . even as Theodor Wiesengrund . . . could easily qualify as a Jewish non-Jew. For the Nazis, Klee was a typically "Jewish" painter . . . which is also the reason why they categorized his works as degenerate art. But there may be more to this putative Jewish element in Klee. Think once more of the 1918 Klee drawing I showed you earlier in which there was a face resembling Hitler. **What** did you see to the left of Hitler? The Star of David! (4.24.)

SCHOLEM: Maybe that's just a coincidence . . . some representation of a star.

SCHÖNBERG: You think so? Just look at another of his angel drawings (4.25).

BENJAMIN (*astounded*): Good God! And with two Magen Davids . . . one above and one below the angel!

SCHÖNBERG: Klee called it *Angelus Descendens* and painted it two years before your own beloved *Angelus Novus*. Or take this Egyptian vignette (4.26): is it an allusion to the flight of the Jews?

SCHOLEM: Amazing! Still, the mathematician in me cannot accept three examples out of some nine thousand works as statistically meaningful.

SCHÖNBERG: What if I tell you that, solely in the period 1917–1918, there were dozens upon dozens of Klee drawings and paintings liberally sprinkled with Magen Davids . . . And several with menorahs as well (4.28) . . . all of them in 1918?

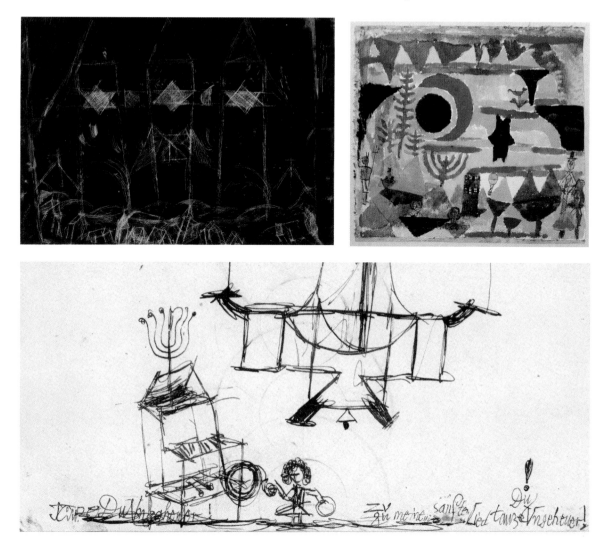

4.27. Paul Klee, *The Three Star Towers*, 1917.

4.28. Paul Klee, *With the Balloon*, 1918.

4.29. Paul Klee, detail of *Dance, You Monster, to My Gentle Song* (drawing for 1922).

SCHOLEM: How do you know they're menorahs? Perhaps they're trees with seven branches.

SCHÖNBERG: Don't think that hadn't occurred to me as well. But what about this drawing? (4.29.) Even the most skeptical of skeptics wouldn't call this a tree. Just consider the title: *Dance, You Monster, to My Gentle Song*.

SCHOLEM: Could it be some musical instrument?

SCHÖNBERG: You aren't easily persuaded, are you? What do you see on top of the Kaiser's helmet in his drawing *The Great Emperor, Armed for Battle*? (4.30.)

SCHOLEM (*laughing*): A menorah... to counterbalance the cross on his chest?

BENJAMIN: With so many supposedly Jewish symbols just in 1918, was there something special about that year in Klee's life?

4.30. Paul Klee, *The Great Emperor, Armed for Battle*, 1921.

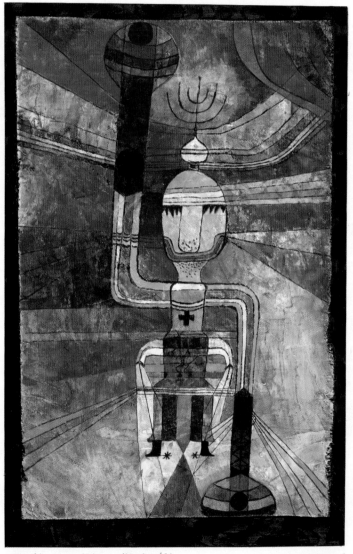

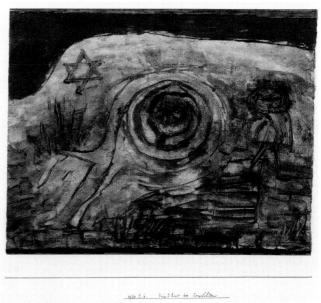

4.31. Paul Klee, *Soaring to the Stars*, 1912.

4.32. Paul Klee, *Childhood of the Chosen One*, 1930.

SCHÖNBERG: Other than that he was still in Munich . . . around the same time as Hitler? Who knows? But these Jewish symbols weren't limited to that year. There were over a dozen the year before and the year afterward . . . a veritable explosion of Stars of David. Even one as early as 1912 . . . his *Soaring to the Stars*, and some as late as 1930. And you know what he called that one? *Childhood of the Chosen One*! How more openly Jewish can you get? (*To Scholem*.) Is this starting to become statistically significant?

SCHOLEM: I'm staggered. But how did you find all this out?

SCHÖNBERG: Once you start on angels . . . stars are a natural consequence. Whether he deliberately or subliminally put in some Jewish symbols is really beside the point. For his critics this just added to their judgment of him as a Jew . . . and enough to drive Klee, the *non-Jewish* Jew, away from Germany to Switzerland, never to return again. But now let's ask our *Jewish* non-Jew, Wiesengrund Adorno, what caused him to return to the Germany that drove him out.

ADORNO: First, do you know what the rector of the university that refused to even let me teach there in the 1930s wrote less than twenty years later to the minister of Education? "The expedited award of a professorship is politically and humanly warranted."

SCHOLEM (*sarcastic*): Tell me, Herr Reparationsprofessor, weren't you embarrassed, if not insulted, by the title of *Wiedergutmachungsprofessor* ... a restitution professor ... and the years it took before you became a non-sanitized real professor who just happened to be Jewish?

ADORNO: You have a wicked tongue. No wonder, one of my friends described you as "simultaneously old-testament-wicked and Berlinish-amusing." But I won't be provoked.

BENJAMIN: For me, it was the German language ... and later also French ... that kept me in Europe until it was too late. (*Back to Adorno.*) And it must've been the language that brought you, the emigrant Adorno, back to Frankfurt in 1949 when hardly any German Jew dreamed of returning to that ruined country.

SCHOLEM: I solved *my* Kafka problem by proving that it is not impossible to write in another language. I learned Hebrew back in Berlin, when it was not fashionable ... and I still a teenager. All my writing on the Kabbalah was conducted in my adopted language.

ADORNO: Not true! At least some of your Kabbalah works are only published in German. How else would I have read them?

SCHOLEM: All right ... most of them were in Hebrew.

BENJAMIN: You are now speaking as Gershom Scholem, the Zionist, and not as Gerhard Scholem, the German Jew, who to the very end conducted all his correspondence in German—

SCHOLEM: How could I write to you in Hebrew? You never delivered on your promise to learn the language.

BENJAMIN: When it came to my personal Judaism, the fatal problem was my continually vacillating attitude between important and problematic. The problematic always kept me from learning Hebrew. What about your correspondence with Escha? You both lived in Jerusalem; you both were Zionists; you both had learned Hebrew. But it was always *Mein Kind* or *Mein Herzchen,* and so were the rest of your letters.

ADORNO (*to Scholem*): Before we go off in yet another direction, I must reply to your implied accusation: that I returned to Frankfurt ... still largely in ruins ... for a Herr Professor title—

SCHOLEM: I said a Herr Wiedergutmachungsprofessor title.

ADORNO: What's the difference? Returning to the place from which you were driven away solely for a title should be condemned ... whatever the title. You all should hear the real reason ... especially my esteemed maestro Schönberg, who never returned to either Germany or Austria!

SCHÖNBERG: Yes, tell us. Because returning was always on *my* mind, since, professionally, the Americans treated me miserably. Instead of getting a decent pension upon retiring from the University of California, I was reduced ... at age seventy-one! ... to applying for a Guggenheim fellowship. (*Agitated.*) Do you realize what I applied for? To complete my two most important unfinished compositions, the *Jakobsleiter* and *Moses und Aron* without the distraction of having to give private lessons to support my family and myself. If anything demonstrated my personal return to Judaism ... or perhaps the fact that I never really left it ... it was those works ... and of course my *Kol Nidre*, which I'd already composed in the late 1930s. But do you know what the secretary general of the Guggenheim Foundation wrote? "We all know your eminence, both in the field of musical composition and in the field of musical theory, so no further documentation is desired or required." I have not forgotten these words to my dying day ... six years later.

ADORNO: Why should you forget such a compliment?

SCHÖNBERG (*bitterly*): Because a few months later, they converted the compliment into an insult by turning me down ... Arnold Schönberg, whom they called "your eminence!" Ever since, I demeaned myself every year by looking jealously at the list of the newest Guggenheim fellows in the New York Times. (*To Benjamin.*) Even your friend, Hannah Arendt got one ... not exactly a spring chicken at forty-six. Still, I didn't have it in me to return to Europe.

ADORNO: I did ... in fact I always thought of it. But then I am different from you three.

SCHOLEM: We all are different ... and it's that difference we're discussing. I also returned to Germany ... as early as 1946—

SCHÖNBERG (*astounded*): What made you do that?

SCHOLEM: It was only for a couple of days ... looking for remnants of Jewish book collections on behalf of the Hebrew University. I was there again in 1949, in 1950, in 1952, and then perhaps another ten times ... but always for short visits. I would never have dreamed of doing what Teddie Adorno did. He returned as a German ... I as a Jewish visitor from Israel.

ADORNO: Now wait a moment. I returned as a German Jew!

SCHOLEM: What does that mean? That you're first a German ... and then a Jew?

ADORNO: Rather than debating with you the difference between a German Jew and a Jewish German—a dilemma our friend Walter never

resolved—let me point out, mein lieber Gerhard Scholem, that you didn't always just come as a visitor. What about 1981—the year before your demise and departure for Parnassus?

SCHOLEM: That was different.

SCHÖNBERG (*irritated*): Everybody is talking about differences, without explaining them. What, Herr Scholem, was suddenly different? And what was different about you, Theodore (*emphasizes next letter*) W. Adorno?

SCHOLEM: In 1981, after doing some research in Berlin, I was offered the German Order pour le Mérite—

SCHÖNBERG: And you accepted it?

SCHOLEM: It's the highest German civilian order.

SCHÖNBERG: In other words, you couldn't resist a big bribe?

SCHOLEM: I didn't consider it a bribe. The order was established in 1842—

SCHÖNBERG: I don't want a history lesson—

SCHOLEM: You're not getting one. But it's important to know that the order was not awarded after 1934 during the Nazi regime and only resumed its operation in 1951. Furthermore, it is only given to thirty Germans and thirty foreigners. I was honored as a citizen of Israel. Actually, I didn't receive it. My wife Fania did on my behalf.

SCHÖNBERG: You were ashamed?

SCHOLEM (*irritated*): Of course not! It was just before my death and I was too ill to travel.

ADORNO: Be honest! You did not consider it a *Wiedergutmachungsorden* . . . a form of moral reparation? (*Pause.*) But don't answer that, because I don't want you to take it as revenge for the Wiedergutmachungsprofessor question you asked. The fact is that I did return permanently and for very personal reasons. I needed to come back to my place of birth, to the site of a magic childhood, to the country where I could again write in my own language, rather than in English . . . the language I learned only as an adult so that I could write at best as well as the others.

BENJAMIN: I have not interrupted any of you, but now I must. Teddie, I understand the feeling about language . . . but there is more to it than wanting to return to the dreams of your childhood . . . however paradisiacal it may have been. You have written about those reasons in words I only learned years later. Do you remember them?

ADORNO: Of course. I think too sociologically to see Fascism as the expression of the German national character. Rather, I interpret it as the consequence of a socioeconomic development and therefore not as a concept for which the entire German nation is to blame.

SCHOLEM: Good God! This sounds like a lecture . . . and even worse, like one by Hannah Arendt.

ADORNO: That's not necessarily an insult.

SCHOLEM: But I meant it as such. It's not unlike Arendt's generalization that Eichmann and the Holocaust were the results of broader political and economic developments . . . and to that extent almost unavoidable. Let me remind you how one of the biggest German newspapers, the *Frankfurter Allgemeine Zeitung,* greeted your return: "These days, we greet a scholar who returned from the United States to Frankfurt and whom we received more heartily and amicably than almost anyone else." (*Sotto voce as a sarcastic aside.*) Not that there were that many to greet. But to continue: "He is Theodor Wiesengrund Adorno, born in Frankfurt, who had received his habilitation at his hometown university and later went to America . . . " (*Again, as an aside.*) And note that contrary to the Americans, *Mister* Adorno, the Germans never let you forget that you were born a Wiesengrund. (*Continues loud and sarcastic.*) "And later went to America!" It rather sounds as if you went voluntarily . . . perhaps even on vacation.

ADORNO: I can respect your feelings, but you will have to respect mine. I, who immigrated to the U.S. trying to disguise any Jewish link . . . even though intellectually or psychically there was very little to disguise . . . returned openly flaunting my Jewish connection. I simply wanted to return to the site of my childhood in the belief that in the final analysis everybody wants to recover his childhood in some changed sense. I didn't underestimate the danger and complications of that decision, but to this day I have not regretted it. I made no concessions to the prevailing politics . . . I fought them and I contributed to the resulting changes. And I am not ashamed to admit that academic recognition . . . as a German Jew . . . pleased me, as did the response of the students.

BENJAMIN: Yet these very students caused your academic downfall in 1968.

ADORNO: Patricide . . . even an academic one . . . has its historical antecedents. (*Pause.*) Anyway . . . there you have it. The reasons for my return . . . as a Jew to whom religion meant nothing.

SCHÖNBERG: I think it's time to give this who is a Jew question an Austrian twist that you are unlikely to find in Germany.

SCHOLEM (*interrupts*): I know exactly what you are going to say: "I decide who is a Jew." Those were the words of Karl Lueger, Vienna's most beloved mayor . . . not very different from what Jean-Paul Sartre said years

4.33. Gabriele Seethaler, *Dr. Karl Lueger's Face Superimposed Upon Dr. Karl Lueger Monument, Vienna.*

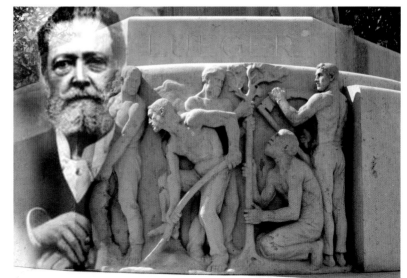

later, "A Jew is a person who others say is Jewish. It is the anti-Semite who makes the Jew"—

SCHÖNBERG (*interrupts*): And don't forget that Lueger was also an avid Jew hater of the pre-Hitler days. No, I have something much more nuanced in mind. Note, I'm talking about Vienna . . . where few things are expressed directly!

ADORNO: A city I once loved and then despised. Better be careful . . . you're addressing three German Jews.

SCHÖNBERG (*to Scholem*): Remember when you complained about the absence of a stamp honoring you?

SCHOLEM: On that front, I had plenty of reason to complain.

SCHÖNBERG: I understand. I've been a complainer most of my life and as I just demonstrated, still indulge in such self-flagellation. But now to my question. What do the following have in common? Karl Kraus, Hugo von Hoffmansthal—

BENJAMIN: Two of my heroes.

SCHÖNBERG: Exactly. That's why I picked them. And let's add a philosopher, Ludwig Wittgenstein, and a couple of composers, Gustav Mahler and Johann Strauss.

ADORNO: Which Johann Strauss?

SCHÖNBERG: Why not both to make it an even half dozen and not argue whether father or son wrote better waltzes? (*Turns to Scholem.*) Even though there is no stamp of you, let's take stamps as a sign of Jewish

identity. Not Israeli stamps ... but Austrian ones. All six have appeared
on Austrian stamps.

SCHOLEM: So what? Bach has been on an Israeli stamp and Mozart on an
Austrian one. It doesn't make them Jews.

SCHÖNBERG: Be patient! Not so long ago the Austrian post office spon-
sored an exhibition on Jewish personalities on Austrian postage stamps,
entitled *Stamped? Branded!* And that all of them were included there as
Jews with thirty-five others?

SCHOLEM: Johann Strauss Jewish?

ADORNO: I pride myself at my knowledge of music, but that I did not know.

SCHÖNBERG: Neither did I ... until I saw the catalog of that stamp exhi-
bition. It turns out that the grandfather of Johann Strauss the elder was
a baptized Jew. So what's good enough for the modern, politically cor-
rect, Austrian post office ... not some Nazi remnant ... ought to be good
enough for us here ... especially since there is no post office on Parnas-
sus. Karl Kraus, born a Jew, was baptized a Catholic at the same age that
I turned into a Protestant, yet, like me, he dropped that union card some
decades later. Mahler never concealed his Jewish origin, even after be-
coming a Catholic, but always said that being a Jew gave him no plea-
sure ... that he felt as if he were born with only one leg or one arm. Or
Wittgenstein, whose grandparents were mostly Jews, although his par-
ents were Catholic and Protestant, respectively. He was given a Catholic

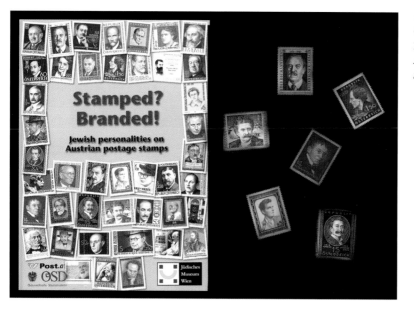

4.34. Catalog of the exhibition of
Österreichische Post AG and Jewish
Museum Vienna, *Stamped? Branded!
Jewish Personalities on Austrian Postage
Stamps*, 2004.

burial, yet confessed to having allowed others to underestimate the extent of his Jewishness.

SCHOLEM: What a convoluted way of admitting that he always wished to pass as a Gentile!

BENJAMIN: That leaves one of my heroes . . . Hoffmansthal—

SCHÖNBERG: Who never acquired another religious union card, yet much of whose later writings dealt with religious, Catholic themes.

BENJAMIN: I know that. But what are you driving at?

SCHÖNBERG: That there is no threshold beyond which one is not Jewish. Once contaminated—

SCHOLEM: What a disgusting word.

SCHÖNBERG: I used it deliberately.

BENJAMIN: I can think of a more elegant way of reaching the same conclusion than licking the back of some Austrian stamps. Consider Moritz Goldstein . . . whom Gerhard here already mentioned. Remember his famous essay of 1912, "The German-Jewish Parnassus?"

SCHOLEM: Considering where we are holding this debate, Goldstein's arguments seem to be more relevant than the Austrian post office's. All the stamps demonstrated that you are considered a Jew because of parentage . . . a synonym for "race" or "blood" . . . and for anti-Semites, parentage goes back ad libidum and ad nauseam.

SCHÖNBERG: So what did Goldstein have to say?

SCHOLEM: "We, the Jews, administer the intellectual property of a people that denies us the qualification and the capacity for doing so."

SCHÖNBERG: Well put. How could I have missed that article?

ADORNO: You were too busy with your music . . . in my opinion a good thing.

SCHÖNBERG: What else did Goldstein say?

SCHOLEM: Basically, that those German Jews up on Parnassus got here on their merits and may have accomplished it all in Germany . . . or in Austria . . . and in the German language, but they are here as Jews and not as German Jews. Jewishness is not necessarily based on religion or history, but on the fact that Jews live among non-Jews who call them Jews. Assimilation is impossible for such pariahs. The obvious solution is Zionism, and that is why I moved to Jerusalem in 1923.

ADORNO: Strange. Even a black American revolutionary, Malcolm X . . . certainly no friend of Jews . . . agreed. He even wrote about it in his autobiography. "History's most tragic result of a mixed ethnic identity has been experienced by a white ethnic group—the Jew in Germany." According to him, the German Jews had made greater contributions to

Germany than the Germans, had won half the German Nobel prizes, had led German culture by becoming some of the greatest poets, artists, stage directors—

BENJAMIN (*interrupts*): Don't forget reviewers. After all, that's how I supported myself. Shortly after Hitler came to power, the Nazis issued a book, *The Jews in Germany*, where that point was made crystal clear. "No one seriously questions the power which the Jews wield in the press. Especially reviewing, at any rate in the capitals and their influential papers, has become a virtual Jewish monopoly."

ADORNO: Malcolm X may have forgotten about the reviewers, but his conclusion still holds. It was that "those Jews made a fatal mistake: assimilating."

SCHOLEM: He was right.

ADORNO: Not for me. It's too black and white a conclusion.

BENJAMIN: Rather than argue, let's sharpen the definition. Nobody would disagree with the statement that fundamentally Jews are neither Europeans nor non-Europeans.

SCHOLEM: More than that. The Jews never lived within a border . . . not until recently when the State of Israel was created. And even there the precise border or even its validity is still up for debate.

ADORNO: Isn't it curious that in the pre-Nazi days, whenever religion had to be specified . . . schools, jobs, passports . . . the Germans or Austrians used mostly *israelitisch*, rather than *jüdisch* or *mosäisch*. The label was not a religious one . . . like Catholic . . . but a nationalistic one, assigning us to a country that hadn't existed for nearly two thousand years.

BENJAMIN: You have moved the argument to geographical borders. I want to return to cultural ones. We're really talking about a very special subset of Jews—not just European, but in fact German . . . and here the borders are precisely defined . . . and, even more important, accepted by that subset. In other words, the type of German Jews we represent and that Goldstein had addressed.

SCHÖNBERG: Don't forget Austrian.

BENJAMIN: Or, more precisely, Viennese and Berliner and Frankfurter Jews. Some wise man once said Jewish sameness is riddled with otherness. So let's address this point. Take the etymology of Hebrew.

ADORNO: Now we're getting somewhere: the literary mind with his academic glasses!

BENJAMIN: Abraham, not Moses, discovered monotheism. He came from across the river and was therefore *a crosser, an ivri* . . . ergo a *Hebrew*.

SCHOLEM (*ironic*): Praise the Lord! Walter Benjamin finally understanding his roots. Walter Benjamin . . . who crossed more literary rivers than any of us here.

BENJAMIN: I'm exhausted. Somehow, I hadn't expected this discussion. I need a nap.

SCHOLEM: Just one more thing! Will you indulge me?

BENJAMIN: You better ask the others. I'm usually putty in your hands when it comes to such requests.

ADORNO: All right, let's hear your one more thing.

SCHÖNBERG: Why not?

SCHOLEM: Given our similar backgrounds . . . German or Austrian . . . but our different takes on the word *Jew*, let me pose a question. What if you could choose your ancestors, now that you know what ancestral baggage the label *Jew* carries with it?

BENJAMIN: I've long ago stopped playing what if games. It's like opium—

SCHOLEM: The expert speaking.

BENJAMIN: Perhaps. Nevertheless, I'll pass.

SCHOLEM: What does our friend Theodor Wiesengrund Adorno have to say on that topic?

ADORNO (*good-naturedly*): Since I can never resist answering a question, let me give you my answer: Voltaire.

SCHÖNBERG: Voltaire? *The* Voltaire?

ADORNO: Yes. François Marie Arouet de Voltaire. By the way, did you know that Voltaire was not his real name, just an anagrammatic adaptation of his family name Arouet?

BENJAMIN: Again anagrams? Haven't we all indulged enough in that verbal sport?

SCHÖNBERG: But you couldn't have thought of that just now!

ADORNO: The anagram was Voltaire's idea, not mine.

SCHÖNBERG: Not the anagram! I mean Voltaire! One second after Scholem asks you whom you'd pick, you named him.

ADORNO: Because I've fantasized about him for years. Just think: he was superbly talented in so many different disciplines, he loved women, he was antireligious, in favor of human rights—

SCHOLEM: I can't believe what I'm hearing. Voltaire may have been one of the key figures in the rise of eighteenth-century Enlightenment, but he was a vicious anti-Semite.

ADORNO: That's too simple . . . and too judgmental. He was a moral Newtonian and a follower of Locke and to that extent against much of what the

Hebrew Scriptures preached, which insisted on revealed ideology, not Voltairean rational criticism. He also hated Christian and Muslim fanaticism . . . not just Jewish. But he was no racist . . . he objected to religion, not biology . . . very different from modern anti-Semites. "When I see Christians cursing Jews, methinks I see children beating their fathers. Jewish religion is the mother of Christianity." Those were Voltaire's words. According to him, "we all are only, at the bottom, Jews with foreskin."

BENJAMIN (*laughs*): Teddie Wiesengrund . . . turning into a circumcised Voltaire! No wonder, you titled your most important book *The Dialectic of Enlightenment*.

ADORNO (*laughs back*): I'm glad I didn't have to point that out myself, but don't forget that I wrote it with Max Horkheimer. Unfortunately, like me, Voltaire had no children. Otherwise, I could be his great-great-great-great grandson.

SCHOLEM: In other words, you decided to pick a non-Jew! I suppose I shouldn't be surprised, considering that you micronized Wiesengrund into just one letter, the anonymous *W.*, to become Adorno.

ADORNO: Coming from anyone else, I would have called your choice of the word *micronized* unnecessarily offensive. You're addressing a man who was baptized a Catholic at birth, yet was one of the first to return after the fall of Hitler as a Jew to confront the remaining Nazis of the University of Frankfurt. But you asked a totally hypothetical question—

SCHOLEM: Forget about it! I shouldn't have questioned your choice of Voltaire or it might color the choices of the others. What about you, Herr Schönberg?

SCHÖNBERG (*smiles*): I wouldn't mind being the grandson of Roald von Bergennosch. (*Pause.*)

Benjamin, Scholem, and Adorno seem puzzled.

BENJAMIN (*hesitantly*): Bergenosch?

SCHÖNBERG (*enjoying himself*): Bergennosch . . . with two *n*. A name with no Jewish connotation. And Roald, a good Norwegian first name.

ADORNO (*with dismissive hand gesture*): Roald Bergennosch? You're trying to make fun of us. An anagram for Arnold Schoenberg.

SCHÖNBERG: Of course! But what's wrong with that? You all know by now that all my adult life, I was playing around with anagrams . . . in my music and in many words. What about your great-great-great-great grandfather Voltaire? Nobody holds the anagrammatic source against him.

SCHOLEM: Fair enough. Especially since we Jews are often credited with the invention of anagrams. Many a Kabbalist has amused himself with

anagrams, claiming that "secret mysteries are woven in the numbers of letters." And Walter, here, certainly played around with anagrammatic noms de plume like his Anni M. Bie. But what about the *von?* Where did you get those letters?

SCHÖNBERG: I just borrowed them. As a composer, coming from a noble family . . . wealthy and non-Jewish . . . would have made my career immeasurably easier.

ADORNO: Again your wish for assimilation?

SCHÖNBERG: Perhaps . . . but without the humiliation of a pointless conversion. Scholem asked a what if question and I gave him a slightly flippant but honest what if answer.

BENJAMIN: You never fantasized about a musical ancestor?

SCHÖNBERG: Never! My music came out of me. Why share it with some hypothetical ancestor? I just craved an easier life as a composer and Roald von Bergennosch might well have provided that.

SCHOLEM (*to Benjamin*): And you Walter?

BENJAMIN: You first.

SCHOLEM: I'll offer a contentious candidate for my putative grandfather: Samuel Holdheim.

BENJAMIN: At least you picked a Jewish-sounding name.

SCHOLEM: Why not? I've never had any problem in that respect with my own name Scholem.

ADORNO: In that case, why change it?

SCHOLEM: It's not the name. It's because my father acted more Prussian than the Prussians. A more Jewish grandfather would have helped.

SCHÖNBERG: Who was Holdheim?

SCHOLEM: Rabbi Samuel Holdheim, one of the founders of German Reform Judaism. He believed in monotheism and morality, but not in kosher food, caftans, or yarmulkes. . . . I don't go to the synagogue on the Sabbath . . . I've been known to eat ham sandwiches . . . my head is bald and uncovered . . . but I believe in a Jewish God. Without such belief, there is no grounding for morality.

BENJAMIN (*astonished*): *You* . . . Gershom Scholem, the convinced Zionist and non-Kabbalistic Kabbalist . . . who insisted on studying the Kaballah from the outside . . . you would pick Holdheim? I know you rejected Orthodox practices . . . as do all Reform Jews . . . but you despised the Reform movement! And wasn't that for their illusory belief in a German-Jewish symbiosis?

ADORNO: A symbiosis in which I never lost faith.

SCHOLEM: The first and foremost prerequisite for such a symbiosis must be a German-Jewish dialogue. It takes two to have a dialogue ... who listen to each other ... who are prepared to receive the other as to what he is and represents ... and to respond to him. I deny that such a type of dialogue ever existed in Germany as a historical phenomenon.

BENJAMIN: Until the creation of the State of Israel, wasn't German Reform Judaism the antithesis of Zionism?

SCHOLEM: Quite right ... and even now you may still find some anti-Zionist Reform Jews.

ADORNO: So how can you possibly go for Holdheim?

SCHOLEM: In the same sense that you selected Voltaire in spite of his anti-Semitism.

ADORNO: I provoked you to choose Holdheim? Isn't that carrying contrariness a bit too far?

SCHOLEM: It would be, if that had been the primary reason for my choice. But I also said in the past ... and will repeat it here: Zionism contains within it enormous religious content and a religious potential. I reject the idea of the absolute secularization of Israel as a state ... or of a Jew as an individual. Holdheim felt the same way. He never preached emancipation for the Jews at the price of Judaism, but he was against Talmudic orthodoxy. Actually he carried it too far ... mercilessly preaching against circumcision. On the other hand, he fought the lower religious status of women as expressed in the Talmud. With such a grandfather, I could have honed my dialectic skills on Judaism at home ... instead of acquiring them on the sly outside. I'm sure I would have become a Zionist even earlier by arguing with my grandfather Holdheim. (*Turns to Benjamin.*) But now you, Walter. No more stalling.

BENJAMIN: Seeing how wide a net you three have been throwing, I'm tempted to go even further in my hunt for different ancestors. What would have happened if I were a direct descendant of the Bernoulli family, say the great-great-great-great grandson of Daniel Bernoulli? Not that it makes much difference which one it would be. It's just that Daniel was the same age as Teddie's Voltaire. I am opting for the mathematical genes of that family ... and a lovely neutral-sounding name. And Swiss to boot ... a nice neutral country where one can even speak German.

SCHOLEM: Aha! Another one rejecting his Jewish label but not wanting to change his mother tongue!

BENJAMIN: Listen . . . my parents, who were Christmas Jews with a Christmas tree every December, would have sympathized. When they had reconciled themselves to the fact that their son would become a writer, they said "it would be good if not everybody noticed that he was a Jew." With Bernoulli I was simply looking for some missing genes. And that family certainly had them. In fact, I'd say they had plenty of "Jewish" characteristics . . . in the sense that Klee, the painter, had them. Just think of how many great mathematicians are Jewish. (*Pause.*) "Walter Bernoulli"—same initials, but much less baggage. I could use some mathematical aptitude. That . . . and music . . . is what I missed.

SCHÖNBERG: If you need a family name starting with B and musical genes, why not Bach, Brahms, Beethoven, Bruckner . . . or even Bartok or Berg?

BENJAMIN: I thought we were trying to fool the anti-Semites. But, in true Marxist fashion, let me indulge in some self-criticism. What made me pick Bernoulli? It's not a dream I've carried around with me . . . it was a spontaneous response to a what if question. Is it simply a reflection of the sorry fact that in some way I always wanted to be culturally assimilated? Become a parvenu Jew as Hannah Arendt called such Jews . . . even though assimilation during my twentieth-century life as a German Jew was ultimately impossible? That I was the sort of pariah Jew, who regretted that he could not become a parvenu, while at the same time ashamed of that desire?

ADORNO: Since the words *pariah* and *parvenu* as applied by Hannah Arendt to German Jews are suddenly bandied about . . . first by Gerhard and now by you. Walter . . . let's remember exactly what she said about *conscious* pariahs. In her eyes these were persons "who were great enough to transcend the bounds of nationality and to weave the strands of their Jewish genius into the general texture of European life . . . who tried to make of the emancipation of the Jews that which it really should have been: an admission of Jews as Jews to the rank of humanity, rather than a permit to ape the gentiles or an opportunity to play the parvenu." (*Addresses Scholem.*) Even though you have distanced yourself so firmly from her, you must agree that she was right in pointing out that, in the process, these conscious pariahs in Europe were not only marginalized by European society but, in the end, by the Jewish community as well . . . meaning the Gershom Scholems of this world. (*Turns to Benjamin.*) And then she listed by name some German inhabitants of Parnassus who openly affirmed their pariah status.

SCHÖNBERG: Who were they?

ADORNO: Three names will suffice: Kafka, Heine, and (*brief pause*) . . . our friend Walter. And it was Karl Marx who pointed out that the cultural impact of such Jews was so powerful that to many Gentiles it appeared that their society was turning "Jewish" . . . one of the reasons for the Nazi variety of anti-Semitism.

SCHÖNBERG (*addresses Scholem*): You started it, so why not end it? What exactly was this all about?

SCHOLEM: A catharsis.

SCHÖNBERG: You think we needed it? Up here, on Parnassus?

SCHOLEM: Precisely here, because here it occurs so rarely.

ADORNO: A catharsis usually leads to relief. I don't feel relieved.

BENJAMIN (*to Scholem*): Gerhard, when you and I held such conversations by correspondence, there was always the unspoken assumption that somehow it would benefit others. That it would be published . . . that it would lend itself to analysis by others, to generalizations—

ADORNO: Stop! Must I remind you again of the rules? What we do up here, stays up here. We know what's going on down there . . . right at this moment and also in the future . . . at least as long as we remain on Parnassus. There are no possible generalizations based on what we just covered . . . no collective catharsis, because no one else knows what's going on up here.

SCHOLEM: The catharsis I am thinking of is personal and Parnassian. The only nondebatable conclusion is that we were discussing our respective personal definitions of what it means to be a non-religious Jew—

BENJAMIN: You think I know it now?

SCHOLEM: At least more than you did before.

BENJAMIN: In that case, summarize it for me.

SCHOLEM: A person is a Jew when he calls himself a Jew or is so identified by others—

BENJAMIN (*interrupts*): How does that differ from a Catholic . . . or a Protestant?

SCHOLEM: You didn't let me finish. *And* . . . please note, I'm saying *and*, not *or* . . . who has some Jewish ancestors—

BENJAMIN (*interrupts, impatiently*): Catholics have ancestors!

SCHOLEM: Of course, they have. But how far back? With Catholics or others, the choice is up to them. Not for Jews. Non-Jews and especially the Jew haters will not offer you that option. They'll go back generation upon generation until a Jewish stain is encountered. . . . Because for them it was an indelible stain . . . invariably labeling them as perpetual outsiders.

That's why Wittgenstein or Johann Strauss—father and son—find themselves in an Austrian stamp exhibition featuring Jewish personalities and labeled *Stamped? Branded!* It's the post office that made that decision, not Wittgenstein or Strauss.

BENJAMIN: That sort of external labeling is all too common. Gerhard, the Berliner ... and you two, who have spent plenty of time in Berlin ... must all know the Kaiser Friedrich Museum—

SCHOLEM: Now called the Bode Museum.

BENJAMIN: Correct. Do you know who was one of the greatest donors to that museum ... one of the most important ones in Berlin?

SCHOLEM: Wasn't it James Simon?

BENJAMIN: Again correct. Some people—mostly other Jews ... called him the Kaiser Jude because he remained on personal terms with the Kaiser even after his abdication.

SCHÖNBERG (*impatiently*): What does that have to do with what we are debating?

BENJAMIN: Simon was lucky to have died in 1932 ... just before Hitler's rise to power. One year later Simon's name ... as the greatest patron of that museum ... was simply erased.

SCHOLEM: Hardly surprising.

BENJAMIN: The name of the museum was changed to the Bode Museum, after the great museum director. And now, long after Hitler is gone, there are two busts on either side of the entrance with the following legends: Under Bode's name, it says, "In the late nineteenth and early twentieth century, Wilhelm von Bode was the central figure of the Berlin museum landscape....He was considered the most significant art connoisseur and museum personality of his time."

ADORNO: What's wrong with that?

BENJAMIN: Only if you compare it with how the James Simon inscription starts: "By far the greatest patron of the Berlin Museums was the humanistically educated Jewish merchant, James Simon."

ADORNO: So?

BENJAMIN: Simon is called a Jewish merchant ... albeit humanistically educated ... not a German one. Bode is not called the most significant Catholic art connoisseur. Nobody dreamed of adding that religious label, because that is all it would have represented. Not with Simon ... where "Jewish" meant much more than religion ... and not just in the politically correct context of the present days. It would also have been used earlier ... with all its damning overtones.

4.35. Busts of James Simon and Wilhelm von Bode, *Bode Museum Berlin*.

Wilhelm von Bode
(1845–1929)

Wilhelm von Bode war im
ausgehenden 19. und frühen 20.
Jahrhunder die zentrale Figur
der Berliner Museumslandschaft.

James Simon
(1851–1932)

Der mit Abstand größte Mäzen
der Berliner Museen war der
humanistisch gebildete jüdische
Kaufmann James Simon.

SCHÖNBERG: So what's new? It's others that label us as Jews . . . be it the Jew haters or Jew lovers . . . even if we have never entered a synagogue in our lives.

BENJAMIN: I'd like to ask you all a question . . . probably a stupid one.

SCHOLEM: You don't ask stupid questions . . . although you've been known to ask unanswerable ones.

BENJAMIN: This may well fall into the latter category. How did we get up here?

ADORNO: Is that what you want to know? Walter! Certain questions simply answer themselves by being asked.

SCHOLEM: This sounds like a quote—

ADORNO: It is a quote: Trotsky.

BENJAMIN: Teddie, not every question merits a Marxist twist. I meant, did we arrive up here because we were Jewish? Was it in spite of being Jewish? Or . . . ?

ADORNO: Or what?

BENJAMIN: You pick the third alternative.

ADORNO: In my case, it was clearly "in spite of." Or even a third alternative . . . because I was brought up a German.

SCHOLEM: My case is unambiguous: because I am a Jew.

SCHÖNBERG: With me, it was none of the above.

ADORNO: Meaning?

SCHÖNBERG: Simple. I was born a musical genius.

ADORNO: Still—

SCHÖNBERG: What do you mean still? Either you are born a musical genius or you'll never become one. Remember what you once said: "there is no half-good performance. Only an outstanding one or none at all."

SCHOLEM: What about you, Walter?

BENJAMIN: Early on, it was mostly "because." Why do I say that, even though ours was such a secular home? I'm ascribing it to the rabbinical tradition of arguing and questioning and interpreting that is transmitted even after religion has disappeared from a formerly Jewish home. But through much of my subsequent life, it was mostly "in spite of."

SCHÖNBERG: No sui generic genius component?

BENJAMIN: I don't write music and I don't use numbers. That's what is mostly transmitted in genes. Perhaps that's why I chose Bernoulli out of the blue for a hypothetic what if ancestor. I use words to critique the words and thoughts of others. That comes with practice, not with genes.

SCHOLEM: Walter . . . you are too severe on yourself. Are you implying there are no born literary geniuses . . . only ones that are generated on earth through hard work?

BENJAMIN: Of course there are Shakespeare and Ovid and a few others. But such genius is noticed early in life . . . as it invariably is in musicians and mathematicians.

ADORNO: But take your writings . . . when you were still in your twenties! Your professors hardly understood what you submitted to them.

BENJAMIN (*bitter laugh*): So it was not my being Jewish but just incomprehension that kept me from getting a teaching position? Incomprehensibility is not a sign of genius.

SCHOLEM: I always understood you . . . even though I didn't always agree with you.

BENJAMIN: Perhaps that was the genius in you.

SCHOLEM: Or was it that I am the only true Jew among the four of us?

END OF SCENE 4

5. BENJAMIN'S GRIP

U P T O this point in *Four Jews on Parnassus*, all exchanges among the Parnassians were based on historically grounded facts—on archival materials and published documentation that has appeared in a flood that, at least in the case of Benjamin, shows no indication of slackening. But in this final chapter we are entering the realm of speculation, starting with the question of Benjamin's death. Did he really commit suicide on September 26, 1940, or did something more nefarious occur, possibly murder, as is implied in the oral testimony of some rather aged Spanish contemporaries shown in David Mauas's documentary film of 2005, *Quién mató a Walter Benjamin . . .* The consensus among academic Benjaminologists still favors suicide,[1] and I share that opinion on three grounds.

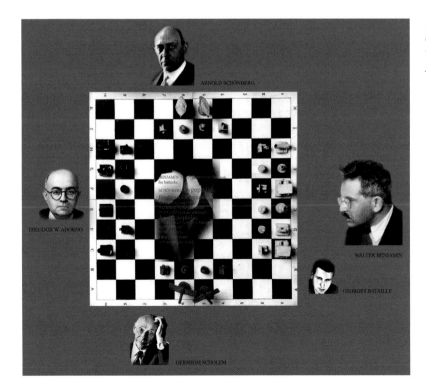

5.1. Gabriele Seethaler, *Walter Benjamin, Georges Bataille, Gershom Scholem, Theodor W. Adorno, and Arnold Schönberg Around Arnold Schönberg's Coalition Chess*.

First, Benjamin was tempted more than once by this drastic, irrevocable solution to life's many problems, of which he certainly bore his share. As we have seen in chapter 2, he was so close to such a final step in 1932 that he composed his last will; it included detailed instructions about the disposal of his meager belongings. Second, his acquaintance and fellow refugee from Vichy France was Arthur Koestler, who later committed suicide himself in London. Koestler disclosed, in one of his autobiographies, the fact that Benjamin had shared with him his supply of pills—an act of bizarre generosity. Third, Benjamin was small fry in terms of Gestapo aims. That the Gestapo would chase him to a small Spanish border town and murder him there seems unlikely.

But, for the purposes of my dialogues on Parnassus, it does not matter *how* Benjamin died, because I represent him as solely preoccupied with what transpired *after* he died. And this brings us to a dramatic teaser: the unanswered question of what Benjamin was carrying in the travel bag (or "grip") that accompanied him across the Pyrenees in his flight from France to Spain. Evidence for Benjamin's obsessive attachment to this grip comes solely from Lisa Fittko, Benjamin's guide across the Pyrenees. The only other potential witnesses, Henny Gurland and her young son José, who were part of the small group of refugees, proved to be of no help by the time Fittko's story was first published in 1982 in the magazine *Merkur* and subsequently more fully in 1985 in her book *Escape Through the Pyrenees* (*Mein Weg über die Pyrenäen*). Any honest autobiographer—a group to which I claim membership—is aware of the unreliability of memory, especially when a hitherto untouched veil is lifted some four decades after the actual event.

Be that as it may, the story first captured the attention of Gershom Scholem, whose lengthy conversation with Lisa Fittko in 1980 caused him to ask Rolf Tiedemann—one of Adorno's most prominent disciples and the person who has published or edited more works on Adorno and Benjamin than any other individual—to visit Port Bou and examine local Spanish archives. Both Scholem and Tiedemann believed that Fittko's account was fundamentally correct, whereupon Scholem prompted Fittko to set the record—insofar as it could still be called a firm, factual record—on paper. That in turn has given rise during the past twenty-five years to numerous speculations in biographical and academic literature as well as in some plays and novels. Benjamin's grip has never been recovered. So why do I feel it necessary to contribute to this mass of speculation, when the unambiguous answer will almost certainly never be known?

The reason for my interest is that none of the published explanations about the contents of Benjamin's grip has seemed to me persuasive. All are based on one single assumption that nobody has questioned: that Benjamin carried with him in his grip manuscripts that he wanted to preserve.

If this were true, why did Benjamin not include one additional *single* sheet of paper—clearly the emotionally as well as financially most valuable one—the *Angelus Novus*? Why did he leave that in the suitcase stuffed with other documents in Georges Bataille's hands at the Bibliothèque Nationale in Paris—material that survived the Nazi occupation and eventually found its way to Adorno in New York? Since the true answer will never be known, I have felt justified in putting forth a totally different hypothesis from those in circulation, namely, that what Benjamin took with him was material he did *not* want to see preserved if he would die. Once that logical premise is granted, then all kinds of possibilities can be explored, one of which I detail in the last conversation of my four heroes on Parnassus. As I indicate in the introduction to my extensive bibliography, aside from one minor factoid, it is the only part of my biographical sketches that is not based on historically grounded evidence but rather on supposition. But my hypothesis allows me to address one other virtually unknown aspect of Benjamin's sojourn in Paris before his final flight south and eventual death in Spain: his relationship to Georges Bataille, whom he saw almost daily during his research in the Bibliothèque Nationale and to whom he entrusted his most valuable literary possessions as well as Klee's *Angelus Novus.*

Georges Bataille himself almost falls into the category of a posthumous canonizee—at least in terms of his current reputation as one of the most sophisticated literary pornographers of his time. Virtually all his pornographic and erotic works were written under pseudonyms and only privately printed during his lifetime. Surprisingly enough, in spite of the likely daily meetings between Bataille and Benjamin, no correspondence and only trivial written documentation concerning their relationship is extant. But why should such correspondence be expected? If they had anything to say to each other, they clearly would have done so face to face during their frequent encounters in the library or perhaps even in the closed pornographic section—*l'enfer*—that we know Benjamin frequented and that must have been a key resource for Bataille in his own work. Even if my extrapolations of such tenuous facts should prove to be incorrect, it does illustrate my views of Benjamin's sexuality, a subject often underplayed or ignored in the conventional hagiographic treatment of his persona.

There are two other German intellectuals who greatly influenced Benjamin and also contributed to his ultimate recognition: Hannah Arendt and Bertolt Brecht. While my biographical spotlights barely touched on them in the first four chapters, I felt it indispensable to offer them the last words. And now let us listen to what Walter Benjamin has to say to his friends Gerhard Scholem and Teddie Adorno, and to his new acquaintance Arnold Schönberg, when pressed about the contents of his grip.

Benjamin sits on his stool, finishing rolling a cigarette. He lights it and starts dreamily exhaling the smoke. Adorno enters, sniffing the air.

ADORNO: Still smoking? And on Parnassus? I thought it was verboten. (*Sniffs ostentatiously.*) Where did you get them?

BENJAMIN: I roll my own. But why object? Didn't you once write, "The smoker isolates himself and makes himself approachable at one and the same time?" (*Pause.*) Well? That's exactly what I'm doing. (*Points to approaching Schönberg.*) You see? He's heading straight for me.

Schönberg enters, also sniffing.

SCHÖNBERG: Peculiar aroma. Not what I smoked in America before I dropped this filthy habit.

BENJAMIN: It's my private brand.

SCHÖNBERG (*still sniffing*): Still . . . it's different.

Scholem enters, also sniffing.

SCHOLEM (*severely*): Walter! I thought you'd given it up. Didn't I warn you way back that it could turn into an addiction?

ADORNO: *Could?* That's what nicotine does to you.

SCHOLEM: This is hashish . . . not tobacco!

ADORNO (*astonished*): How did you get hold of hashish up here?

BENJAMIN (*laughs*): You, who manages to order newly published books up here, ask such a question? But if you must know, Sigmund Freud told me where to get some.

ADORNO: I thought he was into cocaine.

BENJAMIN: The same dealer handles both.

SCHOLEM: Never mind the source. Why still smoke it? All you wrote about drug use has been published by now.

BENJAMIN: Not by me. One of Teddie's students did that. Besides, most of what I planned to write on that topic was never even set on paper. But

why am I smoking it now, you ask? Frankly, to put me into the proper mood for our final conversation.

SCHOLEM: You mean the satchel, the bag, the briefcase, the grip . . . or whatever you had with you on that fateful last day?

BENJAMIN: Its contents. Isn't that what everybody is still so curious about?

SCHOLEM: What does that have to do with hashish?

BENJAMIN (*addressing Schönberg and Adorno*): Can you guess what Gerhard called me when I first told him about my experiments with hashish and some other drugs?

SCHÖNBERG: What others did you take?

BENJAMIN: I wasn't just taking them . . . I was experimenting. With mescaline . . . and on occasion opium, but mostly hashish.

SCHÖNBERG: I suppose he called you what I would have . . . a junkie.

SCHOLEM: Not that. I only warned him that others might. I called him a dialectical theoretician rather than a drugged positivist.

SCHÖNBERG: You philosophical wordsmiths are impossible. Thank God I stuck with music. But, as Scholem asked, why smoke it now?

BENJAMIN: Just think what opium and hashish did for Baudelaire and his poetry!

SCHOLEM: You aren't writing poems. And you don't have to act like Baudelaire in order to write about him.

BENJAMIN: Relax! I was barely inhaling. It isn't easy, you know, to cope with your fascination . . . and seemingly everybody else's . . . with the vanished contents of that black bag of mine.

SCHOLEM: So it was black! That's what Lisa Fittko told me forty years later . . . and that's what she then put on paper. She claimed it was a very heavy bag. Is that also true?

BENJAMIN: On that day, climbing over the mountains in my condition, everything seemed heavy. Why belabor that point?

SCHOLEM: A heavy bag implies a huge manuscript or books—

BENJAMIN: All right. Let's call it heavy.

SCHOLEM (*impatient*): So what was in it?

ADORNO: Do you have any idea how many different hypotheses were raised?

BENJAMIN: I can imagine.

ADORNO: So out with it.

BENJAMIN (*smiling*): Indulge me . . . all of you—

SCHÖNBERG: Thanks for including me. I knew nothing about your bag, but now I've also become curious. But indulge you in what sense?

5.2. Gabriele Seethaler, *Walter Benjamin as a Hippie*.

BENJAMIN: To be patient and let me do it my own way. After all, on Parnassus time is of no consequence. (*To Adorno.*) Let's start with you, Teddie. What do you think was in it?

ADORNO: I always thought it was the *Arcades Project*. If you count all your notes, drafts, quotations ... even with your microscopic handwriting, it could make a briefcase feel heavy ... not to think of the heavy reading it required.

BENJAMIN (*laughing*): You of all people should know that, given that I fed you and Gretel early portions of it over the years while I struggled with it. But tell me, why would I drag it all over the Pyrenees? Didn't I leave so much of it in Paris at the Bibliothèque Nationale? Didn't those items survive the war?

ADORNO: Of course, they did, or in the fifties we couldn't have published the material that brought you up here. I know of three suitcases full of documents, but there could've been more. Two of them reached New York in 1941 through your sister Dora and her lawyer Domke. That's how I got Klee's *Angelus Novus*. And in 1947 Pierre Missac arranged for someone from the American Embassy to deliver the third one to me.

BENJAMIN: In that case, why presume that my heavy black briefcase ... which, incidentally, I always called my grip ... should be stuffed with more detritus of the *Arcades Project*?

ADORNO: Well ... (*Pause.*) Many consider it your most important work ... and certainly your biggest book.

BENJAMIN (*ironic*): Are you thinking of weight or of importance?

SCHOLEM: Both, of course. You aren't fishing for compliments, are you?

BENJAMIN: I'm just trying to be realistic. That huge tome didn't come out until after I'd already spent a couple of decades on Parnassus—all 1,073 pages of it.

ADORNO: It must have pleased you ... since you had so little luck publishing books before your death.

BENJAMIN: Let's be frank. In many respects, the arcades book is unreadable because it isn't a book in the usual sense. Even the editors called it "a torso, a monumental fragment or ruin ... the blueprint for an unimaginably massive and labyrinthine architecture"—

SCHOLEM: Stop this self-flagellation ... this lament!

BENJAMIN: Why? Didn't I write you in 1936 that "not a syllable of the actual text" exists as yet? I had collected hundreds of notes, quotes, truncated reflections ... and had barely categorized them by subject, using a color-coding system people haven't figured out to this day.

SCHÖNBERG: I think I understand what you're driving at. That by the time this so-called book was published . . . and I must confess that I've never read it . . . you had been up here long enough that everything you had ever written before was considered worth publishing?

BENJAMIN: Correct. And in my opinion, the *Arcades Project* was not yet ready to be published. For me, order is everything. Disorder is nothing. Too much had remained unwritten and none of it had as yet been ordered.

SCHÖNBERG: Perhaps its fame . . . not unlike that of the *Angelus Novus* . . . is based on the aura of the Walter Benjamin reputation rather than the intrinsic value of the work.

ADORNO: Let's not revisit that subject! But Walter, if what you say is right, isn't the incomplete nature of that work the best reason that you might have wanted to take it with you? To complete it later?

BENJAMIN (*getting impatient*): But you know that I had left it in the suitcases that eventually made their way to you. How could I possibly have had extra copies of this mass of scribbled notes and excerpts?

SCHOLEM: All right . . . accepted. So it was not the *Arcades Project*. What about your other massive unfinished work . . . your "Baudelaire: A Poet in an Age of High Capitalism" project?

BENJAMIN: Not a bad guess. You . . . better than anybody else among my friends . . . know how much Baudelaire meant to me and what I wanted to write through him about issues that really counted with me. Yet I had always felt that I would use the first person singular . . . the magic word *I* . . . only in letters . . . never in my other writing. Be it social criticism, cultural criticism, literary criticism . . . even Marxism. But for the interior, personal, self-reflective stuff, I, Walter Benjamin, needed surrogates for that *I* . . . and Baudelaire became my most important one.

ADORNO: That argument I'll buy.

BENJAMIN: Of course you'll buy it, since even in the *Arcades Project* there is more about Baudelaire than anybody else. Just look at the index: four long columns under Baudelaire compared to half a column for the two runners-up, Karl Marx and Victor Hugo.

SCHOLEM: So I guessed correctly?

BENJAMIN: In terms of importance? Yes. But no, there was no Baudelaire manuscript in that grip, not even my "The Paris of the Second Empire in Baudelaire" or "On Some Motifs in Baudelaire" texts.

SCHÖNBERG: Let me guess. Was it your "Philosophy of History" material or "The Work of Art in the Age of Its Technical Reproducibility?"

BENJAMIN: My, my! For such an outsider to come up with such a plausible guess is impressive.

SCHÖNBERG (*grins*): Actually, these are the only essays of yours I've ever read And even those only recently when I became aware of your infatuation with Klee's *Angelus*.

BENJAMIN: There are plenty of people who claim to know my writings but haven't read any more than that. Your assumption is not unreasonable, but Teddie Adorno can tell you that you're mistaken. When I saw Hannah Arendt and her husband in Marseille the last time, I left a collection of manuscripts with them, including the "Philosophy of History" text, which they were supposed to deliver to the Institute for Social Research in New York. That's how Teddy got it. So why would I have carried another copy with me?

SCHÖNBERG: What about the other essay . . . the one on art?

BENJAMIN: It had already been published in French a couple of years before my death.

SCHÖNBERG: But was it complete? Didn't you want to extend your generalizations? What about the theater? You hardly pay any attention to the status of theater work in terms of reproducibility—as multiple stagings, as revivals, as reconstructions, as model productions, and even as language changes through translations. Not to mention what actors do to a play every time they reproduce it through performance.

BENJAMIN: Maestro, you're getting warm! But you forget that the grip was heavy! This manuscript, especially if it were still as unfinished as you suggest, was light.

ADORNO: Stop teasing us. If Maestro Schönberg got warm, tell us in what sense! What did you carry with you?

BENJAMIN: One more hint. You know that in one respect, I was a firm believer in diversification.

ADORNO: Don't you mean dissipation? Didn't you yourself once call all your work "endlessly dissipated production?"

BENJAMIN (*laughing*): In the beginning dissipation and diversification are never that different . . . only the end result demonstrates the distinction. But no, that's not what I meant. It was the archivist in me who had started rather early to leave my manuscripts, notes, and reprints in the hands of various friends. You, your wife, and Gerhard are the best examples.

SCHOLEM: We were all guilty of that . . . if guilt is even the correct description. We all kept sending drafts, preprints, and especially reprints to each other.

BENJAMIN: How true . . . and how early in our lives that started. Take Gerhard. There he was . . . in his twenties, writing to his mother from Jerusalem about the fifty reprints he ordered of his first published article in Germany.

SCHOLEM: Walter! You're not going to tell them that story!

BENJAMIN (*grinning*): Why not? We're all undressing today. So Gerhard asks his mother to distribute these fifty reprints, and she replies desperately that she can't even find twenty among their relatives who might be interested and wouldn't it be fiscally prudent to reduce the reprint order from fifty to thirty!

ADORNO: Not a bad story about our great Kabbalist.

SCHOLEM: I'm not a Kabbalist! I'm a student of the Kabbalah . . . not a practitioner.

ADORNO: I stand corrected (*turns back to Benjamin*). But wait a moment, Walter! Are you suggesting that we ascribed the wrong motivation? That it was not preservation you were concerned about?

BENJAMIN (*amused*): Perhaps.

ADORNO: That you took it with you so that others couldn't see it?

BENJAMIN: Well? Why not pursue this tack. Look what happened with my address book, which I had left behind. Small as it was, even that has now been published!

ADORNO: I just got a copy of it through parnassus-libris.dei. I'm embarrassed to admit that I couldn't resist going through it. It only shows how much voyeurism there is—even among your best friends.

BENJAMIN: Even? I'd think that such voyeurism would be especially pronounced among my friends. But you, as one of them, must have been disappointed. Instead of salacious addresses, one can see into what kind of a Schnorrer I'd turned: Aid organizations, publishers—who often didn't even reply, let alone publish my work—

ADORNO: It wasn't that bad. There were also friends, lovers . . . even your former wife.

SCHÖNBERG: Stop! All of you. (*To Benjamin.*) You just virtually admitted that the grip didn't contain something to be preserved . . . but something nobody should see if you perished.

BENJAMIN: And what would be the motive?

SCHÖNBERG: Shame? Embarrassment? Fear?

BENJAMIN: How perceptive! After all, if I'd wanted to retain something valuable, I would have taken my *Angelus Novus* with me. I left it behind . . .

the single most valuable sheet of paper. So why would I have carried a satchel worth of pages with me?

SCHOLEM: But it had to be paper! Your entire life revolved around texts.

BENJAMIN: True enough. And assume for a moment that during that last year in Paris, I was thinking of writing something different . . . something that might be advantageous for me in my new life. Remember, I thought I might escape to join Teddie and Gretel in New York. In fact, I had started doing some research—

ADORNO (impatiently): But on what? How long are you going to draw this out?

BENJAMIN: I'm virtually there. Tell me, what is the most personal topic an intelligent man might wish to address?

SCHÖNBERG: Memory.

BENJAMIN: An interesting answer . . . and worth debating. But no, that's not it . . . not for me . . . memory was the underlying theme of too much of my past writing.

BENJAMIN (turns to Adorno): Teddie, what do you think?

ADORNO: Sex.

BENJAMIN (laughs): I thought you would come up with that answer. . . . Porno Adorno . . . no wonder they rhyme.

ADORNO: Now wait a moment! You can't tar me with that brush just because I happen to take Freud's side in that I consider psychoanalysis to be the only critical inquiry that seriously searches for the subjective conditions of objective irrationality. And that sex is the key.

SCHOLEM: Never mind Teddie's answer. (To Benjamin.) What's yours?

BENJAMIN: The same. It's a topic I have written virtually nothing about, but as you heard Dora say earlier . . . it's a subject that preoccupied me all my life.

SCHOLEM: I think she meant tortured all your life.

BENJAMIN: Torture and preoccupation are not necessarily mutually exclusive.

ADORNO: You called me Porno Adorno.

BENJAMIN: Why not? It rhymes . . . like Golem Scholem.

ADORNO: You just thought of that?

SCHOLEM: Walter is quoting from a poem by Borges called "El Golem."

That cabbalist who played at being God
gave his spacey offspring the nickname Golem.
(In a learned passage of his volume,
these truths have been conveyed to us by Scholem.)

ADORNO: That I like. But before I decide whether Porno/Adorno is meant as a compliment a la Golem/Scholem, first let me hear your definition of pornography.

SCHÖNBERG: And try to do it in language that does not require a lexicon or an encyclopedia.

BENJAMIN: Before I do, suppose you came across a satchel, a briefcase, a grip... or whatever you'd like to call it... that had been found after the owner's death. You opened it and found in it books, pictures, articles, objects... you name it... dealing with the following topics: pygophilia—

SCHÖNBERG: Never heard of it.

BENJAMIN: *Pyge* comes from the Greek... for buttocks.

SCHÖNBERG: Pygophilia... fondness for the rear end?

ADORNO (*laughing*): Ass licking in the vernacular.

BENJAMIN: Pygophilia would apply to both activities. (*Pause.*) Let me continue: Agalmatophilia. (*Pauses, then looks at Schönberg.*) Any comment?

SCHÖNBERG: I don't even know how to spell the word.

BENJAMIN: It refers to a fetish for statues or mannequins.

SCHÖNBERG: Good God!

ADORNO: Actually pretty tame. There used to be ancient statues with removable penises that were then used as dildos.

BENJAMIN: Presbyophilia...

SCHÖNBERG (*laughing*): Love of Presbyterians. Surely that is not improper?

ADORNO: From the Greek *presbus*... old man—

BENJAMIN: Also known as gerontophilia... love of old men.

SCHÖNBERG: At my age I consider this is commendable.

BENJAMIN: Coprophilia—

ADORNO: That's where I draw the line...

BENJAMIN: I'd expect you to, although I can well imagine that Porno Adorno indulged on occasion in coprolalia.

ADORNO: Lots of people like filthy language... they just don't admit it. I enjoy it... in moderation... in the right place.

BENJAMIN: Let me continue: Doraphilia...

SCHOLEM: Love of your wife Dora?

BENJAMIN (*to Schönberg*): Fondness for leather—

ADORNO: Preferably black...

BENJAMIN: And then evidence for (*quick*) pederasty and necrophilia... some pictures of genuphallation—

SCHOLEM: You mean genu (*hesitates*)... phallation? *Genu*, the Latin for knee?

BENJAMIN: Exactly. There are men who enjoy rubbing their membrum virile between the partner's knees. And then some flagellation accessories, a few dildos... say one with the face of a samurai and others of Buddha or the Virgin Mary—

SCHOLEM: Walter! Have you gone out of your mind? This is revolting—

BENJAMIN: Of course it is... some of it even blasphemous.

SCHÖNBERG: Most of it is pure pornography!

BENJAMIN: Agreed! Agreed! Agreed! But suppose you were found carrying such a collection with you—

SCHOLEM: I wouldn't be caught dead with it.

BENJAMIN: Well? Neither would I!

ADORNO: Wait a moment, Walter... wait! You don't mean—

BENJAMIN: Suppose I did?

ADORNO: I've stopped being amused.

BENJAMIN: You mean even you... Porno Adorno... are now revolted?

ADORNO: Just now I'm curious. Depending on your answer, I may also be revolted. So what is this all about?

BENJAMIN: Pornography, of course.

ADORNO (*interrupts*): What do *you* know about pornography? You've written nothing about the topic.

BENJAMIN: There's hardly a topic on which I haven't written something. Isn't that why you accused me of literary dissipation?

ADORNO: All right... I shall modify my statement. As far as I can recall, you have written nothing significant about porn. Remember... this is your friend asking: the one who edited the first posthumous publication of your writings.

BENJAMIN (*with irony*): I believe you *co*edited it.

ADORNO (*chastened*): Well... my wife helped. You can call it coediting if you wish. So where did you acquire that expertise?

BENJAMIN: Simple. There is interactional expertise and there is contributory expertise.

SCHÖNBERG: Translating this convoluted verbiage, you mean it is stolen from others if it's not created by oneself? In my life as a composer, this has been par for the course.

ADORNO: Maestro, forgive me for interrupting. Right now we aren't dealing with music. Pornography is about words and images... areas in which Walter has been both student and master. (*Turns to Benjamin.*) But Wal-

ter, what do you *really* know about pornography? For instance, when does erotica turn into porn?

BENJAMIN: Impossible to say. We all know there's no sharp boundary between legitimate and illegitimate literature.

ADORNO: In that case, at least tell us what *you* consider to be the essential difference.

BENJAMIN (*jokingly*): Erotica is what appeals to me. It becomes pornography in Adorno's cup of tea.

ADORNO: No jokes or stupid rhymes, please! I asked a serious question.

BENJAMIN: Sorry about that. But doesn't the etymology of the two words spell it all out? *Eros* is love, while *pornē* in Greek means harlot.

ADORNO: Walter! Don't patronize me with some elementary instruction in etymology. I also studied Greek in my gymnasium.

BENJAMIN: You're being touchy... uncommonly so, I'd say. But how can I answer your question, which is not only culture specific... take the ancient Greeks and homosexuality... but differs so much from person to person? For me, erotica leaves some details to the person's imagination... that subtlety is a fundamental component. Superb erotica is never explicit... you always need to add something on your own. It's an important filter that is always lacking in pornography. Porn is entirely explicit and solely for sexual arousal. Most of the time, its consequence is masturbation.

SCHÖNBERG: But since so much pornography is also about violence, doesn't it revert from fantasy back to reality. Violence begetting more violence?

BENJAMIN: I'm not sure how easy it would be to establish a cause and effect relationship. Violence arose long before pornography. But I'm not arguing the case for pornography or denying the absence of pain, humiliation, or violence... I take them as given. Let me present a nugget of information that ought to appeal to Gerhard. (*To Scholem.*) The other day, you piqued my interest when you mentioned googling under my name and then found over one million entries. So guess what I found? Nearly forty-four million entries under the word *erotica*.

SCHOLEM: Where did you do your googling?

BENJAMIN: At the usual place; the Parnassus Internet Café!

SCHOLEM: Usual? You keep surprising me. You used to hang out at very different cafés.

ADORNO: What's wrong with twenty-seven million hits for *erotica*? In fact, I'm surprised there weren't more.

BENJAMIN: I'm not finished yet. I then searched under the word *porn*. And what did I find? Around 207 million hits!

SCHÖNBERG: How many of those millions were garbage?

BENJAMIN (*laughing*): Perhaps all of them . . . considering that I was looking for pornography. But let me continue with my google popularity rating. The term *masturbation* has over forty million hits.

SCHOLEM (*laughing*): The mathematician in me must ask what conclusion you reached from this quantitative analysis.

BENJAMIN: None . . . other than that all three are very popular—with *porn* clearly leading the pack—and none likely ever to be outlawed successfully.

SCHÖNBERG: You were never tempted to search for *love*?

BENJAMIN: How typical of me that I forgot love! But that's really another subject. Now . . . all of you know how much attention I've paid to the question when a work of art turns into a commodity. Even Herr Schönberg has read my essay on that subject. So I asked myself: since pornography is mostly a commodity, what causative factor is responsible for its current rapid growth?

SCHÖNBERG: Technical reproducibility?

BENJAMIN: Of course.

ADORNO: But that still doesn't tell me why and how you became suddenly inspired to write about pornography. And what does that have to do with the contents of your briefcase . . . the very heavy one?

BENJAMIN: Let me finish with my comparison of art and pornography. Over time, as taste and technology changes, so does our perception of much of art or even what constitutes art. That's why some of my conclusions in my essay on the work of art in the age of its technical reproducibility have become outdated—

SCHOLEM: Because you couldn't leave Marxist dialectics alone! That's why!

BENJAMIN: Hardly that. These days some have called my essay "beautiful ruins in a philosophical landscape" . . . primarily as digital technology is taking over. (*Chuckles.*) At least they consider my ruins beautiful. But, be that as it may, in sex only one thing changes over time: the level of acceptance. It's tolerated . . . or it's forbidden, meaning it's erotic or it's pornographic. Sexual practices never become outdated.

ADORNO: Walter! This response . . . if that's what you would call it . . . is so typical of you: essentially nonfrontal, like the movement of the knight in chess!

BENJAMIN: And why not? To me, the inveterate chess player, the knight was always the most intriguing piece. I wanted to write something significant about pornography . . . as a complement or mirror image to my essay on art and technical reproducibility. But for that I needed examples—not just verbiage. As you said before . . . pornography is not only about words but also images and objects.

ADORNO: And that's what you carried with you over the Pyrenees?

BENJAMIN: Only the rarest examples.

SCHÖNBERG: Meaning the most valuable?

BENJAMIN: No . . . the most shocking.

SCHOLEM: Like the dildo with the Virgin Mary?

BENJAMIN: I prefer not to be more specific. And, of course, some books, which made it so heavy. But you know how obsessed I always was about books. Now do you understand why I didn't want anyone to find my grip?

SCHÖNBERG: Either you overlooked something or you're not telling us the whole story.

BENJAMIN: What makes you say that?

SCHÖNBERG: If you had not committed suicide and had reached Portugal, what about customs control?

SCHOLEM: Of course! How could I have overlooked that? Just imagine a Portuguese customs inspector . . . naturally a Catholic . . . finding a dildo with the head of the Virgin Mary? They would immediately have sent you back . . . or perhaps even arrested you.

BENJAMIN (*laughs*): You are right about that dildo. I made this up . . . because I wanted to test your shock threshold for pornography.

SCHOLEM: Well . . . you just crossed mine! I'll admit to indulging every once in a while in what some might call dirty literature—reading that I would simply call titillating—but blasphemous dildos are simply beyond the pale.

SCHÖNBERG (*to Benjamin*): Was all of it made up?

BENJAMIN (*now serious*): Only that I didn't carry any devices or pictures that even an ignorant customs agent might have picked up. It was all notes . . . and some books.

SCHOLEM: And why would they not draw the attention of a customs inspector?

BENJAMIN: Gerhard! You and Teddie were always complaining about my minute handwriting. Do you think any customs agent could have deciphered my scribbled German notes? Yet these were the irreplaceable part.

SCHOLEM: And the books?

BENJAMIN: Some rare French and German seventeenth- and early eigh-teenth-century erotica. You know how possessive I was about books . . . almost as much as you! What Portuguese or American customs inspector would have paid attention to them? Do you now understand why I told Henny Gurland on that last day to destroy the contents without looking at them? But one thought still haunts me. Did she bury the grip . . . or did she burn it?

SCHOLEM: What's the difference? It's gone.

BENJAMIN: What if she buried it?

SCHOLEM: You mean in your grave?

BENJAMIN: It's not impossible. Yet didn't people say my so-called grave was empty when they opened it some years later? Was it empty because someone absconded with that grip?

SCHÖNBERG: Don't tell me you're afraid somebody might blackmail you?

BENJAMIN: It's not inconceivable.

SCHOLEM: After all those years?

BENJAMIN: I don't even know whether blackmail is an operative concept on Parnassus. But inadvertent disclosure? Of a secret that, if it came to light one day, might cast a shadow over everything I'd accomplished?

ADORNO: Walter, are you just being paranoid or is there more behind this?

BENJAMIN: You all must have heard of a famous author—still alive, though already up here—in possession of a dark secret that he had to realize would eventually surface—

5.3. Gabriele Seethaler, *Cemetery, Port Bou, Spain*.

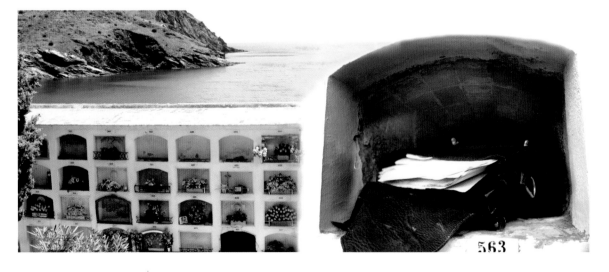

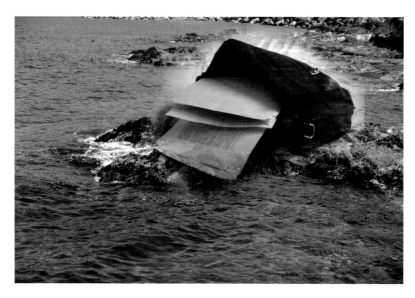

5.4. Gabriele Seethaler, *Sea Around Port Bou, Spain, with Benjamin's Grip.*

ADORNO: Who are you talking about?

BENJAMIN: I don't like to name names. But he's German and so famous, he was even anointed with the Nobel prize. He kept a foul secret to himself for half a century, but now it's out. Are they going to kick him out of here?

ADORNO: Let's not go off on such a silly tangent. I know who you're thinking of and whatever damage was caused was not only self-inflicted but also based on fact. You, however, are worried that this material . . . pornographic as it clearly is . . . will tar you as an active pornographer or practitioner. And you aren't that or (*Pause.*) . . . are you?

BENJAMIN: Teddie!

ADORNO: Relax. This is not the inquisition but your friend Porno Adorno asking. All you need to explain . . . in front of three witnesses . . . is how you ever got hooked on the idea of writing about porn in the first place. Once that's clear, nobody will blame you for holding such research material.

BENJAMIN: It started with Georges Bataille at the Bibliothèque Nationale.

ADORNO: Ah yes . . . Bataille and his friend Caillois with their Collège de sociologie sacrée. We did correspond, but never met. Even though I disagreed with him on two essential points . . . that the Enlightenment broke away from religion and that myth is as ideological as reason. He never accepted either view. But I was always thankful that he hid your papers in the Bibliothèque Nationale. Yet how well did you know him?

BENJAMIN: I went to some sessions of his Collège de sociologie—

SCHOLEM: What does all that have to do with pornography?

BENJAMIN: Plenty. He was a librarian at the Bibliothèque Nationale, and you all know how much time I spent there. His heroes were Hegel and Nietzsche, Marx and Freud ... and especially the Marquis de Sade—

SCHÖNBERG: What a mixture!

ADORNO: Careful! Don't automatically condemn someone just because of their interest in the Marquis de Sade.

BENJAMIN: True enough. Didn't you have an entire chapter on him in your *Dialectic of Enlightenment?* But the common denominator in Bataille's personal philosophy was his acceptance of everything powerfully disruptive to conventional society: from deviance such as incest to defilement such as human sacrifice ... from violence and death to necrophilia—

SCHOLEM: Now I see it coming.

5.5. Carl Djerassi and Gabriele Seethaler,
Collage of Pornographic Lexicon Entries.

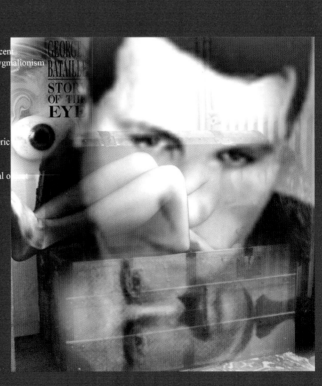

SEXUAL FETISHES:

To Specific Items -
Acousticophilia - arousal from sounds
Adolescentalism - cross dressing or playing the role of an adolescent
Agalmatophilia - arousal from statues or manikins; also called pygmalionism
Altocalciphilia - high heel fetish
Anaclitism - arousal from items used as infant
Doraphilia - arousal from animal fur, leather, or skin
Entomophilia - arousal from insects or using them in sex play
Exophilia - neophilia; fetish of the unusual or the bizarre
Galateism - agalmatophilia; sexual attraction to statues
Hyphephilia - arousal from touching skin, hair, leather, fur or fabric
Iconolagny - arousal from pictures or statues of nude people
Pediophilia - arousal from dolls
Pictophilia - arousal from pictures, video, or movies with a sexual o
Retifism - shoe fetish

To Specific Environments -

Acrophilia - arousal from heights or high places
Actirasty - arousal form exposure to sun's rays
Agoraphilia - arousal from open spaces or having sex in public
Agrexophilia - arousal from others knowing you are having sex
Albutophilia - arousal from water
Amomaxia - sex parked in car
Antholagnia - arousal from smelling flowers
Barosmia - arousal from smell
Capnolagnia - arousal from watching others smoke
Gregomulcia - arousal from being fondled in a crowd
Lygerastia - tendency to only be aroused in darkness
Melolagnia - arousal from music
Mysophilia - arousal from soiled clothing or foul decaying odors
Thalpotentiginy - arousal from heat
Undinism - arousal from water

BENJAMIN: Under various pseudonyms, he started writing what he thought was erotica, but what many others would call extreme pornography. Eventually, some called Bataille the twentieth-century Sade. None of it was published while we knew each other, but we talked and argued. He introduced me to *l'enfer*—

ADORNO: Ah yes . . . the hell I would have loved to have visited.

SCHOLEM: Even I would have been tempted. When it comes to library research, I draw no limits.

SCHÖNBERG: What are you talking about?

BENJAMIN: The hell or *l'enfer* in French . . . is the locked pornographic section of the Bibliothèque Nationale. Bataille, who regarded the brothels of Paris as his true churches, was my guide in that hell. He was even the one who showed me the bordello right next to the library . . . pointing out that the all too frequent extreme tumescence produced by some particularly juicy passages in *l'enfer* is preferably released in vivo in the brothel rather than single-handedly in the stacks.

SCHOLEM: And that prompted an entire section on bordellos and gambling in your *Arcades Project*?

ADORNO: There is much more about gambling than whoring.

BENJAMIN: Gerhard does not approve of either. But Bataille had nothing to do with my including prostitution in the *Arcades* notes . . . after all, bordellos played an intrinsic role in nineteenth-century Paris and in Baudelaire's life.

SCHOLEM: Don't forget that chapter in your *A Childhood in Berlin Around 1900*.

ADORNO: What chapter? Remember, I was the editor of that book when it first came out.

SCHOLEM: About his sexual awakening.

ADORNO (*dismissive.*) Oh that! All of one page!

BENJAMIN: And quite discreet. When I first encountered a prostitute on the street, I simply wrote that "for the first time I sensed the nature of the services that she might provide in response to my awakening urge."

SCHOLEM: As the guardian of your reputation, I thought it was a bad idea publishing it.

ADORNO (*laughs*): Gerhard, you're such a prude!

SCHOLEM: I object! Personally, I was never a prude! But as a guardian of Walter's reputation? Perhaps.

ADORNO: What Walter wrote was neither erotica nor porn. It was dainty descriptive prose.

BENJAMIN: Sexual initiation was typical of the debates and arguments I had with Bataille... meaning how they might be depicted. My allusion about the teenager's temptation by a prostitute... or all I ever wrote about prostitution, for that matter, could not possibly be called pornographic. Bataille's views of sexual initiation were much more brutal, much more confrontational... and hardly ever more so than when he illustrated them through incest with his sadomasochistic, lesbian mother... whom he depicted as a god seducing her son to the highest truth, namely, the path of sensuality. But that is how I became hooked—

SCHÖNBERG (*shocked*): By incest between mother and son?

BENJAMIN: No... by reflecting what pornography might mean to me.

ADORNO: Might mean? Not did mean?

BENJAMIN: At that time, it just meant "might mean." As Bataille used me as a foil for his belief in a direct link between sex and death or the irresistible need for humans to transgress, I started to formulate my own views about the boundary between erotica and porn. For me, the more the sexual content is aesthetically veiled to challenge the imagination of the reader, the more erotic I find it. Porn enters as the veil is ripped away... when there is no more room for personal, private imagination. Naturally, mentally we may still edit and rearrange its content before we masturbate.

ADORNO: Did Bataille buy that?

BENJAMIN: His hard erotomaniac intellectualism just caused him to guffaw at my soft-porn views when I explained that for me silk or velvet were erotic, but leather and metal pornographic—

ADORNO: Now I see why Gretel wrote you that letter: "To assist your fantasy, I am enclosing a small swatch of material... to be caressed!" Was that velvet?

BENJAMIN: Teddie, I'm not the only one who finds silk or velvet arousing. Or take colors: I consider red erotic, but black? There's always a touch of illicit porn associated with that color. Somehow, you always feel a bit dirty when you dip into pornography...

ADORNO: I never knew that side of Bataille until I got up here and continued reading. That's when I came across his own posthumously published books... *My Mother* or *Madame Edwarda*—

BENJAMIN: Which he wrote under the name Pierre Angélique or as Lord Auch for his most famous pornographic creation, *The Story of the Eye*, which he never publicly acknowledged having written. Strange... we both used pseudonyms, because we were afraid: I, because I thought my articles would not be published if people knew I was a Jew. And he, in case

he might lose his position at the library if people knew he was such a provocative pornographer.

SCHOLEM: What caused you to collect those shocking contents of your grip?

BENJAMIN: As I already told you, it was research. Bataille opened my eyes to an area of porn I had never been attracted to—

SCHÖNBERG: Quite frankly, I didn't even know of the existence of some of the practices you alluded to. Monogamy . . . and its violation . . . just about covered the range of my sexual imagination.

BENJAMIN: Perhaps because you dealt mostly with music. And that's porno free—

SCHÖNBERG: Unless it is accompanied by words.

ADORNO: That's why there are no pornographic composers. Sexually provocative words in a musical work assume the same function as filthy pictures in an erotic text. It's only when these words or images make explicit what was left open to interpretation that we enter the terrain of pornography. The person who adds that explicit component is the pornographer.

BENJAMIN: Bataille was the ultimate far-out solo pornographer. He used no pictures, often he described no explicit sex, but rather focused on the interior motivation for violating taboos through shocking perversions, even extreme blasphemy. By definition, he felt that his erotic writing had to be transgressive and unacceptable.

SCHOLEM: How appalling!

BENJAMIN: I won't defend Bataille—not anymore than I will defend pornography—but there is no question that his writings had literary merit. Just consider a sentence like this: "The mind's pleasure, fouler than the body's, is purer and the only one whose edge never dulls." But in order to write about what I'd call common pornography . . . lacking any aesthetic component . . . and inquire into its growth, I needed to read about its extreme excesses and practices beyond what Bataille and I debated. (*To Scholem.*) Gerhard, why are you looking at me like that? I'm referring to research, not personal experiments.

SCHOLEM: Pretty unappetizing research.

ADORNO: I don't know about that. Appetizing is hardly an adjective I would ever use for research.

BENJAMIN: But as you know, I never wrote anything about the topic. I died while I was still educating myself. So there it is: my answer to the puzzle of my lost grip.

Long pause.

(*Turns to Schönberg.*) Earlier on, you made a justified complaint about the short shrift I gave to theater in my essay on the work of art in the age of its technical reproducibility. Of course, in theater the changing composition of the audience also modifies the acting of the players in every performance … quite distinct from film. Might this also apply to pornography? Take us here … a minute sample. Yet I am sure that much pornography … and not just Bataille's extreme one … will be perceived very differently by the three of you.

ADORNO: Meaning that none will surprise me?

BENJAMIN: Or, more relevantly, that much will be new to the maestro.

SCHÖNBERG: I'm not ashamed to agree with that statement.

SCHOLEM: What about me?

BENJAMIN: I can't say. In all the years of our correspondence, we've never touched on the subject of sex … other than that silly contretemps about my childhood remembrance. Just think how much I, your closest friend, did not even know about your relationship with Escha! But I suspect that at the very least you'd condemn all porn and perhaps even erotica.

SCHOLEM: Hmm.

ADORNO: That sounds very noncommittal.

SCHOLEM: I meant it to be. I most certainly do not condemn erotica. I've even been known to dip into some soft porn—

BENJAMIN: No matter. The question I want to raise is to what extent knowledge of new or unusual sexual practices depicted in pornography might change one's own view—

SCHÖNBERG (*interrupts*): Exactly what I said earlier. That violence in pornography would beget violence.

BENJAMIN: There is much pornography that is not violent in the conventional sense, but unusual—

SCHOLEM: Don't you mean perverted?

BENJAMIN: Yes and no. Again take us here. I am sure that Porno Adorno will see less perverted sex than Judge Scholem or the virtuous Schönberg.

SCHOLEM (*interrupts*): Calling me *Judge* Scholem implies that I'm a prude. And only because I may draw a sharper distinction between porn and erotica than Adorno or you? How often do I have to repeat that in sexual matters I'm no prude? I just didn't flaunt it.

ADORNO: Because it wouldn't have fit the public image of a scholar of Jewish mysticism?

SCHOLEM: Precisely!

BENJAMIN: Your writings were much too antinomian for me to ever paint you as a prude. But to what extent does exposure to pornography affect the viewer's or reader's subsequent sex life … beyond masturbation?

ADORNO: This is a very circular argument. But why raise it?

BENJAMIN: A remarkable feature of this modern Parnassus is one that your wife has already commented upon. That modern technology keeps being introduced up here almost seamlessly.

SCHOLEM: You mean Internet cafés—?

ADORNO: Or Internet availability of books through Parnassus-libris.dei?

BENJAMIN: Precisely. And what do I find? That my somewhat simplistic view in 1940 of the spread of pornography through technical reproduction has reached incredible proportions since it is now combined and compounded by technical transmission.

SCHÖNBERG: What are you driving at?

BENJAMIN: Just come with me to one of the Internet cafés and look at the range of Internet porn sites. It's turned into a huge industry.

SCHÖNBERG: Why should I? I have not even been curious enough after our earlier conversation about googling to see how many hits of garbage there are about me.

BENJAMIN: Still, why not come with me and look at some of the porno sites … with all their airbrushed carnality. It will tell you what's now going on down on earth in that area. What if the next step is the appearance of interactive porno sites? What will that do to sex and erotica in the future?

ADORNO: I pride myself at always keeping a mind open to new ideas, but somehow the solitary nature of such potential cybersex repels me. But Walter, do I sense something proud or proprietary behind these last remarks of yours?

BENJAMIN: My perceptive Teddie! As I observe the current psychosocial sexual scene down there—

SCHOLEM: Walter! You mean you've been spending that much time at the Internet Café? Why?

BENJAMIN: Research. I've come to realize how spectacularly prescient I was in 1940 to pick "Pornography in an Age of Technical Reproducibility" as my latest theme. The only change I should have made … and would make now … is in the title, replacing *Reproduction* by *Transmissibility*.

ADORNO: Hold it, Walter! From Parnassus, you can *observe* the scene on earth … now and in the future. You can even gloat about what you call your prescience. But you cannot use *any* of it, because your own creativity

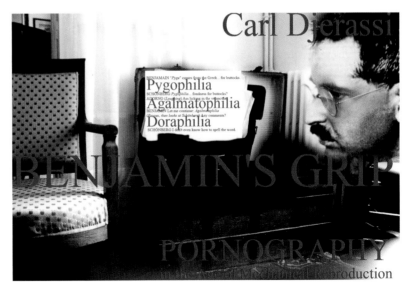

stopped the day you died. That's why our use of computers is not allowed here and that's why e-mail access is blocked at all Parnassus Internet Cafés. (*Pause.*) Now if others, still living, conclude that you foresaw what you just said . . . that would be another matter. But, for that, your grip and its contents would suddenly have to surface before anyone would credit you with foresight about the Internet porno explosion.

SCHÖNBERG: What a conclusion! (*Turns to Benjamin.*) You have my sympathy.

Long pause.

BENJAMIN (*reflective*): Isn't it curious? Not so long ago, I asked you . . . Teddie and Gerhard . . . to meet me for an answer to some missing facts. (*To Adorno.*) You brought along Herr Schönberg, who certainly couldn't have helped since he didn't even know me before. So what happened instead? First, I am confronted by my former wife with questions I did not wish to address. Then Herr Schönberg proceeds to demolish the only significant work of art I ever possessed—

SCHÖNBERG: You owned two Klees, not one. And I certainly did not demolish your *Angelus Novus*—

BENJAMIN: There are times when deconstruction turns into demolition. And in my book your Hitlerian interpretation went well along toward demolishing that drawing. Now, it is tainted in perpetuity.

SCHÖNBERG: I addressed the work's canonization... not its aesthetic quality. You... more than any of us... ought to be interested in that process... as a canonizer as well as a canonizee. You completely misunderstood my critique.

BENJAMIN: Perhaps I did not wish to understand it. But, instead of addressing the issue I came to discuss, I was led down one garden path after another: wifely confrontation... Klee demolition... (*turns to Scholem*) debating what it means to be a Jew... and then all of you questioning *me* about the one topic where I could provide the answer to your nagging curiosity. Well? I satisfied it. You now know what I schlepped over the Pyrenees. But what about satisfying *my* concern? (*With emphasis.*) Where was I buried? How often do I have to ask? Are you hiding something?

SCHOLEM: Only secondhand information.

BENJAMIN: Better than no information.

SCHOLEM: I doubt it. But let me tell you what I read a few years before my death. That some Spaniards, on checking the Port Bou cemetery files once more, discovered that an empty crypt, no. 563, had been rented for your remains.

BENJAMIN: Rented? What does that mean?

SCHOLEM: Your companion on that flight, Henny Gurland, paid the grave rental for five years. But once that fell into arrears, someone else took it over. A Spanish family, named Morell. Apparently they took good care of it.

BENJAMIN: With my remains in it?

SCHOLEM: They were removed.

BENJAMIN: Where to?

SCHOLEM: Walter... please don't persist.

ADORNO (*kind, warm voice*): Walter... consider where you're asking this question: on Parnassus! (*Pause.*) In a Parnassian sense you aren't buried, because you haven't died. There are people up here who are truly buried as historical footnotes. People, whose works or ideas once flourished, but to whom nobody pays any more attention. And there are those whose ideas proved to be false after they got here. Their graves have been opened and their remains quietly exhumed. All they're left with is some tombstone down below. But then there are some whose ideas continue to flourish... who offer sustenance to generations of thinkers long after their earthly demise. They are not dead. You are one of them. You shouldn't pine after a nonexistent grave on earth... you ought to be

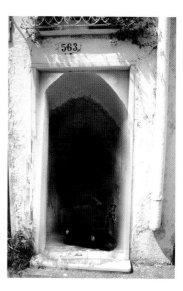

5.7. Gabriele Seethaler, *Walter Benjamin's Open Grave, No. 563, with Benjamin's Grip, Port Bou, Spain.*

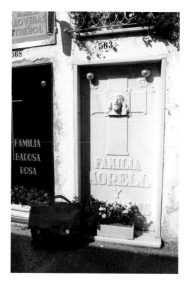

5.8. Gabriele Seethaler, *Walter Benjamin's Grave, No. 563, Port Bou, Spain.*

satisfied that as yet there is no Benjamin tomb on Parnassus. Well? (*A pause during which Benjamin does not reply.*) Walter! Answer me!

BENJAMIN: Nolo contendere.

SCHOLEM: That, Walter, is a cheap answer.

BENJAMIN: Not cheap. Just cowardly.

SCHOLEM: Not even that ... it's unworthy of you. In the end, even Dora ... your only wife ... didn't accept nolo contendere as an answer. Why should your friends? When one of them just paid you the ultimate compliment: Even though we can create nothing more on Parnassus, on earth your ideas continue to lead to wild proliferation—

BENJAMIN (*with mild irony*): "Wild proliferation" has a pejorative whiff—

ADORNO: How can it? The Latin root of proliferation is *proles* ... progeny. You can't just expect perfect children ... intellectual clones. Let them go in all directions ... meaning that some will go forward. One can't ask more than that. Otherwise, one is truly buried. What was that tombstone inscription you were pining for?

BENJAMIN: "It is more arduous to honor the memory of the nameless than that of the renowned."

SCHÖNBERG (*disdainfully*): Of course it's more arduous, but is it relevant? There are no nameless on Parnassus.

SCHOLEM: Remember how you started when we first met?

BENJAMIN: No ... remind me. You, the collector of all my written and perhaps even spoken detritus.

SCHOLEM: "Vorbei—ein dummes Wort." (*Pause.*) And then you called it Goethe's tritest quote.

BENJAMIN: You don't consider it trite?

FEMALE VOICE (*offstage*): Oh you men! Stop quibbling!

SCHOLEM (*taken aback, to the others*): Whose voice is that?

FEMALE VOICE (*offstage*): Whether you're quoting Goethe or not, saying, "Gone ... what a stupid word" is not trite ... not here, on Parnassus. That's what got all of us up here.

SCHOLEM: "Us?" Who is she? There's something familiar about that voice.

BENJAMIN: Hush! I want to hear the rest.

FEMALE VOICE (*offstage*): But it is trite as far as you ... Walter Benjamin ... are concerned.

BENJAMIN (*exclaims*): My God! It's Hannah Arendt.

ARENDT (*offstage*): I thought you'd recognize my voice. (*Steps forward.*)

SCHOLEM: What are you doing here?

ARENDT: On Parnassus? I got here by myself.

SCHOLEM (*outraged*): For writing *Eichmann in Jerusalem*? With the obscene subtitle *The Banality of Evil*?

ARENDT: Back then, you certainly made your disapproval clear—

SCHOLEM: By cutting off all further contacts.

ARENDT: A polite term for excommunication . . . a judgment exercised by so many of your fellow Zionists. Somehow, I'd expected better from you.

SCHOLEM: Why? For me, some of the worst anti-Semites are Jews. And then defending your Nazi ex-lover Heidegger! They shouldn't have let you up here!

ADORNO: Stop it, Gerhard! We all know the subtitle to her Eichmann book was a terminological infelicity—

SCHOLEM (*interrupts infuriated*): *The Banality of Evil* a terminological infelicity? How preposterously delicate you put it! It was an ideological profanity, stating that vicious evil was not a prerequisite for complicity in a diabolic crime!

ADORNO: She did have a point in identifying evil with the trivial. That doesn't have to mean that evil is trivial, but rather that the trivial is evil. But there were other reasons for Hannah's arrival on Parnassus. Just take her *Origins of Totalitarianism*. That came out twelve years earlier and dramatically illuminated the problem of political evil in the context of the gutter-born Nazi ideology.

ARENDT: And got me a professorship at Princeton . . . the first woman in that male bastion . . . as well as a Guggenheim fellowship.

SCHÖNBERG (*whispers*): You see? She got one and I didn't!

ARENDT: I didn't come to revive old arguments . . . and least of all the *Banality of Evil*. If I could do it over again, I would have changed the title. Actually, it was my husband Heinrich . . . my goyish husband, Heinrich Blücher . . . for whom I'd wanted a Jewish funeral with the Kaddish spoken—

SCHOLEM: Now that I didn't know.

ARENDT: Gerhard, there's lots you didn't know, because you didn't want to listen. Just think of our last public exchange of letters in 1963! So now, for a change, listen. It was Heinrich, who first suggested the title, but since I accepted it, I also accept the consequences. But by *banality* . . . that infelicitous word . . . I never meant the death of millions of fellow Jews.

For me ... at that time ... the word solely defined the specific quality of mind of one of the chief perpetrators. But I will not allow anyone ... not even one of the greatest scholars of Jewish mysticism of all time ... to tar me with the brush of Jewish self hatred or anti-Zionism. Arrogance, perhaps—

SCHOLEM: And tastelessness.

ARENDT: Tastelessness is a matter of taste ... so I shall not dispute that comment. But must I really remind you of all my earlier involvement and writings about Jewish and Zionist politics ... my work in Paris to help settle children in Palestine ...

BENJAMIN (*gently*): Hannah ... you needn't go on.

ARENDT: Other than conclude that my ambivalence ... and even what Gerhard calls tastelessness ... is nothing but a reflection of the interior struggle that the German secular Jews of our generation had to fight continuously.

ADORNO: I don't wish to enter into this argument or prolong it, but one point must be made. You, Hannah Arendt, in your book and long before, did not disguise your contempt for the *Ostjuden*, the religious Yiddish-speaking Jews from Poland and Russia. Of course, that sort of selective Jewish anti-Semitism was typical of so many German Jewish bourgeois—

ARENDT: My dear Adorno. I'm honest enough to plead guilty to your accusation, but didn't that also apply to at least some degree to the rest of you?

SCHOLEM: Perhaps to my parents ... but never to me! Not even as a teenager.

ARENDT: Exception granted. Still, much of what you four debated just now ... your own differences ... illustrate the never-ending self-torture of the secular German Jews. But you all seem to forget something.

ADORNO: Namely?

ARENDT: Who first got Walter on Parnassus—?

ADORNO (*suddenly outraged*): What?

SCHOLEM (*equally outraged*): *You* got Walter up here?

ARENDT: You interrupted me ... the way you used to down there ... at least in that regard your manners have not changed. I was about to say that I brought Walter across the Atlantic to a new generation of readers way beyond your tight circles of German philosophers ... by editing his *Illuminations* ... and that's why I came to interrupt you. I've been listening to you for the past few hours—

SCHOLEM: You have been snooping around? Not even daring to show your face?

ARENDT: Stop spouting nonsense. Parnassus is no longer a male club. I happened to be passing through the neighborhood when I heard loud, familiar voices. You may accuse me of curiosity or tastelessness . . . but not of snooping.

BENJAMIN: Hannah . . . go on. What made you stop . . . and then join us?

ARENDT: I've always been proud of helping to get you up here—

SCHOLEM *(interrupts)*: How often do you have to be told—

BENJAMIN: Gerhard, please let Hannah finish.

5.9. Hannah Arendt.

ARENDT: I couldn't pass up the chance to point out to all of you that Goethe's phrase "Vorbei—ein dummes Wort" isn't trite, nor the word *Vorbei* . . . in other words, *past* or *gone* . . . a stupid word. It just happens to be inappropriate under the present circumstances. You wouldn't be *the* Walter Benjamin, if it's only your past work that counts up here. As Teddy Adorno just said, it's what others have done with it since . . . that's crucial. I wanted to leave you with a variant of that phrase before I withdraw.

SCHOLEM: I don't want to hear it.

ADORNO: Gershom, this should be Walter's prerogative. (*Turns to Benjamin.*) Well?

Long silence

ARENDT: Well, Walter? Do you?

BENJAMIN: I'm not sure.

ARENDT: An answer you gave me all too often down there. But I shall ignore it this time. Instead of "Vorbei—ein dummes Wort" you should have said, "Danach . . . ein kluges Wort."

BENJAMIN: "Subsequent . . . a wise word" instead of "Gone . . . a stupid word"? Where did Goethe say that?

ARENDT: He didn't. I did. Which brings me to my other purpose . . . a comment on your tombstone obsession. Your two friends here . . . Teddie and Gerhard . . . don't approve much of me. There is another friend of yours . . . of whom they've been even more critical.

SCHOLEM: Bertolt Brecht.

ARENDT: Yes . . . Bertolt Brecht . . . who probably understood you better than any of us . . . who, before anyone else, wrote that your death was the first loss Hitler had caused German literature. Pay attention to some lines Brecht wrote around the time you first thought about committing suicide.

5.10. Gabriele Seethaler, *Walter Benjamin's Face Superimposed Upon Bertold Brecht's Grave.*

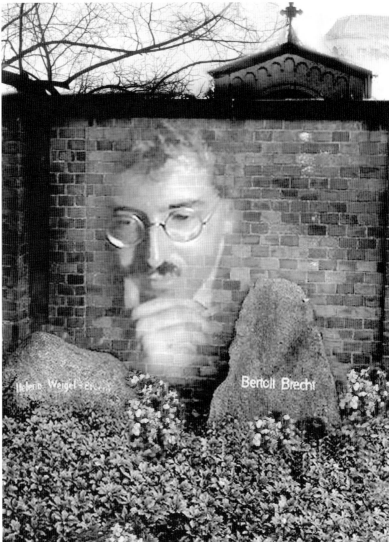

I need no gravestone, but
If you need one for me
I would like it to bear these words:
He made suggestions. We
Carried them out.

Don't you think Brecht may also have meant those words for you, Walter . . . the grand master of suggestions? As Brecht ended,

Such an inscription would
Honor us all.

END

NOTES

Preface

1. Carl Djerassi, *Steroids Made It Possible* (Washington, DC: American Chemical Society, 1990).
2. Carl Djerassi, *The Pill, Pygmy Chimps, and Degas' Horse* (New York: Basic Books, 1992).
3. Carl Djerassi, *This Man's Pill: Reflections on the Fiftieth Birthday of the Pill* (Oxford: Oxford University Press, 2001).

1. Four Men

1. An early example of their testy relationship in Vienna can be gleaned from two letters written by Adorno to his friend Siegfried Kracauer. In 1925 Adorno wrote that Schönberg "talked to me like Napoleon to a young Adjutant, who had just arrived from a distant battlefield. Naturally Napoleon had to express some interest, even though he had long forgotten its relevance." And a year later, Adorno wrote that "he is irritated at me since I have a deep relationship with Berg rather than devoting myself to him [Schönberg]. He seems to have a real Wiesengrund Complex and even quarreled with Berg about me."
2. Numerous CD versions are available such as *Jewish Cello Masterpieces* (Richard Locker, cellist) from Leggiero Records, New York, NY.
3. Available as CD (SWR Sinfonieorchester, conducted by Michael Gielen), Hänssler Classic, Holzgerlingen, Germany. Note that Schönberg's work is entitled *Kol Nidre*, in contrast to Bruch's *Kol Nidrei*.

2. Four Wives

1. While Scholem used here the spelling *Fanya*, most other references refer to her as *Fania*, and this is the spelling that is retained here. *Fanja* was also used on occasion as for instance by Dora Sophie Benjamin.
2. In the correspondence between the Adorno family and Benjamin, the name is sometimes spelled *Felicitas*. In the sequel both spellings of the name are employed consistent with its use in the written records.

3. This excerpt from "Sonnet 11 (Vom Genuss der Ehemänner)," in Bertolt Brecht, *Brechts Gedichte über die Liebe,* ed. W. Hecht (Frankfurt: Suhrkamp, 1982), was translated by Carl Djerassi.

3. One Angel (by Paul Klee)

1. The play has already been staged in London (New End Theatre and King's Head Theatre, 2005) and New York City (Cherry Lane Theatre, 2007) and published in German translation: Carl Djerassi, "*Phallstricke/Tabus: Zwei Theaterstücke aus den Welten der Naturwissenschaft und der Kunst*" (Innsbruck: Haymon, 2005).

2. Subsequently given brief mention (see the bibliography) by Geoffrey H. Hartman, of Yale University, in a footnote (5) to his "Benjamin in Hope" without further citation.

3. www.schoenberg.at/6_archiv/music/works/no_op/compositions_Fruehe_Lieder.htm.

4. In English-language texts, Benjamin's original German title, "Das Kunstwerk im Zeitalter seiner technischen Reproduzierbarkeit," is most commonly (yet also incorrectly) translated as "The Work of Art in the Age of Mechanical Reproduction." In the present text, I have chosen to use the correct translation: "The Work of Art in the Age of Its Technical Reproducibility."

5. CD available in *Musik in Deutschland 1950–2000* (www.bmgclassics.de and www.musikrat.de/index.php?id = 765&cd_id = 37) RCA 74321 73630 2.

6. CD (Skifan SCD 226) available through www.egill-olafsson.com.

5. Benjamin's Grip

1. Additional support has been provided by the publication in 2006 of *The Narrow Foothold*, a memoir written in 1975 by Carina Birman, who crossed the Pyrenees on the same day as Benjamin and stayed overnight in Port Bou in the same hotel where, in her words, "he had some very effective poisonous pills with him." The following day, she witnessed the arrival of a priest and monks to say a requiem at Benjamin's deathbed.

BIBLIOGRAPHY

THE DESCRIPTION of this book as a docudrama implies documentation, in other words, factual evidence. I have taken this restriction very seriously and, with two exceptions, every incident and many quotations are based on research in the sources listed in the bibliography and from interviews or correspondence with a large number of persons who are identified by name in the acknowledgments. Hence an important *caveat lector* relates to two exceptions that are not based on the historical record.

The first is the putative letter mentioned in the Gretel Karplus/Theodor Adorno/Walter Benjamin trialogue in chapter 2, according to which Benjamin proposed to Adorno that they should finally switch from the formal *Sie* to the informal *Du*. This would have been much more consistent with their personal intimacy and with the tone of the many letters in which they always addressed each other by their first names. In actual fact, they always stuck to the *Sie* address. Any reader will have noticed the reluctance of all four of my German-speaking male protagonists to employ the informal *Du*. That avoidance was typical of their early twentieth-century German bourgeois intelligentsia background. I highlighted this behavior to contrast it with the extraordinary rapidity with which Benjamin and Adorno passed from *Sie* to *Du* with some of their women. In heterosexual social intercourse among adults in Germany and Austria—especially at that time—the trigger for the sudden drop of linguistic formality frequently indicated sexual intimacy. In view of all the other historically documented *Sie/Du* transformations in my book, why did I find it necessary to invent this particular letter of Benjamin's? Quite simply, because it offered me a psychologically plausible illustration of the role that Gretel Adorno (née Karplus) played in Adorno's life.

The second invention occurs in the last chapter ("Benjamin's Grip") with reference to the contents of Benjamin's lost briefcase or "grip." I base this conversation and its consequences on the historically grounded acquaintance of Benjamin with the philosopher, librarian, and well-known author of erotica and pornography Georges Bataille, who hid many of Benjamin's papers in the Bibliothèque Nationale upon Benjamin's flight from Paris. Since the fate of that briefcase and its contents has never been determined, I have allowed myself the authorial liberty to assume that Benjamin's intention was not the preservation, but rather the destruction of the contents in the event he should not survive his flight from France in 1940. Once that rather plausible premise is granted, then the scope for further authorial

speculation about the nature of the contents is widened enormously. My speculation may well arouse anger in the realm of hagiographic Benjaminiana, but hagiography is an outcome I have tried to subvert throughout this work.

Benjamin

A. Koestler. *The Invisible Writing: An Autobiography*, pp. 420–421. New York: MacMillan, 1954.

A. Koestler. *Scum of the Earth*, p. 280. 1st American "Danube" ed. New York: MacMillan, 1968.

W. Benjamin. *Über Haschisch*. Ed. T. Rexroth. Frankfurt: Suhrkamp, 1972.

W. Benjamin. *Walter Benjamin Gesammelte Schriften*, I 2a: 431–707. Ed. R. Tiedemann and H. Schweppenhäuser. Frankfurt: Suhrkamp, 1978.

W. Fuld. *Walter Benjamin: Zwischen den Stühlen*. Munich: Hanser, 1979.

B. Witte. *Walter Benjamin*. Reinbeck b. Hamburg: Rohwolt, 1985.

W. Benjamin. *Berliner Kindheit um neunzehnhundert*. Frankfurt: Suhrkamp, 1987.

C. Hein. *Passage*. Darmstadt: Luchterhand Literaturverlag, 1988.

R. Tiedemann. *Die Abrechnung: Walter Benjamin und sein Verleger*. Hamburg: Kellner, 1989.

Walter Benjamin 1892–1940. Ed. R. Tiedemann, C. Gödde, and H. Lonitz. *Marbacher Magazin* 55. Marbach am Neckar, 1990.

H. Puttnies and G. Smith. *Benjaminiana*, pp. 135–165. Giessen: Anabas, 1991.

L. Fittko. *Escape Through the Pyrenees*. Evanston: Northwestern University Press, 1991.

Für Walter Benjamin: Dokumente, Essays und ein Entwurf. Ed. I. and K. Scheurmann. Frankfurt: Suhrkamp, 1992.

J. Grossman. "The Reception of Walter Benjamin in the Anglo-American Literary Institution." *German Quarterly* 65(3/4; 1992): 414–428.

C. Kambas. "Walter Benjamin–Adressat literarischer Frauen." *Weimarer Beiträge* 39(2; 1993): 242–257.

L. Fittko. *Solidarity and Treason*. Evanston: Northwestern University Press, 1993.

M. Brodersen. *Walter Benjamin: A Biography*. Ed. M. Dervis. London: Verso, 1996.

G. Fischer, ed. *With the Sharpened Axe of Reason: Approaches to Walter Benjamin*. Oxford: Berg, 1996.

J. Parini. *Benjamin's Crossing*. New York: Henry Holt, 1997.

J. Schimmang. "Der absolute naive Egoist: Über Walter und Dora Benjamin." *Merkur* 51(12; 1997): 1150–1155.

Adrienne Monnier Aufzeichnungen aus der Rue de l'Odéon: Schriften 1917–1953, pp. 243–246. Ed. C. H. Buchner. Frankfurt: Suhrkamp, 1998.

Walter Benjamin Gesammelte Briefe: 1931–1934, 4:116–122. Ed. C. Gödde and H. Lonitz. Frankfurt: Suhrkamp, 1998.

W. Benjamin. *The Arcades Project*. Trans. H. Eiland and K. McLaughlin. Cambridge: Harvard University Press, 1999.

D. Cesarini. *Arthur Koestler: The Homeless Mind*, p. 167. London: Heinemann, 2000.

E. Leslie. *Walter Benjamin: Overpowering Conformism,* pp. 218–222. London: Pluto, 2000.

"Was noch begraben lag:" Zu Walter Benjamins Exil. Briefe und Dokumente. Ed. Geret Luhr. Berlin: Bostelmann and Siebenhaar, 2000.

N. Isenberg. "The Work of Walter Benjamin in the Age of Information." *New German Critique*, no. 83 (2001): 119–150.

V. B. Leitch, ed. *The Norton Anthology of Theory and Criticism*, pp. 1163–1186. New York: Norton, 2001.

C. Eisendrath and R. Spivek, "The Angel of History" (theater play, unpublished), 2002.

Ed. H. U. Gumbrecht and M. Marrinan. *Mapping Benjamin.* Stanford: Stanford University Press, 2004.

D. Mauas. *Quién mató a Walter Benjamin* (film). Barcelona: Milagros Producciones A.C., 2005.

Benjamin Handbuch: Leben-Werk-Wirkung. Ed. B. Lindner. Stuttgart: Metzler, 2006.

C. Birman. *The Narrow Foothold.* London: Hearing Eye, 2006.

C. Fischer-Defoy, ed. *Walter Benjamin: Das Adressbuch des Exils 1933–1940.* Leibzig: Koehler and Amelang, 2006.

U. Marx, G. Schwarz, M. Schwarz, and E. Wizisla, eds. *Walter Benjamins Archive: Bilder, Texte und Zeichen.* Frankfurt: Suhrkamp, 2006.

D. Schöttker and E. Wizisla, eds. *Arendt und Benjamin: Texte, Briefe, Dokumente.* Frankfurt: Suhrkamp, 2006.

Trajekte 7 (13; September 2006). The entire issue contains articles related to the Benjamin Festival organized in October 2006 by the Zentrum für Literatur- und Kulturforschung Berlin.

M. Taussig. *Walter Benjamin's Grave.* Chicago: University of Chicago Press, 2006.

In Walter Benjamins Bibliothek. Stuttgart: Antiquariat Herbert Blank (Katalog 56), 2006.

J. Harding. "(Benjamin's Last Day): Through the Trapdoor." *London Review of Books* 29 (14; 2007): 3–6.

Adorno

W. Speyer. *Ein Mantel, ein Hut, ein Handschuh.* Munich: Drei Masken, 1931.

M. Jay. *Adorno.* Cambridge: Harvard University Press, 1984.

H. Steinert. *Adorno in Wien.* Vienna: Verlag für Gesellschaftskritik, 1989.

Theodor W. Adorno und Alfred Sohn-Rethel Briefwechsel 1936–1969. Ed. Christoph Gödde. Munich: text + kritik, 1991.

Theodor W. Adorno Walter Benjamin Briefwechsel 1928–1940. Ed. H. Lonitz. Frankfurt: Suhrkamp, 1994.

M. Jay. *The Dialectical Imagination: A History of the Frankfurt School and the Institute of Social Research, 1923–1950.* Berkeley: University of California Press, 1996.

S. Jarvis. *Adorno: A Critical Introduction.* London: Polity, 1998.

Walter Benjamin and Theodore Adorno: The Complete Correspondence, 1928–1940. Ed. H. Lonitz. Trans. N. Walker. Cambridge: Polity, 1999.

O. A. Böhmer. "Dieser glänzende Kopf: Die stille Wut der Gretel A." *Wiener Zeitung,* November 23/24, 2001, p. 11.

J. Tillmans. "Der Teddie und sein Drachodond: Theodor W. Adorno und Gretel Karplus." In H. Fertsch-Röver and B. Spielmann, eds., *Hessen: Wo die Liebe hinfällt,* pp. 124–126. Marburg: Jonas, 2001.

R. Krausz. "Geliebter Teddie: Hommage an Theodore W. Adorno." Deutschland Radio Köln, September 5, 2003.

Adorno: Eine Bildmonographie. Ed. Theodor W. Adorno Archiv. Frankfurt: Suhrkamp, 2003.

Adorno in Frankfurt: Ein Kaleidoskop mit Texten und Bildern. Ed. W. Schütte. Frankfurt: Suhrkamp, 2003.

Adorno Kindheit in Amorbach. Ed. R. Pabst. Frankfurt: Insel, 2003.

Adorno und seine Frankfurter Verleger: Der Briefwechsel mit Peter Suhrkamp und Sigfried Unseld. Ed. W. Schopf. Frankfurt: Suhrkamp, 2003.

D. Claussen. *Theodor W. Adorno: Ein letztes Genie.* Frankfurt: Fischer, 2003.

S. Müller-Doohm. *Adorno Eine Biographie.* Frankfurt: Suhrkamp, 2003.

Theodor W. Adorno Briefe an die Eltern 1939–1951. Ed. C. Gödde and H. Lonitz. Frankfurt: Suhrkamp, 2003.

Theodor W. Adorno/Lotte Tobisch: Der private Briefwechsel. Ed. B. Kraller and H. Steinert. Graz: Literaturverlag Droschl, 2003.

Theodor W. Adorno/Max Horkheimer: Briefwechsel 1927–1969. Ed. C. Gödde and H. Lonitz. Vol. 2. Frankfurt: Suhrkamp, 2004.

S. L. Von Boeckmann. "The Life and Work of Gretel Karplus/Adorno: Her Contributions to Frankfurt School Theory." Ph.D. thesis, University of Oklahoma, 2004.

L. Jäger. *Adorno: Eine politische Biographie.* Munich: Deutscher Taschenbuch, 2005.

S. Nessel. "Adorno, Grzimek James Dean. Der Briefwechsel zwischen Theodor W. Adorno und Bernhard Grzimek." *Preisfrage 2003: Tiere schauen dich an.* Berlin: Die Junge Akademie, 2005.

T. W. Adorno. *Traumprotokolle.* Ed. C. Gödde and H. Lonitz. Frankfurt: Suhrkamp, 2005.

Theodor W. Adorno/Max Horkheimer: Briefwechsel 1927–1969. Ed. C. Gödde and H. Lonitz. Vol. 3. Frankfurt: Suhrkamp, 2005.

T. W. Adorno. *Philosophy of New Music.* Ed. R. Hullot-Kentor. Minneapolis: University of Minnesota Press, 2006.

S. Müller-Doohm, ed. *Adorno-Portraits: Erinnerungen von Zeitgenossen,* Frankfurt: Suhrkamp, 2007.

S. L. Von Boeckmann. "Trachodon und Teddie: Über Gretel Adorno." In S. Müller-Doohm, ed., *Adorno-Portraits: Erinnerungen von Zeitgenossen*, pp. 335–352. Frankfurt: Suhrkamp, 2007.

Scholem

E. Scholem and E. Simon. "Mit unseren Augen." In *Zum Jüdisch-Arabischen Problem: Ein Sammelbuch*, pp. 138–143. Berlin: Hechaluz Deutscher Landesverband, 1933.

C. Ozick. "The Mystic Explorer." *New York Times,* September 21, 1980, BR 1.

G. Scholem. *Walter Benjamin und sein Engel.* Ed. R. Tiedemann. Frankfurt: Suhrkamp, 1983.

Gershom Scholem: Modern Critical Views. Ed. H. Bloom. New York: Chelsea House, 1987.

Gershom Scholem (1897–1982): Commemorative Exhibition, March 1987. Ed. M. Cohn and R. Plesser. Jerusalem: Jewish National and University Library, 1988.

Betty Scholem–Gershom Scholem: Mutter und Sohn im Briefwechsel 1917–1946. Ed. I. Shedletzky and T. Sparr. Munich: Beck, 1989.

The Correspondence of Walter Benjamin and Gershom Scholem, 1932–1940. New York: Schocken, 1989.

Gershom Scholem: Briefe II 1948–1970. Ed. T. Sparr. Munich: Beck, 1995.

G. Scholem. *On the Possibility of Jewish Mysticism in Our Time and Other Essays.* Ed. A. Shapira. Trans. J. Chipman. Philadelphia: Jewish Publication Society, 1997.

G. Scholem. *Von Berlin nach Jerusalem—Erweiterte Ausgabe.* Frankfurt: Suhrkamp, 1997.

G. Scholem. *Walter Benjamin: Die Geschichte einer Freundschaft.* 4th ed. Frankfurt: Suhrkamp, 1997.

S. E. Aschheim. *Scholem, Arendt, Klemperer: Intimate Chronicles in Turbulent Times.* Bloomington: Indiana University Press, 2001.

A Life in Letters, 1914–1982: Gershom Scholem. Ed. A. D. Skinner. Cambridge: Harvard University Press, 2002.

E. Jacobson. *Metaphysics of the Profane: The Political Theology of Walter Benjamin and Gershom Scholem.* New York: Columbia University Press, 2003.

Lamentations of Youth: The Diaries of Gershom Scholem, 1913–1919, pp. 325–326. Ed. A. D. Skinner. Cambridge: Harvard University Press, 2007.

Schönberg

E. Freitag. *Schönberg.* Reinbek bei Hamburg: Rowohlt, 1973.

H. H. Stuckenschmidt. *Schönberg: Leben Umwelt Werk.* Zurich: Atlantis, 1974.

M. Macdonald. *Schoenberg.* London: Dent, 1976.

Arnold Schoenberg, Wassily Kandinsky: Letters, Pictures, and Documents. Ed. J. Hahl-Koch. London: Faber and Faber, 1984.

J. A. Smith. *Schoenberg and His Circle: A Viennese Portrait.* New York: Schirmer, 1986.

E. Steiner. *Schoenberg on Holiday: His Six Summers on Lake Traun. Musical Quarterly* 72(1; 1986): 28–50.

A. L. Ringer. *Arnold Schönberg: The Composer as Jew.* Oxford: Oxford University Press, 1990.

B. Schmid. "Neues zum 'Doktor Faustus' Streit zwischen Arnold Schönberg und Thomas Mann." In *Augsburger Jahrbuch für Musikwissenschaft 1989,* pp. 149–179. Tutzing: Hans Schneider, 1990.

Arnold Schoenberg Correspondence. Ed. E. M. Ennulat. Metuchen: Scarecrow, 1991.

K. A. Schröder. *Richard Gerstl 1883–1908.* Vienna: Kunstforum der Bank Austria, 1993.

The Arnold Schoenberg Companion. Ed. W. B. Bailey. Westport: Greenwood, 1998.

N. Nono-Schoenberg. *Arnold Schönberg 1874–1951: Lebensgeschichte in Begegnungen.* Klagenfurt: Ritter, 1998.

Schönberg Kandinsky: Blauer Reiter und die Russische Avantgarde. Vienna: Arnold Schönberg Center, 2000.

A. Shawn. *Arnold Schoenberg's Journey.* New York: Farrar, Straus and Giroux, 2002.

Arnold Schönberg und sein Gott (Symposium, June 26–29, 2002). Vienna: Arnold Schönberg Center, 2003.

J. Auner. *A Schoenberg Reader.* New Haven: Yale University Press, 2003.

L. Singer. *Wahnsinns Liebe.* Munich: Deutscher Taschenbuch Verlag, 2003.

Arnold Schönberg: Spiele, Konstruktionen Bricolagen. Vienna: Arnold Schönberg Center, 2004.

Der Maler Arnold Schönberg (Symposium, September 11–13, 2003). Vienna: Arnold Schönberg Center, 2004.

Arnold Schönberg Catalogue Raisonné. London: Thames and Hudson, 2005.

R. Coffer. *Adagio, Liebe und Verrat.* Trans. V. Gargl and R. Treichler. *Fleisch Magazin* no. 5 (2005). Vienna (http://fleisch-magazin.at/mt/2005/06/adagio_liebe_un.php).

Arnold Schönberg, Alban Berg Briefwechsel 1906–1935. Ed. J. Brand, C. Hailey, and A. Meyer. Mainz: Schott, 2007.

Paul Klee's *Angelus Novus* and *Vorführung des Wunders*

Artlover: J. B. Neumann's Bilderhefte. Vol. 3. Ed. J. B. Neumann. New York: J. B. Neumann New Art Circle, ca. 1937.

Paul Klee Exhibition October 9–November 2, 1940 Catalog. New York: Buchholz Gallery/Willard Gallery, 1940.

J. B. Neumann. "Autobiography." Unpublished MS. New York, 1957.

P. von Haselberg. "Benjamins Engel." In P. Bulthaup, ed., *Materialien zu Benjamins Thesen "Über den Begriff der Geschichte,"* pp. 337–356. Frankfurt: Suhrkamp, 1975.

J. Toland. *Adolf Hitler.* New York: Doubleday, 1976.

J. M. Jordan. *Garten der Mysterien* in Paul Klee, *Das Frühwerk,* pp. 233–238. Munich, 1979.

Paul Klee: Briefe an die Familie 1893–1940, 2:1234. Ed. F. Klee. Cologne: DuMont, 1979.

P. Bealle. "J. B. Neumann and the Introduction of Modern German Art to New York, 1923–1933." *Archives of American Art Journal* 29 (1/2; 1989): 2–15.

L. Harmon. "The Art Dealer and the Playwright: J. B. Neumann and Clifford Odets." *Archives of American Art Journal* 29 (1/2; 1989): 16–26.

E. Muchawsky-Schnapper. "Paul Klee's *Angelus Novus*, Walter Benjamin and Gershom Scholem." *Israel Museum Journal* (Spring 1989), pp. 47–52.

R. Alter. *Necessary Angels: Tradition and Modernity in Kafka, Benjamin, and Scholem.* Cambridge: Harvard University Press, 1991.

I. Balfour. "Reversal, Quotations (Benjamin's History)." *MLN* 106(3; April 1991): 622–647.

J. K. Eberlein. "Ein verhängnisvoller Engel: Paul Klees Bild 'Angelus Novus' und Walter Benjamins Interpretationen." *Frankfurter Allgemeine Zeitung*, DII, July 20, 1991.

O. K. Werckmeister. "Walter Benjamin's Angel of History, or the Transfiguration of the Revolutionary Into the Historian." *Critical Inquiry* 22 (2; Winter 1996): 239–267.

O. K. Werckmeister. *Linke Ikonen*, pp. 25–31. Munich: Hanser, 1997.

Paul Klee Catalogue Raisonée. Ed. J. Helfenstein, C. Rümelin, and E. Wiederkehr-Sladeczek. 9 vols. London: Thames and Hudson, 1998–2004.

K. Heiden. *The Führer.* New York: Carroll and Graf, 1999.

G. H. Hartman. "Benjamin in Hope." *Critical Inquiry* 25(2; Winter 1999): 344–352.

I. Riedel. *Engel der Wandlung: Die Engelbilder Paul Klees.* Freiburg: Herder, 2000.

Paul Klee: Masterpieces of the Djerassi Collection. Ed. C. Aigner and C. Djerassi. Munich: Prestel, 2002.

Johnson Jahrbuch 11. Jahrgang 2004, pp. 23–24. Ed. M. Hofmann. Göttingen: V&R Unipress, 2005.

E. W. Kornfeld. *Paul Klee Verzeichnis des graphischen Werkes.* Bern: Galerie Kornfeld, 2005.

J. K. Eberlein. *Angelus Novus: Paul Klees Bild und Walter Benjamins Deutung.* Freiburg: Rombach, 2006.

Jewish Identity

M. Goldstein. "Deutsch-jüdischer Parnass." *Der Kunstwart* 25 (1912): 281–294.

J-P. Sartre. *Anti-Semite and Jew.* New York: Schocken, 1948.

M. Goldstein. *German Jewry's Dilemma: The Story of a Provocative Essay.* London: Leo Baeck Institute Yearbook, East and West Library, 1957.

G. Scholem and H. Arendt. "Eichmann in Jerusalem: An Exchange of Letters." *Encounter* 22(1; 1964): 51–56.

Malcolm X. *The Autobiography of Malcolm X.* New York: Ballantine, 1999.

A. Hertzberg. *The French Enlightenment and the Jews.* New York: Columbia University Press, 1968.

L. Poliakov. *The History of Anti-Semitism: From Voltaire to Wagner.* Vol. 3. New York: Vanguard, 1975.

H. Arendt. *The Jew as Pariah: Jewish Identity and Politics in the Modern Age.* Ed. R. H. Feldman. New York: Grove, 1978.

J. Katz. *From Prejudice to Destruction: Anti-Semitism, 1700–1933.* Cambridge: Harvard University Press, 1980.

H. I. Bach. *The German Jew: A Synthesis of Judaism and Western Civilization, 1730–1930.* Oxford: Oxford University Press, 1984.

A. Hertzberg. "Gershom Scholem as Zionist and Believer." *Modern Judaism* 5(1; 1985): 13–19.

R. Wistrich. *Between Redemption and Perdition: Modern Anti-Semitism and Jewish Identity.* London: Routledge, 1990.

S. Gilman. *The Jew's Body.* New York: Routledge, 1991.

Gershom Scholem, Tagebücher, 1913–1917, p. 327. Ed. K. Gründer and F. Niewöhner. Frankfurt: Jüdischer Verlag, 1995.

Hannah Arendt und Kurt Blumenfeld, "in keinem Besitz verwurzelt": Die Korrespondenz, p. 178. Ed. I. Nordman and I. Philling. Nodlingen: Rotbuch, 1995.

M. Graetz. *The Jews in Nineteenth Century France.* Trans. M. Todd. Stanford: Stanford University Press, 1996.

I. Wohlfarth. "Männer aus der Fremde": Walter Benjamin and the "German-Jewish Parnassus." *New German Critique* no. 70 (Winter 1997): 3–85.

S. E. Aschheim. "Nazism, Culture, and the Origins of Totalitarianism: Hannah Arendt and the Discourse of Evil." *New German Critique* no. 70 (Winter 1997): 117–139.

N. Isenberg. *Between Redemption and Doom: The Strains of German-Jewish Modernism.* Lincoln: University of Nebraska Press, 1999.

S. E. Aschheim. *In Times of Crisis: Essays on European Culture Germans and Jews.* Madison: University of Wisconsin Press, 2000.

D. Villa, ed. *The Cambridge Companion to Hannah Arendt,* part 2: "Political Evil and the Holocaust." Cambridge: Cambridge University Press, 2000.

E. Wilcock. "Negative Identity: Mixed German Jewish Descent as a Factor in the Reception of Theodor Adorno." *New German Critique* no. 81 (Autumn 2000): 169–187.

D. Biale. *Cultures of the Jews: A New History.* New York: Schocken, 2002.

H. Chisick. "Ethics and History in Voltaire's Attitudes Toward the Jews." *Eighteenth-Century Studies* 35 (4; 2002): 577–600.

A. Elon. *The Pity of It All: A History of the Jews in Germany, 1743–1933.* New York: Henry Holt, 2002.

M. A. Meyer. "'Most of My Brethren Find Me Unacceptable': The Controversial Career of Rabbi Samuel Holdheim." *Jewish Social Studies* 9 (3; 2003): 1–19.

J. Anger. *Paul Klee and the Decorative in Modern Art,* pp. 125–155. Cambridge: Cambridge University Press, 2004.

D. Cesarini. *Eichmann: His Life and Crimes,* chapter 9. London: Heinemann, 2004.

A. Morris-Reich. "Three Paradigms of 'The Negative Jew.'" *Jewish Social Studies* 10 (2; 2004): 179–214.

S. Gilman. "Einstein's Violin: Jews and the Performance of Identity." *Modern Judaism* 25(3; 2005): 219–236.

H. Arendt. *The Jewish Writings.* Ed. J. Kohn and R. H. Feldman. New York: Schocken, 2006.

D. Cohn-Sherbok. *The Paradox of Anti-Semitism.* London: Continuum, 2006.

S. E. Aschheim. *Beyond the Border: The German-Jewish Legacy Abroad,* chapter 3. Princeton: Princeton University Press, 2007.

J. Judaken. *Jean-Paul Sartre and the Jewish Question.* Lincoln: University of Nebraska Press, 2007.

I. Wohlfarth. *Unterwegs zu Adorno, unterwegs zu sich* in *Adorno-Portraits: Erinnerungen von Zeitgenossen,* pp. 40–94. Ed. S. Müller-Doohm. Frankfurt: Suhrkamp, 2007.

Pornography and Georges Bataille

B. Brecht. *Poems: Bertolt Brecht.* Ed. J. Willett and R. Manheim. London: Methuen, 1979.

P. Buck, ed. *Violent Silence: Celebrating Georges Bataille.* London: Georges Bataille Event, 1984.

G. Carchia. *La métacritique du surréalism dans le "Passagen Werk"* in *Walter Benjamin et Paris,* pp. 173. Paris: Cerf, 1986.

S. Kappeler. *The Pornography of Representation.* Cambridge: Polity, 1986.

W. Kendrick. *The Secret Museum: Pornography in Modern Culture.* New York: Viking Penguin, 1987.

B. Love. *Encyclopedia of Unusual Sex Practices.* Fort Lee, NJ: Barricade, 1992.

L. Hunt, ed. *The Invention of Pornography.* New York: Zone, 1993.

M. Richardson. *Georges Bataille.* London: Routledge, 1994.

G. Bataille. *My Mother, Madame Edwarda, The Dead Man.* Trans. A. Wainhouse. London: Marion Boyars, 1995.

R. A. Champagne. *Georges Bataille.* New York: Twayne, 1998.

M. Surya. *Georges Bataille: An Intellectual Biography.* London: Verso, 2002.

T. W. Laqueur. *Solitary Sex: A Cultural History of Masturbation.* New York: Zone, 2003.

L. Z. Sigel, ed. *International Exposure: Perspectives on Modern European Pornography, 1800–2000.* New Brunswick, NJ: Rutgers University Press, 2005.

ACKNOWLEDGMENTS

I N A biographical work like the present text, where historical evidence is crucial and where such an enormous and diverse body of documentation exists, proper acknowledgment of assistance is indispensable. I offer my own with deep gratitude and will cite below the various individuals and organizations with reference to my main topics. The bibliographical references I consulted are listed chronologically for each chapter in the bibliography. But since so many came from the holdings of my home institution, Stanford University, I must start with Grace A. Baysinger, who secured for me throughout the entire project, tirelessly and graciously, books, documents, and esoteric Web-based links without which my work, largely done in London, would have been greatly impeded. Never have so many non-chemical literature requests passed through the hands of this wonderful head librarian and bibliographer of the Swain Library of Chemistry. In addition, the following individuals from the Stanford University Library system—Zachary M. Baker, Phyllis Kayten, Henry Lowood, Alex Ross, and Barden N. Shimbo, as well as my former long-time secretary, Shannon Moffat, and my present one, Nancy Tolin—provided key library assistance or services that simplified my life enormously. A grant request by a chemist wishing to do humanities research in Jerusalem and Berlin was diplomatically allowed to circumvent department-focused hurdles by Stanford University's Dean Arnold Rampersad of Humanities and Letters, who cut all red tape by tapping his own deanly resources.

Before proceeding to the specific five sections, I wish to thank Adam Mars-Jones (London) for sophisticated anagrammatic counsel, Sean Keilen (Princeton University) for important background on sixteenth-century literary use of dialogue, and Karin Eveslage (Charité, Berlin) for selflessly traipsing on my behalf all over Berlin to locate various memorials on James Simon, one of the greatest Jewish art patrons of pre-Hitler Germany.

Music plays an important role in the chapter dealing with Paul Klee, an artist who so profoundly affected the lives of three of my main personages as well as so many modern composers—more than any other painter in art history. Stephen Ellis of Glenview, Illinois, is the world's greatest collector of Klee-inspired music; the knowledge that he has shared unselfishly with me over so many years made it easy for me to select three of the twelve composers who had been stimulated by Benjamin's interpretation of Klee's *Angelus Novus*. For my purposes, the German composer Claus-Steffen Mahnkopf was the most attractive choice, because his Schönbergian mode

and Adorno-influenced theoretical writing fit ideally into the intellectual ambience of my main characters. I thank him for offering great insight into his highly sophisticated and moving musical style. Were it not for Stephen Ellis, I would probably also not have had been led to my delightful correspondence with the Icelandic singer and composer Egill Ólafsson, nor would I have been exposed to Hiroshi Nakamura's solo trombone piece, which was played so hauntingly by the British trombonist Barrie Webb. All of them have generously allowed me to present short excerpts of their *Angelus Novus* pieces. Finally, I need to put on record my pleasure that the American actor, rap composer, and performer Erik Weiner, who in the past created rap songs for two of my plays, consented to make an unique musical contribution to Benjaminian lore through his *Angelus Novus* rap.

Benjamiana

In spite of the enormous volume of descriptive and critical literature on Walter Benjamin, or perhaps because of its overwhelming scope, the assistance of the Walter Benjamin Archiv in the Akademie der Künste Archiv, Abteilung Literatur in Berlin was crucial. I would like to acknowledge the tireless willingness of Dr. Gudrun Schwarz and her colleagues Dr. Michael Schwarz and Ursula Marx as well as the Archiv's director, Dr. Erdmut Wizisla, in answering questions and providing me with documentary information. They as well as Adriane von Hoop (Suhrkamp Verlag) deserve thanks for permitting the use of several valuable photographic images. Micky Draper (London), one of Dora Sophie Benjamin's granddaughters, very generously provided copies of two rare and hitherto unpublished photographs of her grandmother, for which I express my appreciation.

Scholemiana

The Scholem archives are at the Hebrew University in Jerusalem; since I was on crutches during much of my research, logistic support during my visit to Jerusalem in June 2006 was indispensable. My longtime friend and former rector of the Hebrew University, Raphael Mechoulam, needs to be mentioned first. Walter Benjamin, who experimented extensively with hashish, would have been delighted to learn that Mechoulam was the chemist who first identified and characterized the active ingredient of marijuana. Mechoulam was also the one who put me in touch with many persons in Israel who either knew Gershom and Fania Scholem directly or knew whom to contact about the most arcane aspects of Scholemiana. Prominent among the long list were Prof. Rachel Elior, chair of the Department of Jewish Thought, Hebrew University, who recounted some moving interchanges with Fania Scholem during their joint travel to Berlin in the 1990s; Prof. Steven Aschheim, chair of European Studies, Hebrew University, who engaged with me in a fascinating conversation and also provided several leads to relevant but rare citations of Gershom

Scholem and Hannah Arendt; Avraham Shapira, emeritus professor of Jewish History, Tel Aviv University, who had been an editorial associate of Gershom Scholem and personal friend of Fania Scholem during her long widowhood, supplemented a long interview with many rare clippings and photos; Prof. Ruth Katz (University of Pennsylvania), Prof. Menachem Haran (Hebrew University Bible Department) and his wife Raya, who related many episodes based on their long personal acquaintance with Scholem and his second wife Fania; and, finally, three scientists—former rector of the Hebrew University, Gideon Czapski, Prof. Nathan Sharon (Weizmann Institute), and Prof. Alex Keynan (Israel Academy of Sciences and Humanities)—who surpassed any directory assistance or Google in providing me with leads to other personal acquaintances of Scholem.

One of the high points of my Jerusalem research was the time spent at the Scholem archives with Dr. Ruth Zur (Hadassah Hebrew University Hospital) trying to decipher dozens upon dozens of letters between Scholem and his first wife Escha (subsequently the wife of Hugo Bergman), which had been put at my disposal through the generosity of Rivka Plesser and Margot Cohn of the Department of Archives of the Jewish National and University Library. Their permission to let me photocopy the most important documents made it possible for me to utilize in Vienna the expertise of Harald Hihs, an expert in old German "Kurrent" style, who deciphered many virtually illegible handwritten letters from the Scholem archives that may never have been studied before.

But the most memorable events in Jerusalem were the hours I was able to pass with Hanna Bergman, Escha (Scholem) Bergman's older daughter. She had prepared herself for our meeting by rereading the extensive private correspondence between her mother and father prior to Escha's divorce from Scholem, and offered a poignant personal account that could not be matched by any archival research. I am grateful beyond words to her for answering my many intrusive personal questions and contributing some rare personal photographic images.

In London, I had the privilege of spending some hours with Prof. Chimen Abramsky, the ninety-year-old professor emeritus of Jewish Studies at University College, London, who bewitched me; he had the memory of a man half his age. He had been instrumental in establishing Stanford University's Program in Jewish Studies, and it was through Stanford University's Profs. Steven Zipperstein and Peter Stansky, along with Prof. David Biale (University of California at Davis) that I was able to establish contact with him. Abramsky was the first person to inform Scholem of Benjamin's "missing grip"—the focus of my final chapter—after learning about it during a visit to Stanford University in the late 1970s.

Another memorable interview in London took place with Renee Goddard, Gershom Scholem's niece, and her husband Hanno Fry. From her I learned personal details about Scholem that no one else had disclosed to me before. The gracious manner in which she responded to my rather invasive barrage of questions will long stay with me.

One unsuccessful research effort deserves mention: Lydia Marinelli, Freud Museum, Vienna and Michael Molnar, Freud Museum, London kindly searched the genealogy of Sigmund Freud's family without, however, being able to support the claimed distant family relationship of Fania Freud, Scholem's second wife, with the father of psychoanalysis.

Adorniana

At the very outset of my research on Adorno, Dr. Robert Kaufman (formerly of the Stanford English Department), who had studied Adorno for many years, served as an invaluable guide to key references, thus making my initial work much more efficient. Three individuals in Germany, Dr. Rolf Tiedemann, one of Adorno's most important students and long-term editor of Adorno and Benjamin writings, and Drs. Henri Lonitz and Christoph Gödde, of the Adorno archives in Frankfurt, were so steeped in Adorno lore that their unique knowledge made them walking encyclopedias. The generosity and speed with which they replied to my queries were truly impressive. It is to Dr. Tiedemann's recollection of a personal meeting with Scholem in Frankfurt that I owe the elucidation of the final missing part in the passage of Klee's *Angelus Novus* to Jerusalem. Acknowledgment is also due Dr. Sabine Nessel of the University of Frankfurt for commentary on animal images and names in Adorno's life and writings. Last but not least, I thank Rosvitha Krausz of the Deutschland Radio Köln, who kindly furnished me with the transcript and background notes to a broadcast on Adorno (September 5, 2003), a few sentences of which found their way into Gretel Adorno's voice in my chapter 2, and Lotte Tobisch von Labotyn (Adorno's great Viennese friend) for permission to use one of her photographs and for sharing so generously her personal insight into the personae of Theodor and Gretel Adorno and of Gershom Scholem.

Schönbergiana

My deep appreciation goes to Nuria Schoenberg Nono, the daughter of Arnold Schönberg, for an insightful discussion about all aspects of Schönbergiana, as well to her and her brother, Lawrence Schoenberg, for generous permission to use certain photographs and musical excerpts. For additional assistance with my work on Schönberg, I thank Eike Fess and Jasmin Vavera of the staff of the Arnold Schönberg Center in Vienna, as well as its archivist, Dr. Therese Muxeneder and its director, Dr. Christian Meyer, for providing special written material as well as poorly accessible examples from Schönberg's discography, in addition to supplying certain photographs and permission to reproduce them, Prof. Albert Cohen of the Stanford University Music Department and Jerry McBride of its Music Library for helpful hints, and Randol Schoenberg (Los Angeles), the composer's grandson, for a fascinating lead to the distant relationship between the composer and Walter Benjamin.

Dr. Klaus Schröder, the director of the Albertina Museum, is one of the foremost authorities on Richard Gerstl—an important and tragic figure in Schönberg's life—and I thank him for sharing with me some of his writings on that artist.

Paul Klee

I have been infatuated for over forty years with Paul Klee: as collector, admirer, reader, and connoisseur. Hence, writing about him—be it as the artist who painted Benjamin's *Angelus Novus* or as an individual branded by some as a non-Jewish "Jew"—did not seem to me to be a daunting task. But the longer I immersed myself in the story of the *Angelus Novus* or the second Klee owned by Benjamin, the *Vorführung des Wunders*, and the gaps in their provenance from Benjamin to their ultimate museum destinations, the more I realized that I would need to consult others whose help I now acknowledge.

I start with three staff members of the Paul Klee Zentrum in Bern: Dr. Christine Hopfengart, who engaged with me in lengthy and insightful correspondence, including documentation, about the supposed Jewish symbolism in many of Klee's works; Eva Wiederkehr-Sladeczek, who good-naturedly answered my almost unending requests for Klee images; and Heidi Frautschi, of the Fotoarchiv Department, for the extraordinarily generous permission of the Paul Klee Zentrum to reproduce so many images of Paul Klee's works that were key to my discussion of his oeuvre. I then move to the Israel Museum in Jerusalem, where its director, James Snyder, and its chief curator, Yigal Zalmona, allowed me to examine the original Klee oil transfer drawing in private, in addition to providing some documentation. As I have already mentioned, Dr. Rolf Tiedemann supplied the key to the missing details concerning the transfer of the *Angelus Novus* to Gershom Scholem in Jerusalem, but it was Dr. Peter G. Neumann (SRI, Menlo Park, California) who helped me solve the puzzle how the second Klee, *Vorführung des Wunders*, passed from Benjamin ultimately to the Museum of Modern Art in New York. As the son of one of the most passionate Klee dealers, J. B. Neumann (from whose gallery this first Klee was purchased in 1920 by Dora Sophie Benjamin), he inherited his father's love and deep knowledge of Paul Klee along with his father's archives, which contained the missing information. I am enormously grateful to him for allowing me to make this information public through the voice of Dora Sophie Benjamin. Nora Lawrence of the Museum of Modern Art in New York first suggested that J. B. Neumann might be the source of an answer to my puzzle, and Carey Gibbons of MoMA's Department of Publications kindly provided an image of Klee's *Vorführung des Wunders* as well as permission to reproduce it. Rose Candelaria of the San Francisco Museum of Modern Art supplied a number of high-resolution images of several Paul Klee drawings in their collection, for which I thank her.

I already referred to the valuable assistance given by Stephen Ellis with esoteric details on the musical influence of Paul Klee. I also need to thank one of the greatest

collectors and auctioneers of the works of Paul Klee, Dr. Eberhard W. Kornfeld (Galerie Kornfeld und Cie, Bern) for searching his archives to produce for me the original letter written to him in 1969 by Gretel Adorno asking for a valuation of the *Angelus Novus*.

I end with acknowledging a memorable meeting in Graz with Prof. Johann Konrad Eberlein, an art historian at the University of Graz, whose book on the *Angelus Novus* had just appeared at the time I completed the first draft of my own manuscript. The case he makes for the Hitlerian antecedent in the image of the *Angelus Novus* seemed to me highly plausible, and I am pleased to acknowledge his priority in the two literature sources cited in the bibliography.

The following individuals have read individual chapters and responded with numerous valuable comments that I gratefully incorporated into the final manuscript: Prof. Robert Alter (University of California, Berkeley), Prof. David Biale (University of California, Davis), Alan Drury (Leicester, UK), Prof. Sander L. Gilman (Emory University), Prof. Walter Grünzweig (University of Dortmund), Prof. Noah Isenberg, (New School, New York City), Ben Jancovich (Royal National Theatre, London), Prof. Alvin Rosenfeld (University of Indiana), Prof. Avishai Margalit (Institute for Advanced Studies, Princeton), Elaine C. Showalter (professor emerita, Princeton University), and Prof. Steven J. Zipperstein (Stanford University). In addition, my Stanford colleagues Prof. Hans Ulrich Gumbrecht and Prof. Herbert S. Lindenberger, both of the Department of Comparative Literature, went well beyond the norm of academic collegiality to read my entire manuscript with great critical insight—a courtesy I appreciate enormously.

A completely separate accolade belongs to Gabriele Seethaler, a phenomenally competent and efficient artist from Radstadt, Austria, who was not only responsible for producing a visual case for the Hitler image but also created the many Benjaminian variations of the *Angelus Novus* along with numerous other illustrations reproduced in this book. Words of acknowledgment, however fulsome, cannot do justice to her artistic contribution. A more meaningful expression of deep appreciation is represented by this illustrated book resulting from our initial collaboration, which was conducted mostly, though not exclusively, in cyberspace through the exchange of hundreds of e-mail messages with enormous attachments that cumulatively equaled many gigabytes. Were it not for the fact that I deleted the majority of her messages immediately after responding, I might well need a new computer by now.

BIOGRAPHICAL SKETCHES

Carl Djerassi, emeritus professor of chemistry at Stanford University, is one of the few American scientists to have been awarded both the National Medal of Science (for the first synthesis of a steroid oral contraceptive—"the Pill") and the National Medal of Technology (for promoting new approaches to insect control). A member of the U.S. National Academy of Sciences and the American Academy of Arts and Sciences as well as many foreign academies, Djerassi has received twenty honorary doctorates together with numerous other honors, such as the first Wolf Prize in Chemistry, the first Award for the Industrial Application of Science from the National Academy of Sciences, the Erasmus Medal of the Academia Europeae, the Perkin Medal of the Society for Chemical Industry, the Gold Medal of the American Institute of Chemists, the Serono Prize in Literature (Rome), and the American Chemical Society's highest award, the Priestley Medal.

For the past twenty years, he has turned to fiction writing, mostly in the genre of science-in-fiction, whereby he illustrates, in the guise of realistic fiction, the human side of scientists and the personal conflicts faced by scientists in their quest for scientific knowledge, personal recognition, and financial rewards. In addition to five novels (*Cantor's Dilemma*; *The Bourbaki Gambit*; *Marx, Deceased*; *Menachem's Seed*; *NO*), poetry (*The Clock Runs Backwards*), autobiography (*The Pill, Pygmy Chimps, and Degas' Horse*), and memoir (*This Man's Pill*), he embarked in 1997 on a trilogy of science-in-theater plays. *An Immaculate Misconception*—first performed at the 1998 Edinburgh Fringe Festival and subsequently (1999–2008) in London, San Francisco, New York, Los Angeles, Detroit, Vienna, Munich, Cologne, Sundsvall, Stockholm, Sofia, Geneva, Seoul, Tokyo, Lisbon, Singapore, and Zurich—has been translated into eleven languages and broadcast by BBC Radio on its World Service in 2000 as Play of the Week, in 2001 by the West German and Swedish Radio, in 2004 by NPR (USA), and in 2006 by Radio Prague. *Oxygen* (coauthored with Roald Hoffmann) premiered in April 2001 at the San Diego Repertory Theatre, in September 2001 at the Mainfranken Theater in Würzburg, and in November 2001 at the Riverside Studios in London and was broadcast by both BBC World Service and the West German Radio in December 2001; it has since been translated into fifteen languages. *Calculus* premiered in 2003 in San Francisco, followed by a London production in 2004 as well as performances in Vienna, Munich, Berlin, Dresden, Dublin, and Cambridge; it has already appeared in book form in English, German, and Italian. A chamber opera version, with music by Werner Schulze, premiered in May 2005 in the Zurich Opera (Studiobühne).

Among his "nonscientific" plays, *Ego* premiered at the 2003 Edinburgh Festival Fringe and under the title *Three on a Couch* in London (2004) as well as New York (2008). A German translation of *Ego* was broadcast by the WDR in 2004, followed by its Austrian theatrical premiere in 2005 and a major German tour (Landgraf) in early 2006 and again early 2007. The London premiere of Djerassi's fifth play *Phallacy*, featuring a science-versus-art theme, occurred in 2005, with a German radio version broadcast in early 2006 by the WDR; its New York premiere was held in May 2007. His sixth play, *Taboos* opened in London in 2006 and had its German language premiere in July 2006 in Graz, with a New York opening in September 2008. Dramatic readings of excerpts from *Four Jews on Parnassus—a Conversation* have already been held in Berlin at the Walter Benjamin Festival as well as in Madison, Wisconsin, London, Stockholm, Cambridge, Vienna (in German), and Las Palmas (in Spanish). There is a Web site about Carl Djerassi's writing at http://www.djerassi.com.

Djerassi is the founder of the Djerassi Resident Artists Program near Woodside, California, which provides residencies and studio space for artists in the visual arts, literature, choreography and performing arts, and music. Over seventeen hundred artists have passed through the program since its inception in 1982.

Djerassi lives in San Francisco and London.

GABRIELE SEETHALER, born in 1964 in Linz, Austria, is equally at home in the precise world of science as in the incalculable and intuitively driven world of art. She studied biochemistry at the University of Vienna and received her Ph.D. at the Institute of Molecular Biology of the Austrian Academy of Sciences in Salzburg. Following the birth of her daughter Katharina, she pursued her new passion of photography in a scientific way. Gabriele Seethaler's strength in artistic design lies in the settings and expressions of her medium, which is frequently herself. After her initial series of self-portraits—far away from science and the laboratory—she started to fuse art and science through her widely exhibited Identity Genotype-Phenotype project. Gallery Heike Curtze (Vienna and Berlin) has shown her work since 2000. Exhibitions in connection with *Four Jews on Parnassus* have taken place at Gallery Heike Curtze (Four Jews on Parnassus: A Photographic Dialogue Between Carl Djerassi and Gabriele Seethaler) in 2006 and 2007. Exhibitions or projections of Gabriele Seethaler's work were included at dramatic readings of *Four Jews on Parnassus* in 2006 at Walter Benjamin Festival in Berlin, in 2007 at Lederman Theater in Stockholm, Centro Atlántico de Arte Moderna, Las Palmas, Gran Canaria, and Semper Depot, Vienna in 2007, and in 2008 at Arnold Schönberg Center and Albertina in Vienna and Zentrum Paul Klee in Bern. Exhibitions have occurred as well in Rome, Paris, Milan, Brussels, Radstadt, Salzburg, Vienna, New York, and Berlin. Since angels have followed Gabriele Seethaler from the very beginning of her artistic career, the present collaboration with Carl Djerassi is a logical extension of that angelic preoccupation.

Gabriele Seethaler lives in Radstadt, Salzburg, Austria.

ILLUSTRATION SOURCES

Gabriele Seethaler, *Mirror Images of Walter and Dora Sophie Benjamin, Theodor W. and Gretel Adorno, Gershom and Escha Scholem, and Arnold and Mathilde Schönberg* (preface): Walter Benjamin in Mallorca, photographer unknown, courtesy Walter Benjamin Archiv, Akademie der Künste, Berlin; Dora-Sophie Benjamin, copyright © Micky Draper, London; Arnold and Mathilde Schönberg, copyright © Arnold Schönberg Center, Vienna; Gershom and Escha Scholem, copyright © Gershom Scholem Archive, ARC. 4° 1599, the Jewish National and University Library, Jerusalem, Israel; Theodor W. and Gretel Adorno, courtesy Theodor W. Adorno Archiv, Frankfurt.

Gabriele Seethaler, *Walter Benjamin, Theodor W. Adorno, Gershom Scholem, and Arnold Schönberg on Parnassus Inserted Into Arnold Schönberg's Coalition Chess* (fig. 1.1): Walter Benjamin, Foto Studio Joël Heinzelmann, courtesy Walter Benjamin Archiv, Akademie der Künste, Berlin; Arnold Schönberg and Arnold Schönberg's coalition chess, copyright © Arnold Schönberg Center, Vienna; Gershom Scholem, copyright © Gershom Scholem Archive, ARC. 4° 1599, the Jewish National and University Library, Jerusalem, Israel; Theodor W. Adorno, courtesy Theodor W. Adorno Archiv, Frankfurt.

Walter Benjamin (fig. 1.2): Walter Benjamin (*left*), copyright © Suhrkamp Verlag; Benjamin (*center*), copyright © Nachlass Germaine Krull, Museum Folkwang, Essen; Benjamin (*right*), courtesy Walter Benjamin Archiv, Akademie der Künste, Berlin.

Walter Benjamin (fig. 1.3): Walter Benjamin in Mallorca, photographer unknown, courtesy Walter Benjamin Archiv, Akademie der Künste, Berlin.

Theodor W. Adorno (fig. 1.4): courtesy Theodor W. Adorno Archiv, Frankfurt.

Gershom Scholem (fig. 1.5): copyright © Gershom Scholem Archive, ARC. 4° 1599, the Jewish National and University Library, Jerusalem, Israel.

Arnold Schönberg (fig. 1.6): copyright © Arnold Schönberg Center, Vienna.

Gabriele Seethaler, *Walter Benjamin's Face Superimposed Upon Walter Benjamin Platz, Walter Benjamin's Plaque in Berlin* (fig. 1.7): Walter Benjamin in Mallorca, photographer unknown, courtesy Walter Benjamin Archiv, Akademie der Künste, Berlin.

Gabriele Seethaler, *Arnold Schönberg's Face and Stamp Superimposed Upon Arnold Schönberg Platz, Vienna* (fig. 1.8): Arnold Schönberg, copyright © Arnold Schönberg Center, Vienna.

Gabriele Seethaler, *Gershom Scholem's Face Superimposed Upon Scholem's Family Grave in the Jewish Weissensee Cemetery (Berlin), Where the Other Berlin Scholems Are Buried, and Gershom Scholem's Grave in Jerusalem* (fig. 1.9): Gershom Scholem, copyright © Gershom Scholem Archive, ARC. 4° 1599, the Jewish National and University Library, Jerusalem, Israel; Gershom Scholem's grave in Jerusalem, copyright © Prof. Raphael Mechoulam, the Hebrew University, Jerusalem, Israel; Scholem family grave in Weissensee, Berlin, copyright © Vivian Wagner, Berlin.

Gabriele Seethaler, *Gershom Scholem's Face Superimposed Upon Israeli Stamps* (fig. 1.10): Gershom Scholem, copyright © Gershom Scholem Archive, ARC. 4° 1599, the Jewish National and University Library, Jerusalem, Israel.

Gabriele Seethaler, *Theodor W. Adorno's Face Superimposed Upon Theodor W. and Gretel Adorno's Grave and Alois Alzheimer's Grave in Frankfurt* (fig. 1.11): Theodor W. Adorno, courtesy Theodor W. Adorno Archiv, Frankfurt.

Gabriele Seethaler, *Theodor W. Adorno's Face Superimposed Upon the Theodor W. Adorno Monument on Theodor W. Adorno Platz in Frankfurt* (fig. 1.12): Theodor W. Adorno, courtesy Theodor W. Adorno Archiv, Frankfurt.

Gabriele Seethaler, *Arnold Schönberg's Face Superimposed Upon Arnold Schönberg's Grave, Zentralfriedhof, Vienna* (fig. 1.14): Arnold Schönberg copyright © Arnold Schönberg Center, Vienna.

Gabriele Seethaler, *Walter Benjamin's Face Superimposed Upon Walter Benjamin's Monument by the Israeli Sculptor Dani Karavan in Port Bou, Spain* (fig. 1.16): Walter Benjamin in Mallorca, photographer unknown, courtesy Walter Benjamin Archiv, Akademie der Künste, Berlin.

Gabriele Seethaler, *Mathilde Schönberg, Dora Sophie Benjamin, Escha Scholem, and Gretel Adorno Around Arnold Schönberg's Coalition Chess, Their Husbands as Chess Pieces* (fig. 2.1): Dora Sophie Benjamin, copyright © Micky Draper, London; Walter Benjamin, courtesy Walter Benjamin Archiv, Akademie der Künste, Berlin; Arnold and Mathilde Schönberg and Arnold Schönberg's coalition chess, copyright © Arnold Schönberg Center, Vienna; Gershom and Escha Scholem, copyright © Gershom Scholem Archive, ARC. 4° 1599, the Jewish National and University Library, Jerusalem, Israel; Theodor W. and Gretel Adorno, courtesy Theodor W. Adorno Archiv, Frankfurt.

Walter Benjamin and Dora Sophie Benjamin (fig. 2.2): Walter Benjamin, copyright © Suhrkamp Verlag; Dora Sophie Benjamin, copyright © Micky Draper, London.

Cover of exhibition catalogue, Buchholz Gallery, Willard Gallery, 1940, showing Paul Klee's *Introducing the Miracle*; courtesy Zentrum Paul Klee, Bern (fig. 2.3).

Cover of J. B. Neuman's *Artlover* catalogue, 1937, showing Paul Klee's *Introducing the Miracle*; courtesy Dr. Peter G. Neumann (fig. 2.4).

Hugo Bergman (fig. 2.5): Hugo Bergman, copyright © Hanna Bergman, Jerusalem, Israel.

Escha Scholem (fig. 2.6): Escha Scholem copyright © Gershom Scholem Archive, ARC. 4° 1599, the Jewish National and University Library, Jerusalem, Israel.

Fania Scholem (late in life) (fig. 2.7): Fania Scholem, copyright © Prof. Avraham Shapira (Kibbutz Yisreel), emeritus professor Tel Aviv University. Israel.

Escha Scholem's letter to Gershom Scholem superimposed upon Escha and Gershom Scholem (fig. 2.8): copyright © Gershom Scholem Archive, ARC. 4° 1599, the Jewish National and University Library, Jerusalem, Israel.

Gabriele Seethaler, *Escha and Gershom Scholem with Pheasant* (fig. 2.9): Gershom and Escha Scholem, copyright © Gershom Scholem Archive, ARC. 4° 1599, the Jewish National and University Library, Jerusalem, Israel.

Fania Scholem and Gershom Scholem (1897–1982), 5.12.1937. Commemorative Exhibition, March 1987 (ed. M. Cohn and R. Plesser), the Jewish National and University Library, Jerusalem 1988 (fig. 2.10): copyright © Gershom Scholem Archive, ARC. 4° 1599, the Jewish National and University Library, Jerusalem.

Escha and Hugo Bergman (late in life) (fig. 2.11): copyright © Hanna Bergman, Jerusalem, Israel.

Escha and Hugo Bergman (early in their marriage) (fig. 2.12): copyright © Hanna Bergman, Jerusalem, Israel.

Gabriele Seethaler, *Hottilein and Rossilein with Gretel and Theodor W. Adorno's Faces* (fig. 2.13): Gretel and Theodor W. Adorno, courtesy Theodor W. Adorno Archiv, Frankfurt.

Gabriele Seethaler, *Gretel Adorno as Giraffe Gazelle with the Little Horns (Giraffe Gazelle mit den Hörnchen)* (fig. 2.14): Gretel Adorno, courtesy Theodor W. Adorno Archiv, Frankfurt.

Gabriele Seethaler, *Theodor W. Adorno's Parents with Wondrous She-Hippo (Wundernilstute) and King of Boars (Wildschweinkönig)* (fig. 2.15): Theodor W. Adorno's parents, courtesy Theodor W. Adorno Archiv, Frankfurt.

Gabriele Seethaler, *Hippo-King Archibald (Nilpferdkönig Archibald)* (fig. 2.16): Theodor W. Adorno, courtesy Theodor W. Adorno Archiv, Frankfurt.

Gretel Adorno puts on her green dress (fig. 2.17): Gretel Adorno, courtesy Theodor W. Adorno Archiv, Frankfurt.

Lotte Tobisch von Labotyn (fig. 2.18): copyright © Paul Swiridoff, Schwäbisch Hall.

Bertold Brecht (fig. 2.19): BBA FA 1/61, BB 1930. Photo copyright © Bilderdienst des deutschen Verlages, Akademie der Künste, Bertolt Brecht Archiv.

Mathilde and Arnold Schönberg (fig. 2.20): copyright © Arnold Schönberg Center, Vienna.

Arnold Schönberg, *Mathilde Schönberg* (fig. 2.21): tempera on cardboard, 36.8 × 24.6 cm, around 1907–1909, Arnold Schönberg Center, Vienna, copyright © 2007 VBK, Vienna.

Arnold Schönberg, *Gertrud Schönberg* (fig. 2.22): watercolor and chalk on paper, 40.3 × 26.6 cm, 1925? Arnold Schönberg Center, Vienna, copyright © 2007 VBK, Vienna.

Richard Gerstl, *Sitting Nude Woman*, 1907/1908 (fig. 2.23): tempera on canvas, 166 x 116 cm, personal archive, Klaus Albrecht Schröder, Vienna.

Richard Gerstl, *Nude Self-Portrait*, 1908 (fig. 2.24): oil on canvas, 140.5 x 110.5 cm, personal archive, Klaus Albrecht Schröder, Vienna.

Richard Gerstl, *Portrait Arnold Schönberg*, 1906 (fig. 2.25): oil on canvas, 182 x 130 cm, personal archive, Klaus Albrecht Schröder, Vienna.

Hanna Fuchs-Robettin (fig. 2.26): courtesy Suhrkamp Verlag.

Gabriele Seethaler, *Meeting of the Four Women Under the Tree: Escha Scholem, Mathilde Schönberg, Dora Sophie Benjamin, and Gretel Adorno* (fig. 2.27): Escha Scholem, copyright © Hanna Bergman, Jerusalem, Israel; Mathilde Schönberg, copyright © Arnold Schönberg Center, Vienna; Dora Sophie Benjamin, copyright © Micky Draper, London; Gretel Adorno, courtesy Theodor W. Adorno Archiv, Frankfurt.

Gabriele Seethaler, *Arnold Schönberg, Theodor W. Adorno, Walter Benjamin, and Gershom Scholem Around Arnold Schönberg's Coalition Chess with Paul Klee's* Angelus Novus (fig. 3.1): Walter Benjamin, Foto Studio Joël Heinzelmann, courtesy Walter Benjamin Archiv, Akademie der Künste, Berlin; Arnold Schönberg and Arnold Schönberg's coalition chess, copyright © Arnold Schönberg Center, Vienna; Gershom Scholem, copyright © Gershom Scholem Archive, ARC. 4° 1599, the Jewish National and University Library, Jerusalem, Israel; Theodor W. Adorno, courtesy Theodor W. Adorno Archiv, Frankfurt. Paul Klee, *Angelus Novus*, see fig. 3.2.

Paul Klee, *Angelus Novus*, 1920 (fig. 3.2): 32, India ink, color chalks and brown wash on paper, 31.8 x 24.2 cm, gift of Fania and Gershom Scholem, John and Paul Herring, Jo Carole and Ronald Lauder Collection, the Israel Museum, Jerusalem, photograph copyright © Collection the Israel Museum by David Harris, copyright © 2007 VBK, Vienna.

Paul Klee, *Presentation of the Miracle*, 1916 (fig. 3.3): 54, watercolor and pen on primed cardboard, 26.4 x 22.4 cm, the Museum of Modern Art, New York, gift of Allan Roos, M. D. and B. Mathieu Roos, copyright © 2007 VBK, Vienna.

Letter of Gretel Adorno to E. W. Kornfeld, September 29, 1969 (fig. 3.4): courtesy Galerie Kornfeld, Bern.

Letter of E. W. Kornfeld to Gretel Adorno, October 4, 1969 (fig. 3.5): courtesy Galerie Kornfeld, Bern.

Paul Klee, *Pierrot lunaire*, 1924 (fig. 3.6): 257, watercolor on paper on cardboard, 30.5 x 37.5 cm, Honolulu Academy of Arts, gift of Geraldine P. und Henry B. Clark Jr., copyright © 2007 VBK, Vienna.

Paul Klee, *Baroque Portrait*, 1920 (fig. 3.7): 9, watercolor on paper on cardboard, 25.5 x 18 cm, collection Carl Djerassi, copyright © 2007 VBK, Vienna.

Paul Klee, *Absorption* (self-portrait), 1919 (fig. 3.8): 113, hand-painted lithograph, collection Carl Djerassi, copyright © 2007 VBK, Vienna.

Paul Klee, *A Spirit Serves a Little Breakfast, Angel Brings What Is Desired*, 1920 (fig. 3.11): 91, hand-colored lithograph, 19.84 cm x 14.61 cm, collection Carl Djerassi, copyright © 2007 VBK, Vienna.

Paul Klee, *Ruins of the Barbarian Temple,* 1934 (fig. 3.12): 154, ink on cotton on artist's mount, 32.39 cm x 36.83 cm, collection Carl Djerassi, copyright © 2007 VBK, Vienna.

Carl Djerassi and Gabriele Seethaler, *Gruppe zu elf, mutant 2, Superimposed by Walter Benjamin and Gershom Scholem,* 2006 (fig., 3.18); 82 x 110 cm, jet-print on canvas, after Paul Klee, *Gruppe zu elf,* 1939, 1129 (JK9) Walter Benjamin, Foto Studio Joël Heinzelmann, courtesy Walter Benjamin Archiv, Akademie der Kunste, Berlin; Gershom Scholem, copyright © Gershom Scholem Archive, ARC. 4° 1599, the Jewish National and University Library, Jerusalem, Israel.

Hitler photograph in trench coat (fig. 3.19): http://www.nobeliefs.com/nazis.htm.

Paul Klee, detail of *Bird Comedy,* 1918 (fig. 3.21): lithograph, 42.5 x 21.5 cm, SFMOMA, gift of Carl Djerassi, copyright © 2007 VBK, Vienna.

Paul Klee, detail of *Demonry,* 1925 (fig. 3.22): 204, pen on paper on cardboard, 24.7 x 55.4 cm, Zentrum Paul Klee, Bern, copyright © 2007 VBK, Vienna.

Otto Dix, detail of *Pimp and Girl,* 1923 (fig. 3.23): brush and India ink and watercolor on paper, the Pierpont Morgan Library, New York, bequest of Fred Ebb, 2005.126, detail, copyright © 2007 VBK, Vienna.

Score of the beginning of Claus-Steffen Mahnkopf's *Angelus Novus,* a "music theater" based on Walter Benjamin's interpretation of Klee's *Angelus Novus,* together with a portrait of Claus-Steffen Mahnkopf (fig. 3.24): www.claussteffenmahnkopf.de. CD available as *Musik in Deutschland, 1950–2000* (www.deutscher-musikrat.de and www.bmgclassics.de), photo copyright © by Gabriel Brand, Freiburg.

Score of the first twenty seconds of Hiroshi Nakamura's *Angelus Novus* for solo trombone, together with a portrait of Hiroshi Nakamura (fig. 3.25): http://hmnak.ld.infoseek.co.jp.

Part of the score of Hiroshi Nakamura's *Angelus Novus* for solo trombone, together with a portrait of Barrie Webb (fig. 3.26): CD available as *The Japan Project,* Barrie Webb trombone metier MSV CD92017, www.classical-artists.com/barrie-webb.

Score from the beginning of the vocal section of Egill Ólafsson's *Angelus Novus,* together with a portrait of Egill Ólafsson (fig. 3.27): CD (Skifan SCD 226) available through www.egill-olafsson.com.

Text of Erik Weiner's *Angelus Novus* rap, together with a portrait of Erik Weiner (fig. 3.28): www.erikweiner.com.

Paul Klee, *Two Men Meet, Each Supposing the Other to Be of Higher Rank* (invention 6), 1903 (fig. 3.29): 5, etching, 11.7 x 22.4 cm, collection Carl Djerassi, copyright © 2007 VBK, Vienna.

Gabriele Seethaler, *Gershom Scholem, Arnold Schönberg, Walter Benjamin, and Theodor W. Adorno Around Arnold Schönberg's Coalition Chess, with Adolf Hitler* (fig. 4.1): Arnold Schönberg and Arnold Schönberg's coalition chess, copyright © Arnold Schönberg Center, Vienna; Gershom Scholem, copyright © Gershom Scholem Archive, ARC. 4° 1599, the Jewish National and University Library, Jerusalem,

Israel; Theodor W. Adorno, courtesy Theodor W. Adorno Archiv, Frankfurt; Walter Benjamin, copyright © Gisèle Freund, Agence Nina Beskow. Adolf Hitler: http://www.bytwerk.com/gpa/hitler2.htm. See fig. 4.17.

Walter Benjamin (fig. 4.2): Walter Benjamin in Mallorca, photographer unknown, courtesy Walter Benjamin Archiv, Akademie der Künste, Berlin.

Theodor W. Adorno (fig. 4.4): courtesy Theodor W. Adorno Archiv, Frankfurt.

Arnold Schönberg (fig. 4.5): copyright © Arnold Schönberg Center, Vienna.

Theodor W. Adorno and Arnold Schönberg (fig. 4.6): Theodor W. Adorno, courtesy Theodor W. Adorno Archiv, Frankfurt; Arnold Schönberg, copyright © Arnold Schönberg Center, Vienna.

Arnold Schönberg (fig. 4.7): copyright © Arnold Schönberg Center, Vienna.

Arnold Schönberg (fig. 4.9): copyright © Arnold Schönberg Center, Vienna.

Gershom Scholem (fig. 4.10): copyright © Gershom Scholem Archive, ARC. 4° 1599, the Jewish National and University Library, Jerusalem, Israel.

Carl Djerassi and Gabriele Seethaler, *Gershom Scholem, Walter Benjamin, and Gershom Scholem with Walter Benjamin's Hair* (fig. 4.12): Walter Benjamin in Mallorca, photographer unknown, courtesy Walter Benjamin Archiv, Akademie der Künste, Berlin; Gershom Scholem, copyright © Gershom Scholem Archive, ARC. 4° 1599, the Jewish National and University Library, Jerusalem, Israel.

Carl Djerassi and Gabriele Seethaler, *Walter Benjamin Without Glasses, Theodor W. Adorno, and Walter Benjamin with Theodor W. Adorno's Eyes* (fig. 4.13): Theodor W. Adorno, courtesy Theodor W. Adorno Archiv, Frankfurt. Walter Benjamin in Mallorca, photographer unknown, courtesy Walter Benjamin Archiv, Akademie der Künste, Berlin.

Adolf Hitler (fig. 4.17): Adolf Hitler on the train, 1932, Berlin: Zeitgeschichte Verlag, Heinrich Hoffmann, *Hitler wie ihn keiner kennt.* http://www.bytwerk.com/gpa/hitler2.htm

Excerpt of letter of Arnold Schönberg to Wassily Kandinsky, April 19, 1923 (fig. 4.21): copyright © Arnold Schönberg Center, Vienna.

Carl Djerassi and Gabriele Seethaler, *Paul Zion Klee (Paul Klee's Jewish Symbols from Figures 4.25–4.31 and Nazi Yellow Star Superimposed Upon Paul Klee's Face)* (fig. 4.22): Paul Klee, Dessau, 1927, photograph copyright © Hugo Erfurth, Archiv Bürgi, Bern.

Theodor W. Adorno, U.S. immigrant identification card and certificate of naturalization (fig. 4.23): courtesy Theodor W. Adorno Archiv, Frankfurt.

Paul Klee, detail of *Bird Comedy*, 1918 (fig. 4.24): lithograph, 42.5 x 21.5 cm, SFMOMA, gift of Carl Djerassi, copyright © 2007 VBK, Vienna.

Paul Klee, *Angelus descendens*, 1918 (fig. 4.25): 96, pen and watercolor on paper on cardboard, 15.3 x 10.2 cm, private collection, Great Britain, copyright © 2007 VBK, Vienna.

Paul Klee, *Small Vignette to Egypt*, 1918 (fig. 4.26): 33, watercolor and gouache on paper on cardboard, 16.8 x 9.1/8.9 cm, private collection, Switzerland, long-term loan Zentrum Paul Klee, copyright © 2007 VBK, Vienna.

MUSIC FOR *FOUR JEWS ON PARNASSUS*—A CONVERSATION BY CARL DJERASSI

BY THE SAME AUTHOR

FICTION
The Futurist and Other Stories
Cantor's Dilemma
The Bourbaki Gambit
Marx, Deceased
Menachem's Seed
NO

POETRY
The Clock Runs Backward

PLAYS
An Immaculate Misconception
Oxygen (with Roald Hoffmann)
Calculus
Ego (Three on a Couch)
Phallacy
Taboos

NONFICTION
The Politics of Contraception
Steroids Made It Possible
The Pill, Pygmy Chimps, and Degas' Horse
From the Lab Into the World: A Pill for People, Pets, and Bugs
This Man's Pill: Reflections on the Fiftieth Birthday of the Pill

SCIENTIFIC MONOGRAPHS
Optical Rotatory Dispersion: Applications to Organic Chemistry
Steroid Reactions: An Outline for Organic Chemists (editor)
Interpretation of Mass Spectra of Organic Compounds (with H. Budzikiewicz and D. H. Williams)
Structure Elucidation of Natural Products by Mass Spectrometry (with H. Budzikiewicz and D. H. Williams)
Mass Spectrometry of Organic Compounds (with H. Budzikiewicz and D. H. Williams)

DESIGNED BY *Chang Jae Lee*

COMPOSED BY *Audrey Smith*

TYPESET IN *10/14 Freight Text Book*

PRINTED BY *Sheridan Books*